S.J. PEPLOE

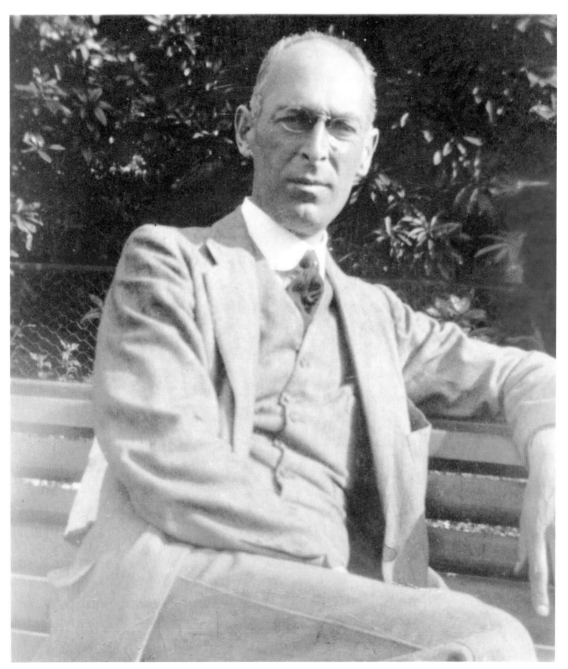

S.J. Peploe c.1920

S.J. Peploe

1871–1935

GUY PEPLOE

MAINSTREAM
PUBLISHING

EDINBURGH AND LONDON

The publishers gratefully acknowledge the assistance of
The Scottish Gallery

AITKEN DOTT LTD
FINE ART DEALERS ESTABLISHED 1842

First published in Great Britain in 2000 by

MAINSTREAM PUBLISHING COMPANY (EDINBURGH) LTD

7 Albany Street

Edinburgh EH1 3UG

ISBN 1 84018 306 3

A catalogue record for this book is available from the British Library

Designed by Janene Reid

Typeset in Gill Sans and Adobe Garamond

Printed and bound in Great Britain by the Bath Press

ACKNOWLEDGEMENTS

I would like to thank my colleagues at The Scottish Gallery for their forbearance during the lengthy generation of this book; the kind, patient curators, librarians and dealers who have indulged my enthusiasm with practical assistance; the many private collectors who have allowed me to disrupt their homes and dismantle their paintings; and members of the Peploe family for their unstinting support. Particular thanks go to Christina Jansen for her help and advice on the illustrations and picture research.

Dedicated to Denis Peploe RSA

PREFACE

Sam Peploe was my grandfather. His late-arriving family and early death at the age of sixty-four meant that I didn't know him. To the outside world he was a shy, austere, even forbidding figure. By family accounts he was warm, loving, absent-minded, capable of hilarious inventions and the occasional extraordinary performance. Jessie King once persuaded him to play the part of the Pied Piper in one of her elaborately dressed and staged pageants, leading the children through the streets of Kirkcudbright. He was tall and slim and moved athletically with a distinct spring in his step. On his walk to the studio from his India Street flat he would have been taken for a professional – a lawyer or an accountant. Always immaculate in dress, but comfortable; suits, perfectly tailored, in brown or grey with a modest check but left to rest in a wardrobe for a few years before being adopted; he would have a bowler hat and a raincoat over his shoulder. In the South of France his city footwear would give way to espadrilles, but the same three-piece suits would suffice, as they would in Iona.

Writing this preface makes me feel a strong bond: proud and loving, and hopeful that he might even be pleased with my book or at least smile indulgently and pull me stiffly against his worn tweed suit, always smelling of oil paint. His life was not extraordinary but ran a course familiar to us all: triumphs and setbacks, love and friendship, indifference and enthusiasm. His legacy to the world is his paintings.

SAMUEL JOHN PEPLOE

was born on 27 January 1871 in the family home at 39 Manor Place, Edinburgh. His father, Robert Luff Peploe, was by then forty-three. He had already been married once, to Mary Seymour Reid, and she had borne him a son, James; sadly, she died in 1863, just three years into their marriage. His second wife, Anne Watson, bore him three children, William, Sam and Annie, but tragically she too died, aged only thirty-nine, in 1874.

Robert Luff Peploe was one of at least seventeen children, by six marriages, of William Peploe of Royston in Hertfordshire, who went north to Elgin as a supervisor in the Excise Service in November 1833. This branch of the Peploe family can be traced back directly to a William Peploe of Shawbury in Shropshire, whose will was dated 1551. William was of yeoman farming stock, but others had done better; Peplow Hall (demolished in the 1930s) was a John Nash house near Market Drayton, built by the Pigot family, and taking its name from the township of Peplow which was listed as a Manor in the Domesday Book. There had been a family by the name of Papelau living in Alençon in Normandy before the Conquest; they were associated with the Corbet family, and

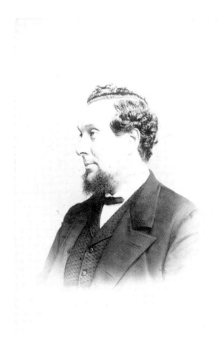

Robert Luff Peploe

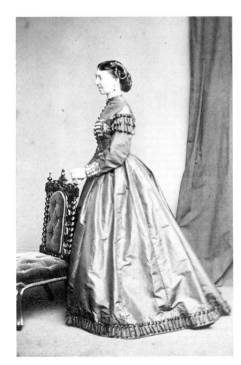

The artist's mother

perhaps the Peplows came to England as squires to their Corbet overlords in 1066. A Samuel Peploe was made Bishop of Chester, gaining approval when he refused to abandon his royal prayer when threatened by Jacobites during the 1715 uprising in Preston. 'Peep low, peep low, he shall peep high,' George I is supposed to have exclaimed.

The Excise Service was a way of getting on in life. Like the army or the Church, however, the Service meant a stressful and peripatetic life for its junior officers, and William's final posting to the Highlands came after a dozen moves and a demotion lasting four years made at a time when he lost a wife and two children within the space of three months. Robert Luff Peploe was only five when the family moved to live in Elgin; after a year he had a new stepmother and, at regular intervals, additional half-siblings. William became inspector in Tain and the family lived for the next twenty-eight years there or at Invergordon. He died in September 1862 and was laid to rest in St Duthus Old Cemetery, Tain.

Robert started in the Commercial Bank of Scotland in the town before moving to Edinburgh in 1853. He was obviously a talented man, rising through the ranks to the very top as manager in 1882 but sadly dying two years later. He left a substantial fortune and almost as substantial debts; at the peak of his profession he was in the process of establishing a grand household at the new family home at 39 Manor Place. A decanter and an ashet bearing a family crest (most probably invented) are the only remaining family items to bear witness to that short period of opulence.

So Sam and his elder brother and younger sister were orphaned. They were in the

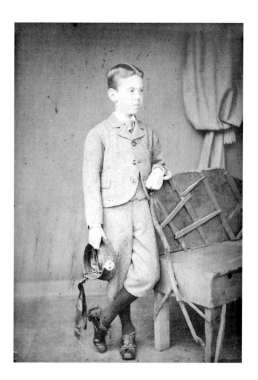

Samuel John Peploe

guardianship of their father's trustees and looked after by their half-brother James, who was twenty-three, and their nanny, Mrs Mary Sanderson. Sam at this point was attending the Collegiate School on the south side of Charlotte Square. He was a bright student, collecting several handsome leather-bound books as class prizes, but by the time he left school he had no clear vocation. The Church, the army and the Empire were all mooted but eventually he began work with the solicitors Scott & Glover in Hill Street. It seems, however, that his inspiration was art, not the law. Time out of the office was spent sketching in Princes Street Gardens and time indoors doodling on his copyist's paper. He was soon able to convince his trustees that he should be allowed to attend classes at the Trustees Academy. These classes took place in the Royal Institution, now the Royal Scottish Academy but then housing several bodies, including the RSA. The classes included drawing from the antique and from life, but were perhaps somewhat in decline since the inspirational teacher Robert Scott-Lauder's death in 1869. As was essential at this time, Peploe went to Paris where he studied at Julian's teaching atelier under the French classicist Guillaume Bouguereau and at the Académie Colarossi, where he won the silver medal in 1894. The following year he won the Maclean Watters Medal at the Royal Scottish Academy Life Class. He must have attended classes in 1896 also because a life painting, *Nude in Studio Interior* (Plate 2), in the Edinburgh College of Art Collection, of considerable charm and virtuosity, bears that date.

From his class photograph we see a bespectacled, fair young man, somewhat moon-faced, not yet hardened by the vigorous, outdoor life of the painter in oils he had chosen.

Sam, Annie and Willie

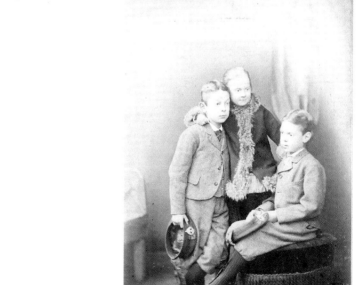

He suffered variable health throughout life but had a wiry strength; he was a lifelong walker, once walking the fifty-six miles from Edinburgh to Jedburgh in a day. His apprenticeship was long; he did not exhibit his first work, entitled *Charcoal Sketch*, until 1897, followed by a painting, *Children*, both at the Royal Glasgow Institute. His first solo exhibition was in 1903 at Aitken Dott & Son, The Scottish Gallery. That this didn't happen earlier can be partially explained by the lack of necessity: modest private means and lifestyle perhaps dulled professional ambition. More importantly, a natural introspection manifested itself in an obsessive need to practise, to observe and contemplate, not as a preparation to launch his career but as part of the process of picture-making. By honing his skills and always seeking to add to his knowledge of the medium, he could see work as a continuous experiment out of which, and not entirely within his control, a work of art could be made.

There is a family story of how Sam, blindfolded, used to draw a pig without lifting the pen from the paper, putting the tail on with a flourish. Drawing was enormously important to him. It was the cutting edge of his skill and he practised incessantly. He filled sketch-

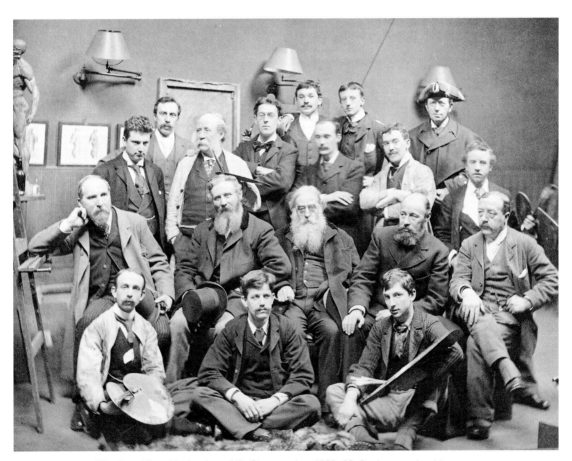

The Royal Scottish Academy Life Class, session 1892–93. Peploe stands with arms folded under the middle lamp

books as he combed the countryside looking for subjects. The preparatory drawings for his paintings are very often framed on the page, with his pencil or conté pen or brush, like *Street, Royan* (page 33), to suit a format of canvas or board, and there might be several sketches on a page.

Although almost no very early work survives, it is known that Peploe drew all his life.

The Fish Market, c.1896
Pastel on paper
32 x 47 cm (12.5 x 18.5 in)
FIFE COUNCIL MUSEUMS; KIRKCALDY
MUSEUM & ART GALLERY

From the early 1890s he worked with pastel depicting Newhaven fisherwives as in *The Fish Market* (above) or working on tinted paper, describing a farmyard or a girl at a dressing-table. These rare works are suggestive of an earlier period and are influenced by Whistler. His first exhibited work, the prosaically entitled *Charcoal Sketch* mentioned above, demonstrates that from the beginning he saw fit to exhibit drawings; and his first two exhibitions at The Scottish Gallery included as many drawings as paintings. He would carry a sketchbook with him wherever he went, making quick, sharply observant drawings of street life in Edinburgh and Paris. With a few deft strokes he could capture the essence of a moment – the handsome profile of his friend J.D. Fergusson (page 25) or a top-hatted gent escorting a toddler along the pavement (page 23).

Peploe loved to draw women. The excitement of drawing from life has been a driving inspiration for artists since the Renaissance and this force is communicated in Peploe's nudes. He worked quickly, changing the model's pose after each sketch, capturing the tension of an extended back or twisting neck, obsessed by the infinite variety of the body's posture. These drawings are the record of Peploe exercising his heart, filling his lungs and breathing out. If Peploe took inspiration from life-drawing he also had a fascination with women as models, elegantly attired, behatted, sometimes with the suggestion of an interior as a backdrop. There is a strength in these women; they are sometimes sexy or challenging but always invested with palpable character.

Peploe had no interest in watercolour, describing himself in his passport under 'profession' as 'Painter in Oils', but he used notes of oil colour with conté or ink in a series

of evocative sketches of Paris including *Flower Seller I* and *II* (page 34) which were dis-covered by his widow and shown in The Scottish Gallery in 1947.

Peploe rarely dated his drawings but some of the character of his drawing, like handwriting, is constant; the sinuous, suggestive line or powerful cross-hatching and taut composition are apparent from first to last. We can guess the age of the artist in his *Self-portrait* (page 61) to be about forty-five and date the drawing to around 1920. It is the face of a modern man, in control of his destiny and looking forward to the maturity of his artistic life with sharp intensity.

In painting as well as drawing he was highly self-critical, and that very little early work survives is testament to his habit of destroying what he saw as unsatisfactory. As a landscape painter he could find ecstasy in the simplest communication with nature, in the intense sensual experience of working in a living landscape, of being part of the balance in the natural order. He believed that sometimes his hand was guided as he worked; that the intellectual could give way to the instinctive. He believed that this heightened state could only be achieved by absolute devotion to the practice and study of his vocation.

Like Albert Camus's Sisyphus, damned for eternity to roll a boulder to the top of a hill but finding happiness from the sun on his neck and the feel of the grass under his feet, Peploe could see life as absurd and wonderful at the same time. His subject is the beauty of the natural order and in this sense the actual subject is unimportant and his outlook modern. There is nothing didactic in his work; we are not required to deconstruct the painting, merely to enjoy it. He could not see the painter's role as inactive, however. He observed at a pitch of intensity that can only be learned, but he also had to distil the truth in the strict confines of an oblong with only brush and paint for tools. It is the same modernist viewpoint and sense of wonder which took Paul Cézanne back a hundred times to Mont St-Victoire and let the north end of the tiny island of Iona or freshly cut roses provide limitless subject-matter for Peploe.

Robert Brough was the best known of his fellow students both in Edinburgh and Paris. Another was a painter from Yorkshire, Alfred Terry, with whom he corresponded during the summer and winter of 1894 after their return from Paris. The letters give little insight to the art historian but tell us something of the passion for life and fragile ego of Peploe in his early twenties. Reading Thomas Hardy novels, discussing opera and having long conversations sustained by cups of tea is a long way from Parisian life as described by Toulouse-Lautrec, but we see a young man fully engaged in life with an intense curiosity about people and a deep sympathy for nature. He wrote in June 1894:

2 Ravelston Park
Edinburgh
4 June '94

Hello! Terry, is that you?

You remember the head popped out of Harley's window and the call up to
you in your room: 'Hello, Terry. Come on up, I'm just going to make tea'; rare
old days. After you'd gone I used to put my head out and call, but the blind was
down in the old room and there was no voice to answer me.

What an age it seems since that carefree dinner: and the midnight farewell –
that half-hour <u>together</u>: then the silent creeping down the dark stairs and out into
the night, full of thoughts. Next morning Paris seemed emptier, poorer . . .

Well, to begin with I'll tell you all the events in order since you left. 'School'
was like a ditch in midsummer, <u>Brough</u> anxious for the country, so down we went
– to Moret. What a glorious time we had! Weather midsummer-hot.

Down by the river of a morning among the long meadow-grass, lying in the
sun, every sense satisfied to the full, the air vocal with the hum of insects and the
song of birds, the perfume of flowers making one drowsy with their sweetness,
and for sights the silver poplars quivering in the sunlight, the river with its
reflections, and penetrating one above all the sense of sunlight and the gentle
suck-suck of the river – warmth and coolness combined. Swallows everywhere
flitting low over the water chasing dragonflies; voice of a woman further up the
stream and the sound of a distant mill wheel. What a place to dream in! And
towards evening when the air became still and the colour deepened and quivered
till inanimate things seemed alive, when the water was a molten mirror, till one
almost feared to breath for fear of spoiling its surface, and the heavy perfume of
the sequoia blossom lulled one to dream, sitting there with every sense often
thinking of nothing – the brain passive – simply drinking in the sensuous beauty
of it, was life – I understood the 'lotus-eaters'. I could have sat there for ever in
sweet forgetfulness. By moonlight, too, when all was silver and silence. At just
before dawn when the river was clothed with long shrouds of mist – ghostlike –
and you heard the waking birds answer the approach of dawn, the mists hurrying
away with the rising of the sun. Oh! The old church of Moret with its grey
tumbling stones with its wallflowers growing here and there – always different –
from the grey of a rainy morning to the warm flush of the evening sun, pure gold
against the eastern sky. It seemed to be built of some wonderful material – no
common stone – that had the power of absorbing beauty from all around. It was
the beauty which June accords.

The peasants with their sun-browned faces and backs bent with toil, how

beautiful they were! There were a lot of American fellows there and we all dined together; sometimes the talk was good.

Albert, the landscape painter, was there – lives there – and a rare good fellow he is. A big mind, a big man, in some things simple as a child, with a deep vein of mysticism. Full of ideas with a poetical side undeveloped – unconscious. A believer in the supernatural or a spiritualist as he would call himself. It was the only way he could account for some things. For instance, his theory that landscape painters are born from a connection between a man and woman in the open air amid natural beauty. A rare fellow, huge in everything – including appetite. I almost loved him . . .

He never worked in a school: works laboriously on his canvases and always out of doors, never works inside. Up every morning at five. Sisley lives there also, an old man now. All those landscapes we had been seeing during the winter at Durand Ruel's I saw there in the 'life'. Old Brough picked up wonderfully down there. I had to leave him there as I had promised to go home with Harley. I have not heard from him yet, but he was all right when I left him. Thank God!

I got your letter when I got up to Paris and read it in the old café. Your letter was most enjoyable, I read it again and again. What edition of Lohengrin was it that you got for two shillings? Harley and I had two or three fine evenings in Paris before we left. I was sorry leaving. We only stayed one day and one night in London – lack of funds. Saw the Guild Hall; I think the Whistler was the finest I ever saw. Henry[1] is a Scotchman. We came up by night and by the time we got to Yorkshire the dawn was breaking. We opened the windows and gazed.

It was, however, that cold which I have still got as yet. I was fully sick to get back, though – I mean I have been living inside since I came and consequently am in distress. I simply can't do anything right now.

I tried Tolstoy but couldn't read him. I'm going to try long walks to try to get back to a saner mind. I'm in a sort of brain fever right now. Music seems the sole reality. I must have beauty – there is surely beauty in Edinburgh – I know what all this comes from but I can't live according to reason yet. I pity Marcus Aurelius. I know this is merely temperism and by next time I write to you it will be different. It might be worse! I think I've written enough: I feel better for it; don't believe a word of all this, it is pure affectation.

Yours, S.J. Peploe

Back in Edinburgh he was perhaps unable to get down to work immediately. It was also in the summer of 1894 that he met Margaret Mackay, who was to be his lifelong partner and his wife. She was three years younger than him and came from Lochboisdale in South Uist but was probably working in the post office in Castlebay in Barra when they first met. It

may have been his first visit to Barra and he was with his brother and most probably his friend, the painter R.C. Robertson (1863–1910). The latter was wealthy and had an ocean-going ketch, *Nell*, on which Peploe was a frequent sailor. A letter he wrote to Margaret, largely recalling an adventurous walking tour of Devon, demonstrates that a real bond of affection had built up between them. She was a mature, calm Hebridean, tall and athletic, with long black hair and a serenity in her presence, which was reflected in her character, and was to give emotional substance to the artist for the rest of his life. She had moved to Edinburgh to be near him, but continued to work for the post office, in Frederick Street.

Margaret

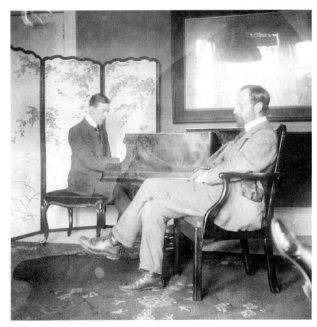

Willie Peploe and R.C. Robertson

Over the next years Peploe had a studio in the Albert Hall in Shandwick Place, a warren of studios and rooms occupied by a variety of small businesses, music teachers and elocutionists giving a noisy, somewhat bohemian atmosphere to the corridors. The studios were north-facing, on the top floor, and were small but well appointed. Here Peploe worked to perfect his technique. There is very little work which is dated to provide a chronology for these years, but we know the subjects he preferred. He used several models including a fair, bonnie Orcadian girl called Maggie Leask. She was introduced to him by R.C. Robertson and was a favourite model of Alexander Roche (1861–1921). Jeannie Blyth was a different type, a dark gypsy girl, who first started to pose around the age of fifteen or sixteen. She was quite unself-conscious, wide-eyed, dark and handsome, and continued to pose for several years until she married. She provided

inspiration for some of Peploe's finest early work. In *Gypsy* (Plate 3) he has captured the free spirit of the sitter, who is animated yet completely at her ease. Her colour is high, her blouse is off her shoulder and her hair is unruly, as if she has been dancing; but there is no challenge in her sexuality – she is captured in the bloom of innocent youth.

Peploe made an extended study trip to Holland, probably in the spring of 1896, with a friend, James Ballantyne, sailing from Leith to Rotterdam. He would already have been familiar with the greats of Dutch painting, not least from the recently rehoused Scottish National Collection. He particularly admired Rembrandt and Frans Hals and he brought back a great deal of illustrated material from the museums he visited. His portrait of *Old Tom Morris* (Plate 8) is quite Dutch in character and the pose a direct reference to Hals' *Verdonck* which he would have known in the National Gallery Collection and which had by then not been cleaned to reveal the ass's jawbone under the overpainted wine glass.

In his figure painting Peploe attempted to describe the character of his sitters and, more ambitiously, give them animation. With *Man Laughing* (Plate 12) we see Peploe

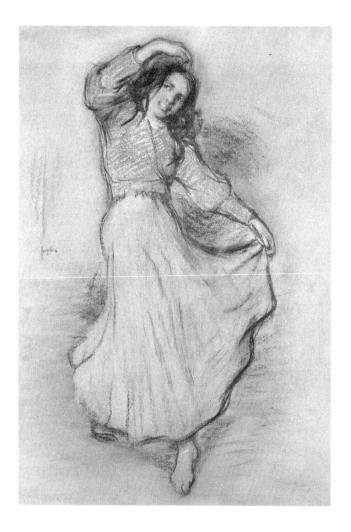

Gypsy Girl, c.1900
Pastel on paper
56 × 38 cm (22 × 15 in)
FIFE COUNCIL MUSEUMS; KIRKCALDY
MUSEUM & ART GALLERY

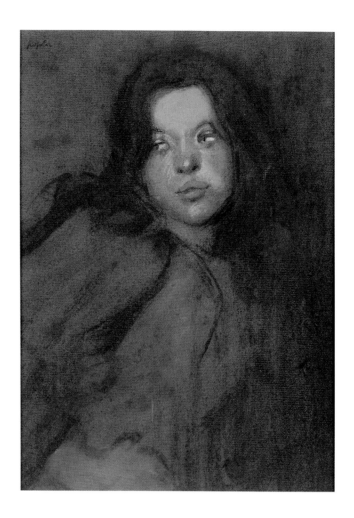

Jeannie Blyth, c.1900
Pastel on paper
26.8 x 19 cm (10.5 x 7.5 in)
THE SCOTTISH GALLERY &
EWAN MUNDY FINE ART

capture the fleeting expression of a face in laughter. It is as if the artist is setting himself an exercise: with a minimum of brushstrokes this most difficult and complex facial contortion must be made permanent. A more immediate influence – or at least inspiration – is the early work of Edouard Manet, particularly in still-life. His preferred compositions were simple – perhaps some fruit, a knife, a modest flower arrangement; small in scale and executed with a controlled economy in a limited palette against a dark background. *Painting Materials* (Plate 5), c.1897, self-referential in subject and calculatedly understated in treatment, is nevertheless a sophisticated essay in tonal construction, painted *alla prima* with great confidence.

In about 1900 he moved studio to an old schoolhouse near Haymarket Station, and took a large, rather gloomy room at 7 Devon Place, a building long since demolished. In clearing out his previous studio Peploe destroyed much work both finished and unfinished. His wife recalled, many years later, when visiting the artist Fiddes Watt in London how he had asked if she wanted to see an early painting by Peploe and produced a smiling portrait of Jeannie Blyth which had been rescued from a skip at the time of Peploe's studio

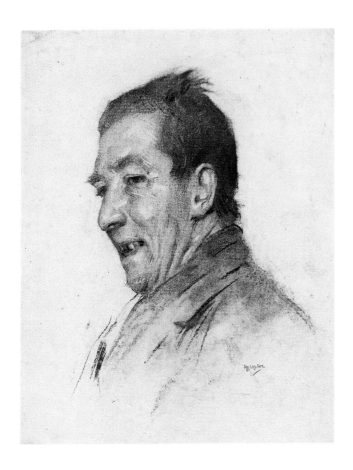

Head of Old Tom Morris, c.1896
Charcoal on paper
34.3 x 26.7 cm (13.5 x 10.5 in)
PRIVATE COLLECTION

removal.[2] In his new environment he began to give more consideration to his still-life subjects, adding considerably to their sophistication. Peploe was not limited to oil painting nor to the studio. We know it had long been his practice to paint landscape in front of the subject, and its direct, emotional appeal, as opposed to the artifice of a studio composition, led him to a swifter, more naturalistic treatment.

His sister Annie had married a doctor, Frederick Porter, and they lived in Comrie in Perthshire. Dr Porter wrote a piece on Peploe in which he recalled the artist's early visits to Comrie and some of his thoughts on how painting:

> . . . was like writing; when you know what to write it was written and when you know what to paint it appeared on canvas. One day I watched him painting just outside the gateway of my house. It was a brilliant afternoon and Peploe was painting a 24 x 20 canvas embracing a roadway of Dallingross with some whitewashed cottages and with a background of a low-lying hill. In the immediate foreground to the left of the canvas there was a woman with a dark sunshade. Beyond this and more centrally placed was a horse and cart. I watched Peploe as he was painting the figure and the horse and cart and it was a revelation to me with what dexterity those moving objects took their place in the picture.[3]

Peploe painted several bright impressionistic views on his first visit to Comrie after having stalked the town and its surroundings for several days looking for possible subjects. He had just returned from a trip to Paris and may well have been looking again at the work of Sisley which seems a clear inspiration in *A Street, Comrie* (Plate 10) of c.1900, referred to in his brother-in-law's recollection. The subject of *Spring, Comrie* is light coming through trees. It has something of the feel of an exercise and is as far as the artist would go in this direction. He would never be drawn instantly to the obvious subject, seeing the selection of what to paint as a vital part of the creative act.

In 1903 he moved on from Comrie to Barra where he continued to be concerned with light and movement; even the little houses and church of Castlebay in *Landscape, Barra* (Plate 17) seem almost to vibrate in the brilliant Atlantic light. His technical approach is in instinctive response to his subject and the vigour of the brushwork in the panels he painted in Barra in 1903 would not be seen again until he painted in Brittany in 1912. His small panels of the previous years are more tenebrous, using longer brushstrokes and less impasto; and, though modest, are compellingly close to Whistler. In *Evening, North Berwick* (Plate 16) he has chosen to paint at dusk as the lamps are lit in the houses and the faint glow of sunset bathes his scene with an even, warm light.

He had two different-sized painting boxes. These were simple devices with enough space inside for small paint tubes, turpentine, a palette and panels, one of which could be fitted inside the lid, while the box could be held with a thumb-strap so that the artist could paint anywhere. The smaller box took 'cigar-box lid' panels (7.5 x 9.5 inches), and could fit in a pocket. This was the scale he preferred until about 1909.

The artist in his studio at Devon Place

From perhaps 1901 onwards he was also working towards his first exhibition, which took place at The Scottish Gallery of Aitken Dott & Son at 26 South Castle Street from 3 November to 1 December 1903. The Scottish Gallery had been established since 1896, within a large framing and artist's materials business, to mount exhibitions of new work by Scotland's leading artists. The firm was established in 1842 and has played a central role in the commercial art world of Edinburgh right up to the present day. Peter McOmish Dott, the son of the company's founder, was a highly cultured man and a tremendous advocate of many of Scotland's most important artists of the period. He was a particular supporter of William McTaggart (1835–1910), the great landscape painter.

The gallery had bought its first work by Peploe, *A Gypsy Queen*, in November 1898 and three paintings a year later, *Girl with Mantilla*, *Moonlight* and *Old Man's Head*. For the exhibition the gallery took a small commission of 10 per cent but charged five pounds' rent per week and the artist had to pay all the expenses: carriage, catalogues, advertising in *The Scotsman*, even preparing and hanging the gallery. In complete contrast to his relationship with The Scottish Gallery in the 1920s, the artist at this point was in large measure responsible for his own show.

The exhibition was a success: twenty works were sold – oil paintings and drawings, including pastels. Top price was for *Village Street* (which may well be *A Street, Comrie*, Plate 10) at £25, followed by *Man Laughing* (Plate 12) for £20, which is certainly the portrait of Tom Morris which is now in the Scottish National Gallery of Modern Art.[4] J.D. Fergusson and another painter, W.S. MacGeorge (1861–1931), bought paintings.

There are some revealing letters to Margaret in the build-up to the show. In the days when there were four postal deliveries a day and no telephones, surviving fragments of hurried correspondence speak of an intense romance with its ups and downs between two very different individuals. Peploe had a genuine wonderment at the human condition, mind and spirit, which was perhaps the other side of an obsessive personality. As a young man, dedicated to a lonely pursuit, he was apt to focus on nuances within his relationships, producing critical, over-analytical judgements. He was also often immersed in the literature of the day, particularly the novels of Henry James whose influence can perhaps be detected in his correspondence. Peploe did come to recognise Margaret as his emotional guide, even his salvation; he used her strength to apply himself to work.

I'm better today; my headache is nearly away.

Coming out of my studio today at two, what freshness in the air – a real feeling of spring. What is there like these first days of spring? The freshness after rain – the huge, mounting clouds – the feeling of life.

These are the things I love – freshness of colour, movement, life.

Today I felt convinced – settled. These are the things I could paint – I will

paint. Not a cold arrangement but these living things – life, caught in the act; intimate, spontaneous.

Will you come on Saturday at 2.30? Will be glad to see you. I'm going off for a walk now, so goodbye.

And on the eve of his exhibition:

I should have liked to have seen you tonight: I felt as if I really wanted to talk to you and tell you everything. I thought of coming up for you but didn't know when you get out. I couldn't get what I wanted in the way of paper for the catalogues: it seems it would take over a week to get the right thing from London. Harley is beginning to see what I suppose Dott saw – that simply anything won't do. I wasted about two hours of his precious time: the poor man is an utter barbarian in matters of taste. I hadn't a moment to myself to think and I enjoyed it hugely. Tomorrow I give the colour of the walls at ten, see catalogue proofs at eleven; at twelve back to studio to receive frames; then there is the work of fixing canvases into them, nailing down etc. and a last embrace – dear farewell – before four o'clock when the van comes for them. How I wish you could be with me. I do wish it were all over, so that I might get back to my quiet work.

I saw Dott's walls this afternoon: he is not pleased with them and talks of having them done over again. Poor man. He has no idea of the right thing; he should have asked me . . .

You were awfully fine last night: nicer I think than I have ever known you; and yet I seemed an awful droop – it was as if you were putting up with me. Don't you think next time we meet we should carry on that talk? It is really, isn't it? That I am too fearfully reserved: that I won't tell you anything; that I can't, unless you draw it out of me with a wonderful sympathy. Do you really understand what a fearfully shy person I am. My real self seems guarded by a hundred defences and nobody – simply nobody – has had the courage or the sufficient knowledge to go to the centre and bring it out into the light and the sun and all the time it lies there in the darkness waiting, oh so patiently, for the voice and the touch. Sometimes when I think how good to me you are it seems to be in the way – bursting into life; sometimes a tone in your voice seems to be the very thing I want – the right touch on the string to turn the trembling into music.

And when I sit down at the piano, alone, as I did tonight, and play, then I seem able to say and do what I want and find a chance to give my soul an airing. That's what I meant last night when I said that even if there were a piano in the studio I might not be able to play before you. I might in time; I don't know. I

wonder at myself at even how I have gone as far as I have. A year ago I would have said it was an utter impossibility. The truth is not as you think, that I just put up with: you would perhaps wonder if I were to tell you . . . but I can't: I can't even write it. Of course we often only see each other as it were in 'working hours'; neither of us has ever seen each other at our 'best'. It is impossible under the conditions. But it isn't as if we could stop, could we? Or go back. Things must go on and every day really there is a difference. I seem to need something infinitely soft and delicate and tender and that is why I sometimes say that I like you so much when you are ill: then you seem to need me. If I could really realise that I was wanted . . . but I can't. You know I think that my first impression of you was truer – nearer the mark, than yours of me; you must have got a slight – in fact a really false impression of me. This is a fearfully coy letter but I hope it won't bother or distress you.

Won't you write me? You write before Wednesday; write so I may get it at four.

Colossal success this morning: everything today a success. My walls wonderful. Wingate, the landscape painter, came in when I was there (with Dott): on entering the room: 'Oh, beautiful, beautiful. What a tremendous improvement.' Dott was standing by and heard it all: he went on: '. . . the purple colour was so damnable. Oh, this is beautiful etc. etc.' Then he turned from my room looking through the doorway to the room done by Dott: 'Oh, what colour, look at the wood, Mr Peploe. Isn't it damnable – simply damnable!' Then we had a talk: my frieze was yellow. Wingate thought it magnificent but I said I was going to change it to a pink. He said: 'You can't do anything better.' I'll show you something finer than that. I've been four hours composing my pink and have got it at last: I think it tremendously finer: tomorrow I hang my pictures. Dott has hung some of his beastly, dirty brass plates on my wall; this morning I ordered them all down etc. etc. etc. etc. Aren't I talking? I was in your office this morning – buying stamps. I wanted to see you but you weren't there. Are you doing anything tomorrow night? When do you get out? Let me know. Now off to my studio to finish.

The show was reviewed by James Caw, the eminent historian of Scottish art, in *The Studio*:

Mr S.J. Peploe describes the exhibition of his pictures held here in November as 'some studies in oil and pastel', and the designation sums up not inaptly the impression left by the show. But if few of these 'studies' were informed with that savour of refined or profound emotion stirred by the spectacle of life and nature and that quest for beauty which, together or separate, are the very life of the higher forms of art, almost all were remarkable for the virile, fresh and vigorous

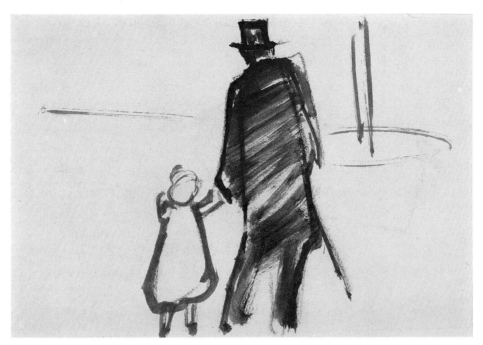

Man and Child, c.1904
Pen and wash on paper
15.2 x 20.4 cm (6 x 8 in)
PRIVATE COLLECTION

way in which they were handled. Mr Peploe's vision is not very subtle and he is possessed with a perverse taste for the ugly or the bizarre in figure and landscape.[5]

Caw finds that the landscapes are too close to Sisley or Pissarro and that the figures are too brutal and tend towards caricature. His highest praise is for *The Lobster* (Plate 11). The cooked crustacean, brilliant in cadmium orange and scarlet with a bone-handled knife to the right, is posed on a dark olive cloth beside a single lemon on a dish, all against a black background; the composition is finished with an upright signature in lobster colour; pure Japanese stylishness.[6] He also liked a picture of paint tubes, brushes and medium bottles (surely *Painting Materials,* Plate 5) and *Fruit Study*, which he had already praised when it was exhibited in the SSA[7] the previous year. These examples, for Caw, are: 'admirably drawn in true painter-like fashion with the brush and by juxtaposition of closely observed tones'. The 'perversity' identified by Caw is most likely the artist's lack of interest in conventional beauty. The sitters for his figure paintings are not chosen to make pretty pictures. A gawky boy, a chubby baby, a tramp, all animated, challenge the artist's skill. The very best combine the bravura performance of painting with an emotional commitment which brings out the character of the sitter. This is most apparent, not surprisingly, in several portraits of Margaret (Plates 22 and 38).

Over the next two years Peploe's still-lives become more elaborate and refined.

Tables are draped in linen and arranged with elegant items – a silver coffee-pot, a dish of black grapes, a Chinese porcelain bowl, a wine bottle and a glass of luscious fruit. His finest achievement in this series is *Still-life with Coffee-pot* (Plate 28). Like its after-dinner subject, the work seems replete; it seeks to satisfy all our senses and is full of sophisticated compositional devices. For example, the orange to the left of the dish, one of three notes of rich colour in delicious counterbalance, has been modelled in an angular fashion to complement the corner of the table, while the black grapes are lustrous against the black background. The work, unusually large in scale at 24 × 32 inches, is, perhaps quite deliberately and self-consciously, his masterpiece in the tonal work of the first ten years of his studio production.

THROUGHOUT HIS LIFE Peploe enjoyed the company and conversation of other artists. It is not known when he met John Duncan Fergusson but this friendship was undoubtedly very important to both artists. Peploe was three years older than Fergusson and he certainly influenced the younger man's early style and choice of subject-matter. Fergusson wrote down his 'Memories of Peploe':

> When we met, S.J. and I immediately became friends and I found great stimulation in telling him my ideas about art. We discussed everything. Those were the days of George Moore, Henry James, Meredith, Wilde, Whistler, Arthur Symons and Walter Pater. I remember sitting on the rocks at the extreme north of Islay and reading Walter Pater's essay on the Mona Lisa and discussing it with Peploe . . . We were very much interested in the latest music and its relation to modern painting. S.J. was also interested in music and played the piano most sympathetically. I had in my studio one of the first pianos signed by Dettmer. When he came, Peploe always played it with complete understanding of the difference between it and an iron-framed grand. S.J. at the old piano is one of my happiest memories.
>
> On fine days I sometimes called at Peploe's studio in Devon Place. When I asked him to come out he would say, 'When it's fine outside it's fine inside!' Most people don't realise how true that is in a studio planned, decorated and lit for painting. So we sometimes had tea instead of a walk. But we often had long walks and talks. Often when I had put some idea forward at great length, he would say, 'I'll give you the answer tomorrow.' And he did . . .
>
> I remember when we arrived at Dunkirk I laughed at the lightness of the railway carriages. S.J. said, 'What's the matter with them – aren't they adequate?'

That was characteristic of him. In his painting . . . he tried . . . to find the essentials by persistent trial. He worked all the time from nature but never imitated it. He often took a long time to make contact with a place and was discouraged by a failure. He wanted to be sure before he started and seemed to believe that you could be sure. I don't think he wanted to have a struggle on the canvas; he wanted to be sure of a thing and do it. That gave his painting something.[8]

Their intense friendship, sharing of ideas and daily observation of each other's working practice had an encouraging effect on both men. At times their work was very similar and though they would often be compared, sometimes to one or the other's disadvantage, there was never any rivalry between them. They began to spend the summer months in Normandy from 1904 and there are pictures, perhaps painted on the same day, which could almost be by the same hand. They saw much less of each other after 1914, never again living in the same city, but their friendship and mutual admiration as painters remained undiminished even as their artistic paths diverged. One can speculate how the progress of their work might have been different had they continued their artistic intimacy. Perhaps it was Fergusson's conviction and strength of purpose that gave Peploe the courage to turn his back on his early style.

J.D. Fergusson, c.1907
Conté on paper
22.8 x 14 cm (9 x 5.5 in)
PRIVATE COLLECTION

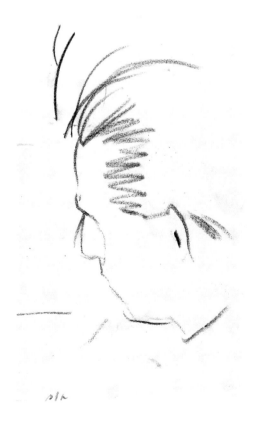

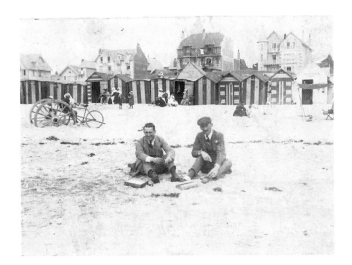

Etaples is the estuary town on the River Canche behind the beach resort of Le Touquet-Paris-Plage. There are many panels by both artists of the vast, empty beach (Plate 26), where, on a grey day, the horizon could be lost and the description almost abstract. In complete contrast, Peploe painted the colourful, bustling streets of the busy Edwardian resort in flurries of brilliant colour and, like Boudin and Renoir before him, he made subjects of the stout bourgeois holidaymakers on the beach. There is no social commentary, but the truth and charm of these observations comes down the decades. The two men also ventured down the Normandy coast, painting at various times at Berck sur Mer, Le Treport, Bernaval with its distinctive rising cliffs, Pourville, Etretat and, in Boudin country, at Deauville. Peploe was in Paris-Plage in 1907 and wrote to Margaret:

> My brother has gone home this afternoon, I am alone here – I begin to come to myself. The weather has been miserably cold these last three days – no sun – as bad as Scotland; cold and wet. I am so glad my brother has gone. I nearly – oh so nearly – went with him, but if I had I know I should have regretted it. I felt wretched after he left; went for a walk on the beach and came in to dinner – alone; since then it has been better. I had my coffee in the café, chatted as best as I could to the proprietor, played games with his little boy and really feel much better since at any time since I came to France. My brother was spoiling everything. He is so particular, nothing was as he imagined it, so everything was a failure and of course it reacted on me. He simply paralysed me. Tonight I feel myself. I'm thinking of going to Paris tomorrow, since Fergusson has not turned up and the weather is so bad. I know I should be ashamed of myself if I turned tail and came home, so I am going to risk it. I know it is what you would advise me to do if you were here. Though it has been a failure so far I still believe it

might turn out well – a few days in Paris and off somewhere to paint – my dear, you know how if I came home I would be wretched. I have been so miserable it was a fearful temptation, but I think this is over. It is a mistake to be too critical – it means one enjoys nothing. I came on purpose to enjoy myself; if I had been alone with Fergusson, all would have been well – I'll say no more about it. Right now I'm feeling splendid.

Yesterday I cycled with my brother to see Charles Mackie,[9] who lives in a village near here – about eight miles – but he was away for the day to Boulogne; but we did see his wife who did not even ask us in – owing to shyness, the usual Edinburgh self-consciousness, what a frightful thing it is. So we had to find the village pub, and then home.

I do like the French people: they always remind me of the Gaelic – so frank and open; and the language is so similar – same accent and intonation. They really are like children to us, so introspective and thoughtful. They so enjoy life, largely in an animal way. That is why France is to me such a good holiday; it takes me out of myself – makes me more like them, more of a healthy animal.

I'm dying to hear from you. I like you because you are Gaelic – what I hate is these damned Free Church, introspective people. My dear, I wish I could see you tonight. I feel quite healthy. I'm going to enjoy myself. I find it hard to restrain myself from singing! I am writing this in the café; someone is playing billiards and the proprietor is eating his dinner and I don't mind the noise at all. A day ago I couldn't have stood it. Tonight I feel like an artist. I hate critical, cold-blooded people – they simply freeze me. I hate the cold side of my nature and wish to be frank and cheery and happy. There's a hell of a lot of noise going on and it doesn't annoy me. Isn't it splendid! My holiday is beginning. I digested my dinner for the first time tonight. And I'm looking forward to seeing Fergusson tomorrow. I'm trying to expand. Cheers. It has been freezing for a week and at last the thaw has come. I'm so devilish sensitive to my surroundings – I take on the colour of the person I'm with. It's really bad for me. You are good for me. Fortune is good to me. How fortunate I am.

Life is ridiculous: one must accept that before one is prepared to live. To be critical is not to live. Accept the absurdity of everything and everybody and at once life becomes possible, even wonderful. Use your eyes, observe people; how funny they are! I hope you are not wearying. I hope the worst is over for you also. The first week. Are you finding something to amuse you? My dear squirrel, goodbye and be good and keep cheery. I shall let you know what is going on and where to write to. I may stay in Paris for a week and make a few sketches,

goodbye and kisses from S.J.P.

Seeking change and new stimulation he had moved, towards the end of 1905, to the Raeburn Studio at 32 York Place. It was built for Henry Raeburn in 1795 and he used it for twenty-eight years. It is a large, high, square room with a tall window in the north wall and fine Georgian detail – the antithesis of Devon Place.

Peploe decorated it in a pale grey with a pink tint, put in a black, polished linoleum floor, a sofa, covered in white, a bureau, his easel and a model's throne. He began to paint in a very light key, choosing still-life (very often with roses), interiors and, in particular, single-figure compositions. He also found a new, inspirational model in Peggy Macrae. She had a poise, grace and elegance which suggested many of the fluid poses Peploe composed. His technique broadened as he employed wide brushes, sometimes loaded with two or three colours. Stanley Cursiter speculates that he used 'a high proportion of stand oil with some addition of varnish' for his vehicle.[10] The paint is smooth and creamy and has a translucent quality, carrying the intensity of the pigment but without being too shiny or fatty. It was a demanding technique because the paint would lose its quality with over-manipulation: each mark had to be just so and work first time. Peploe later likened painting in oil to dancing: movements back and forward to the canvas, precision and control of gesture. There would always be tracks on his studio floor, like a fast bowler's run-up, where the artist had moved back to inspect and forward to paint.

The constructions are still essentially tonal, with colour selected as much for its tonal value as for its ability to enliven and intensify a composition. In many paintings of the York Place or 'White' period, Peploe demonstrates that he is still concerned with how paint could suggest the super-reality of his subject. Up close the painting of Peggy Macrae's face in *Elegance* (Plate 41) can be admired for its deft economy, but only at ten paces does her personality emerge: confident, poised, eyes a-sparkle. The basic anatomy of the subject is correct; we know Peggy Macrae is beautiful as a *A Girl in White* (Plate 40) but the artist's concern has moved on from the particular to the universal. Unlike Raeburn in the same room a hundred years before, Peploe does not seek to place his sitter in the room so that the light gives maximum relief fully revealing the features; instead, the light seems to dissolve form to be reassembled in the viewer's imagination from the swift, suggestive strokes. It is an essay in white: flesh, fabric, walls; tinted with pink, blues and grey. As with *Girl in Pink* (Plate 33), it is the paint itself which is as much the subject as the model. She is dressed in soft pink posed against a background in Georgian drab, with a large folio over her knee, enlivened with brilliant notes of red, blue and green.

In his still-lives the subject, most often roses, is brought forward to fill the canvas, a device which would not vary much for the next thirty years and which, conversely, made the subject less important than the formal means with which Peploe makes an original composition within the picture space. In *Pink Roses in Blue-and-White Vase, Black Background* (Plate 32) and *Still-life with Bananas* (Plate 31) he arranges his composition on a dark, reflective surface and against a black background so that his brilliant whites, yellows

Boy and Girl, c.1907
Conté on paper
17.8 × 12.7 cm (7 × 5 in)
PRIVATE COLLECTION

The Red Dress, c.1908
Conté and oil on paper
21.6 × 14 cm (8.5 × 5.5 in)
PRIVATE COLLECTION

and blues are in dramatic tonal contrast. But the real drama is in the performance of painting. These works simply could not have been created carefully.

Although Peploe was never ambitious to make his way as a painter in the art world, he was by no means disinterested in criticism or success. On reading the review of the Memorial Exhibition for Robert Brough,[11] who sadly died in a train crash in 1907, he could not help writing to Margaret:

> . . . It began talking about the influence of Sargeant on Brough and then it goes on: 'But the real and deepest influence upon him was that of a man whose work is far too little known, nay scarcely known, to us in London: and that man is Mr Peploe, to whom another artist of rare promise, Mr Fergusson, owes a like debt of gratitude. With Mr Peploe young Brough went to Paris and it was to Mr Peploe that he always, and with enthusiasm, avowed his indebtedness. To him he owes a heavy debt and to his compatriot Raeburn . . . etc' and again further down, talking of a picture of Brough's – his best, a real masterpiece – 'This portrait of a slender woman is painted with a nervous pace worthy of a Sargeant, an exquisiteness worthy of a Whistler and a freshness of conception and perfection of simplicity

that recall Peploe's accomplishment.' Eh! What! Perhaps that's why I'm feeling so well.

It is encouraging. I want to go one better. One better every shot – to do something real – my very own (stop me for goodness sake!).

He was by now working in earnest towards another exhibition at The Scottish Gallery and also sending work to London. The Allied Artists Association showed for the first time in the summer, a vast unjuried show, which took place in the Albert Hall and whose democratic purpose was to encourage artists who had never shown in London before to send in their work. Peploe sent a portrait of a baby and another of an old woman titled *Portrait of M.S.* (most probably his old nanny Mary Sanderson). He employed a cuttings agency and gathered several favourable notices. *Whitehall Review*, summing up the exhibition in September 1908, said: 'Mr S.J. Peploe who, though a well-known exhibitor in Edinburgh, has never shown in any London Society before this year, when his powerfully painted old woman's head at the Albert Hall at once made his reputation.'

In October he had a picture in both the New Baillie Gallery and the Goupil Gallery. The *Sunday Times'* critic identified Peploe's *Still-life*, in the launch show of this gallery at 13 Bruton Street, as taking pride of place. Fellow exhibitors were E.A. Hornel (1864–1933) and the highly fashionable French artist Monticelli.

The exhibition at The Scottish Gallery was in March 1909 and there was a flurry of letters to Margaret before its opening:

I wish I could have seen you this morning – I was in the depths of depression. I felt everything was a failure – my sketches[12] abominable. Dott makes me feel like that, but I shall tell you tomorrow. My catalogues are not finished yet – the bother I am having. I can't get a seat for the centre of the floor.

My model turned up this afternoon – much better than she was – in short there's going to be <u>nothing</u>!!

Dott sent me a note this afternoon, with the proposal that he should buy the whole lot except one or two figure paintings! What do you make of that? I said I should see him about it tomorrow: I am curious to see what he offers.[13]

Today I had a vision of the cloven hoof. It is no use being nice to these people: they never understand. Tomorrow I start new tactics.

I came away from Dott's without a grain of belief in myself; if it hadn't been for pride I'd have chucked the whole thing.

I'm looking forward to tomorrow – morning and again at six o'clock.

Come.

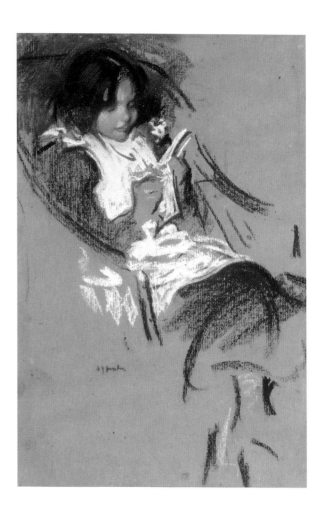

And perhaps the next day:

Dear One,

I've just got your letter – just come in (5.30) from Dott's. We are going to the theatre so I had to come away.

Your letter cheered me immensely. I was in the depths of depression, I don't know why. I think it's because my sketches don't look as well as I expected, also having McTaggart and Wingate[14] crammed down my throat by Dott – I feel as if I was nobody. I shall hang my drawings tomorrow.

When I was hanging today, the Modern Association[15] came in. Walton,[16] Fairley of *The Scotsman* and a lot more including Arthur Kay of Glasgow. A young man, very clever-looking – like a Frenchman. I liked him – he is coming back to see my show. He asked the price of my still-life; but I will tell you all about it when I see you on Saturday. What time? I am nearly in tears.

In the same envelope, written later the same evening:

Street Scene, c.1908
Pen wash and oil on paper
20.3 x 25.4 cm (8 x 10 in)
PRIVATE COLLECTION

Darling Art,

Just home from the theatre and feel much better. Your letter (the second) is splendid – quite exciting. I went behind and saw Davis the tenor before he went on tonight and gave him a 'buck up'. I shook hands with Herdmoth, who was washing off his face-paint, but on the whole it was tame.

Your letter was the best thing tonight. Yes, I must go and paint. I feel as if I have never got down anything good, which means I shall do better someday.

I was depressed when I wrote to you earlier – Dott and Proudfoot[17] think my work a great advance on my last show – I can't feel that. When I get the drawings hung I may feel better – that is tomorrow. What time on Saturday do I see you? Dearest, I am well, very well, and looking forward to Saturday. You must be well too. Is the cold away?

One kiss.

Today has gone well. The place is finished except clearing up – it looks lovely.

I sat this evening in the room alone just when it was growing dark and it was so beautiful I think I cried a little. If it hadn't been for knowing Dott might have looked in at any moment I should have just given up to it and let myself go – as I've done at the sound of your voice.

My brother looked in today and liked it. He said one of my sketches almost made him weep.

I'm not the least tired. I was down at the studio today and it looked desolate. My soul is in another place. And in the street I find myself going there gladly. I have no wish to go to York Place, but I shall go there tomorrow. The place is empty. I must begin to create newly – fresh beauty. I will keep all the news till tomorrow.

And on 9 March, a few days into the exhibition:

I didn't get 'elected'[18] today – isn't it splendid. Everyone is congratulating me. For myself I am really and truly, awfully glad. I was looking forward to it with a kind of dread.

Harley wrote me a very nice letter. He says Wingate and Campbell North almost came to blows in the club over my name: I am well hated. And one or two love me. I think I know of one.

Dear, I'm better today but not allowed up yet. Not till Saturday. I've a slight congestion of the lung and must wait till it is quite away. I'm sorry for your sake but you must be patient. The rest will do me good.

Yes, buy a drawing by all means – one you like.[19] Cadell's friend, Skelton, is talking of buying one or two.

Tell me how you are my love.

S.J.

Up until 1914 Peploe exhibited as many drawings as paintings and was an accomplished pastelist, often favouring a heavy sepia paper which took the pastel colour beautifully. His approach and technique are close to that of Degas, but he eschews strong colour. As with his painting, a few strong colour notes conform with his restrained aesthetic.

Another purchaser from the second exhibition was Alexander Reid, a dealer with a gallery in Glasgow at 117 West George Street, who bought six works from the exhibition. In May Reid took forty works on sale, which he presumably showed together. Reid was a remarkable man: he had been sent to Paris to learn the art business with French dealers

Street, Royan, c.1910
Black ink on paper
12 x 14 cm (4.7 x 5.5 in)
PRIVATE COLLECTION

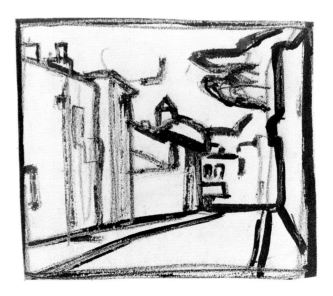

Flower Seller I, c.1909
Conté and oil on paper
15.3 × 25.4 cm (6 × 10 in)
PRIVATE COLLECTION

Flower Seller II, c.1909
Conté and oil on paper
15.3 × 25.4 cm (6 × 10 in)
PRIVATE COLLECTION

Flower Seller III, c.1909
Conté and oil on paper
15.3 × 25.4 cm (6 × 10 in)
PRIVATE COLLECTION

Boussod and Valadon, by his family firm of Kay & Reid. The Paris gallery also employed Theo Van Gogh and Reid roomed with Vincent, who painted Reid at least three times. Back in Glasgow Reid became an influential dealer, assisting many important collectors, like William McInnes and William Burrell, to acquire important French and Scottish paintings. Reid was also a friend of Whistler who became godson to his son, A.J. McNeill Reid. The latter joined his father's firm in 1913 and eventually closed the gallery in Glasgow in 1931 after having combined with the Lefevre Gallery in London to form Reid & Lefevre.[20]

By this time Fergusson was living in Paris and Peploe, having become increasingly frustrated in Edinburgh, was tempted to join him, as is apparent in fragments of letters to Margaret in Edinburgh from Perthshire in November 1908:

Yes as you say the thing is to keep going forward – to live in the present. It's what you and I both want, to go more among people. I expected too much from you – to be always cheerful and bright: the wonder is, I see it now, that you have any brightness left at all.

Yes it is monotony that kills more that anything. It is terrible to be an artist in Edinburgh. I don't think it can be quite so bad for anyone else. You see, Paris is different; the two places cannot be compared and yet if you ask where the difference lies it is difficult to point out. It really lies in one or two small but important matters, at least for me. Art – painting – is considered something. There you have the camaraderie, good talk, enthusiasm, you are among people who are in sympathy with you – there is plenty of amusement just merely to sit in a café and watch the people . . .

It's funny how different one is with different people – of course it's a matter of sympathy, one gets what they give. With Fergusson I am bright and witty – I keep him in a continual state of laughter. Of course the reason is that I know he likes it – he is cheerful himself – he suggests and I, taking it up, carry it on, carry it further; and so the game goes on between us. Whenever we meet, I tell you, we have a really lively time. I know what he gets from me – I stimulate him, I excite him. And I get from him a strength and a cheerfulness which when alone I do not possess.

I met him going to have breakfast yesterday at three o'clock. He is staying in a hotel just now, his 'people' being away – we went to F&F's;[21] he had soup and sole and cheese while I, who had lunched, had coffee and liqueur. He had written a 'prologue' to his catalogue: I criticised it; it was a rich time.

I do wish you could be my friend (and it seems it might be possible now seeing you are a painter).[22] Oh, just friendship, what in the world is finer!

Yours, S.J.P.

LIFE FOR PEPLOE was soon to change rapidly, and for ever. He recognised the qualities and skill in his earlier works but his route forward as an artist was in a different direction: the way of colour and a direct engagement with his subject. The urge for change came from within; he had gone as far as he could in his early style and, perhaps concerned that commercial success would snuff out his creative impulse, he determined to seek a complete change and new stimulation in France. Fergusson had been urging the move for some time but the immediate spur was undoubtedly the pregnancy of Margaret. She and Sam had been together for fifteen years now, but lived apart. Four months pregnant with their first son, Willy, she journeyed to Lochboisdale, no doubt to tell her family what was happening. Writing to her there on 23 March, Sam suggests a trip to Broadway:[23] 'I see the train leaves at 10.15. That is the only morning train and the next is two o'clock which is too late. Shall we need to get married at eight o'clock in the morning – why not? Before breakfast.'

Willy was born in Royan, in the Charante Inférieur, on 29 August 1910, the day Peploe finished *Boats at Royan* (Plate 46). Royan was then a splendid Atlantic resort with a sweeping promenade, magnificent casino and bustling, colourful harbour.[24] The paintings made here and elsewhere in 1910 mark a dramatic *volte face* from anything Peploe had done previously, in terms of the intensity of colour. Paint is often unmixed and used straight from the tube, and the most brilliant colour in the colourman's spectrum is favoured. In *Sunlit Street, Royan* (Plate 48) the strong architecture is enlivened with emerald green, orange terracotta and chrome yellow notes. As well as Royan, Peploe visited Normandy in 1910, painting in Veules les Roses, where, in the summer, the narrow street is bordered with cascades of roses from the gardens of the holiday villas. In several panels of which *Street Scene, France* (Plate 51) is typical he relishes the variation of colour in the tree trunks, moving from lilac to cadmium orange and burnt sienna. The hot terracotta roof in *The House in the Woods* (Plate 52) is picked up in colour notes in the foreground greenery in another frankly fauvist composition.

These brilliant works are also the culmination of Peploe's work as an impressionist. It is an impressionism that has come far from the influence of William McTaggart or Alfred Sisley evident in the early years of the century. But Peploe has not moved in the same direction as the dominant avant-garde which followed the Impressionists: there is no pseudo-scientific investigation as in pointillism, or use of flat areas of paint as with the Nabis, nor yet any interest in the underlying structure of the subject. Instead, and perhaps uniquely in British painting, Peploe seeks to find in his painted surface a direct equivalent to his subject, harnessing the power of light to make colour vibrate; to make permanent the compelling beauty he saw in a model, harbour or promenade. In seeking this equivalent to the experience of the subject he gave up faith in the absolute reality of observation and began to use significant chromatic transpositions. He might use green in

the flesh tones of a portrait head of Margaret, or green and yellow outlines vibrating around statues depicting an avenue in Versailles.

By now he was based in Paris in a small studio apartment at 278 boulevard Raspail in Montparnasse. Fergusson had lived just around the corner, across the Montparnasse Cemetery on boulevard Edgar Quinet, but had moved by the beginning of 1908 to the rue Notre-Dame-des-Champs. Within a short walk were the famous café-restaurants: Closerie des Lilas on the boulevard Montparnasse and the Café d'Harcourt slightly further north on boulevard St-Michel. Here the Peploe family led a simple life; there are many touching drawings of mother and child, and Willy in his tin bath.[25]

It was a highly sociable time and the atmosphere generated in a community of artists was alive with possibilities and enormously stimulating. Fergusson recalled the good times:

By this time I was settled in the movement. I had become a *sociétaire* of the Salon d'automne and felt at home. Peploe and I went everywhere together. I took him to see Picasso and he was very much impressed. We went to the Salon d'automne dinner where we met Bourdelle, Friez, Pascin and others. He started to send to the Salon d'automne. I was very happy for I felt that he was at last in a suitable milieu, something more sympathetic than the RSA. He was working hard and changed from blacks and greys to colour and design. We were together again, seeing things together instead of writing about them.

Things I really like – perhaps I should say love – often make me want to

37

laugh. One day Peploe and I went to see the Pelliot Collection. As we wandered through it we were suddenly halted, fixed by an intensity like a ray, in front of a marble head of a Buddha, white marble, perhaps with a crown of beads painted cerulean blue. I can't remember anything in art with a greater intensity of spiritual feeling. We both stood for what seemed a long time, just looking. Then I laughed. I apologised to S.J. for breaking the spell. With his usual understanding, he said, 'At a certain point you've either to laugh or cry.'

This was the life I had always wanted and often talked about. We were a very happy group: Anne Rice; Jo Davidson; Harry and Yvonne de Kerstratt; Roffy, the poet; La Torrie, mathematician and aviator. Other good friends in the quarter were E.A. Taylor and Jessie King, who made a link with the Glasgow School. We used to meet round the corner table at Boudet's restaurant. We were mothered by the waitress, Augustine, a wonderful young woman from the Côte d'Or, very good-looking and calm, lively dark eyes and crisp, curly black hair, very strong and well made, a character as generous as the finest Burgundy – a perfect type of that great woman, the French *paysanne*. When you came in far too late, tired and empty, Augustine would go across to the butcher and demand through the bars a *bon chateaubriand à quatre-vingt dix*, cook it perfectly herself and present it to you as if you had a perfect right to be an artist. This with such a grace that you did not feel the least indebted. Looking back we realise it is not possible for us to express our indebtedness; what we can do is to say that every picture we painted at that period is partly Augustine. Her health in the best Burgundy! God bless her! Then there was Mme Boudet at the pay desk, sonsie and easy to look at – and very understanding. When we couldn't pay we did our signed and dated portraits on the back of the bill. After dinner we went to Lavenue for coffee and music. La Rotunde was then only a *zinc* with seats for only three.

It was in these pre-war days that Middleton Murray and Michael Sadler came over and asked me to be art editor of *Rhythm*.[26] Later Murray came with Catherine Mansfield. We were all very excited with the Russian Ballet when it came to Paris. Bakst was a *sociétaire* of the Salon d'automne and used all the ideas of modern painting for his decor. Diaghilev made a triumph, surely even greater than he had hoped for. No wonder S.J. said these were some of the greatest nights of his life. They were the greatest nights in anyone's life – Sheherazade, Petruchka, Sacré du Printemps, Nijinski, Karsavina, Fokine. But we didn't spend all our evenings at the Russian Ballet; there was the Cirque Medrano, the Concert-Mayol and the Gaieté-Montparnasse.[27]

In April 1911 Peploe came back to Edinburgh alone to sort out his affairs and try to raise some money. He wrote a series of letters to Margaret:

My own darling,

I got your letter this morning. You will not get the one I wrote till Tuesday morning. Today is spring holiday – shops all shut: I haven't left the house all day. I unpacked all my old canvases – looking at everything that was there. I think far more of them than I used to: I think most of them are good but they don't interest me in the least – I have no wish to do any more like them. I think they are quite amazing in their way – seeing them has given me more confidence in myself. I am going to try to sell them. I will see Dott about them and also go to Glasgow to see Reid and another dealer – they must be worth something. I even thought of sending them to the sale room – you see, I want to get rid of them; they have no interest for me. I put some of my Royan things alongside them and they became simply grey. I am quite pleased with last year's sketches – a great advance in colour and design; but even they seem tame. They don't seem to shock Willie[28] at all now. I think they are all coming around. I have been talking incessantly on every subject. I feel so different from how I used to; far more decided in my opinions, with far more belief in myself. I think they are beginning to feel the difference in me. I know I am much stronger in every way. That's you. How indifferent I am to food and armchairs and material things: oh, I couldn't go back to this house – this life: it all seems so dull. I had a real desire to get back to Paris today; dear Paris, you and Willy. You must be awfully lonely, dearest, will you not get May and Myrtle to come and stay? It would make me so much easier if I thought you had them.

I had my first real talk with Fred Porter[29] at his house at tea-time. As soon as I got in he began, it was like a boxing match; my blows fell like lightning and in ten minutes I had him silent – absolutely dumb. It was awfully funny. He had no real grip of things; ideas, beautiful till I came to show him they weren't true so that he didn't believe in them himself. Oh how different I am from how I used to be. Here everybody seems rather woolly, strained, vague and nice. Paris has charged my brain and made me more definite. And just what they at present like in my work, perhaps they don't like in me. There is a lack of light everywhere, out of doors and in the rooms. They seem afraid of it; they seem to object to it.

I will tackle Dott tomorrow and give him a strong dose. He will be easy. I see plenty of work ahead of me getting these old pictures ready. (Weather here wet and not at all warm.) How easy it seems here; such simple people to deal with, so quiet. Vass, I think, wants to buy a picture or two. I will not miss the opportunity you may be sure. I am going to try my best to make some money for my darling and the boy. Willie seems to cling to me – he has hardly left me all day. I think I am cheering him up a little, perhaps. We had a very serious talk late last night. I begin to doubt whether I can help him at all. I am afraid there is no hope of his

ever becoming normal. I thought that I had him once or twice but he subtly slipped out of my grasp. I will try again in a day or two. He is so difficult – so subtle, subtly wrong. I began to see he could never marry Florence Drummond. She is not the woman, if any woman is possible. It is a difficult problem; a strong blow would kill him, so one has to be careful. You see I am busy – plenty to talk about. I will take up the money question soon. It is nice to know that I have not to stay for long but that I will get back to you, to Paris and life, real life.

Coming here has done me a lot of good (as you said it would – you devil, you knew: you weren't afraid), it has given me more belief in myself. You old rascal, how are you keeping? Is your eye any better? Are you feeling well? It seems years since I saw you. How can I wait till . . . When? Just think of the joy of my coming home; darling, it will be worth the waiting and the loneliness. The train that will carry me to you will be too slow. I shall want to rush like lightning. Shall I come to you tonight and take you in my arms. Oh, my love, my strength. I see you just now, poor darling, alone with Willy. I love the studio now it has got a meaning: and the table where we dine and the stools and yellow buffet have become full of memories. Oh, life is glorious, let us go on without fear of the future, for I know I could do anything for you, my darling.

My darling,

Just got your letter tonight about Willy's tooth! Splendid! But, my love, you are so lonely. I feel inclined to rush off to see you. Everyone here is awfully kind and nice. I've had a busy afternoon. Went down to see Dott. He was away from home but I saw Proudfoot. I talked for two hours and I think I began to make an impression. I felt he can be influenced and I made a beginning. I was very charming and nice and clear and convincing. I had a headache after it all but I felt some of it counted for something. How different I feel now in Edinburgh. I feel quite a big, important person. It has done me a lot of good coming here. I really begin to think I am a genius. I met Peggy Macrae[30] in Princes Street looking very well but awfully bored – same as ever. Oh the women here, how stupid they look and how badly dressed! You will believe that when you come home, believe me. You too will feel quite important. How good that we went to Paris. Oh this Edinburgh is awfully nice, but awfully stupid.

I saw at Dott's some of my old sketches and some of the things he bought just before we married and they are damned good. I saw them with a fresh eye. (They are damned good; how different from the Wingates and Charlie Mackies) – I feel a real, great artist. I am a damned good artist; no one like me at any rate in Scotland. But all the same I like my Royan sketches a thousand times better. I think they are a tremendous advance. I have no further interest in my old things –

beautiful, but limited. I must make others feel the same. I went to see Harley[31] afterwards – same as ever. I forgot to say I am going to send down all my old stuff to Proudfoot. I told him I thought them very good and he is going to see what he can do. It seems impossible to sell anything in Edinburgh just now but we shall see what he says. Harley came over to see my things tonight and collared three small ones for which he paid £12 – every little helps. He also took away four others which he thinks he can sell to a man he knows. He is going to show a lot of my old, small pochades in his office and send out invitations; he says he can sell some. I dine with them on Thursday. Jamie Ballantine also came out to see me tonight – he has just left. How flourishing and well fed all these people look; but I feel myself ten times more clever.

Everyone asks for you and the boy – there will be no further difficulties about that. If you were to walk down Princes Street now in your spotted dress, with Willy, you would be stared at. Everyone is so stupid-looking and dowdy.

Harley said in his office today: 'I believe you are a genius.' I said there was not the least doubt about it! I am beginning to learn that I can impress people and I have never known it before. Oh, I am a different person, so much stronger in every way. Even if everything fails now I have got a big, new belief in myself; this will last for long; even if we have to live on our bare income. I don't mind; I feel I could do it. Willie is beginning to see the advance in my new work. I put several up on the mantelpiece and he is looking at them and comparing. I am now certain that I am right, and this is the thing that counts. Harley got his things damned cheap – brought down the price I asked him, but as he is going to help me I gave in.

Fred says the thing on your eye is a cyst and will need to be cut. You are probably a little run down and he advises an iron tonic and soon to stop the breast. I am longing to get back to my dearie – our bare studio; all so different. I love it a thousand times better than this, because there is love and freedom. This I couldn't put up with; it oppresses me. Weather here cold and wet and oh, the colour of the streets and dresses of people! Willie sends his love to you and Willy – also Nanny. They are very kind and good. My own darling, wait a little, I will come if you want me. I will do my best for you, my darling, my love.

Your letter came tonight. How very kind of Jessie King.[32] Hadn't you better have her or Mary to sleep with you, dear: you would be so much happier. That's the one thing that worries me; the thought of how lonely you must be. I wish I could come away to you at once. I am quite tired of Edinburgh already – it is so dull. No colour, and the weather so cold and windy. The miserable colour of streets and the people's dresses makes me quite ill. You've no idea how awful it is.

I had a busy morning washing my old canvases. Dott calls for them tomorrow. I was also looking out drawings for Glasgow. I've collected quite a lot with colour. I will see about frames tomorrow. I've also been at Reates. I've only one suit of clothes. You are jolly lucky being in Paris – you've no idea how stupid and beastly it is here. Everyone is most kind, but I miss just the thing I get in Paris – the stir of life and the gay brightness, and oh! I'm simply longing for you. I'm restless tonight wanting you. I've a good mind to come tomorrow. When I think of Paris I feel a thrill going through me while here I am losing my gaiety already and getting dull and stupid. I was tremendously alive when I came. I met Annie Blyth[33] in Princes Street this afternoon and we talked for half an hour – I felt so much sympathy with her, a thousand times more so than with these long-faced lawyers and red-cheeked girls. There's nothing here but healthy-looking people with golf clubs. Annie and I were talking like old friends; you should have seen the people stare – they evidently couldn't understand it. And it is astonishing how people stare when I walk down Princes Street, as if I were something strange.

I am awfully satisfied with these Royan sketches. My old stuff was getting loose and chaotic. I really think I am getting something better. There's no doubt about it. Willie seems so much more cheerful since I came back. I think they all quite realise that I am better and stronger than I was in every way. Now, instead of letting other people impress me, I impress myself on them – that is the big difference; it is a beginning. I will try my hardest when Dott comes back on Saturday. I just wonder whether it wouldn't be better to try London. After all, no one is seeing my stuff; the thing is to scatter it about as much as possible.

I thought Fergusson wouldn't stand dining alone for long. Do you dine every night at Boudet's? Do you meet anyone you know? My darling, how lonely you must be. But I shall make it up to you when I come back. I dine with the Harleys tomorrow and probably shall go and see George Porter in the afternoon and take my drawings to Dott to be framed – I wish I could do everything in a day and rush off to you, my darling. I love Paris and the bare studio because you are there. Love is greater than anything in the world. I am already looking forward to getting back – I shall not stay here an hour longer than I can help. Oh, my darling, I am longing for you.

My own darling wife, how glad I was to hear from you tonight. I am just longing for you. And Bill! The wee darling. Oh, here life is so dull, in this house; it seems to be a house of old people; no youth of life. How I appreciate Bill now: I wouldn't part with him for a million pounds. Darling, I am just dying to see you both. How can I wait a whole long, dreary week. You have Bill, what have I got?

I went down to see Dott this morning to see about those pictures. He was out

so I saw Proudfoot. The offer was £50 for twenty-two canvases! He apologised for the smallness of the price but said it was more than I would get in the saleroom. Pictures are not selling at the moment. It was all he could do. I accepted it. We talked, or rather I talked, for over two hours. I don't know whether it did any good. They are all so narrow and stupid here it is hard work, useless work, trying to convince them. No one here seems to care in the least about the things which are so great to me. I shall be heartily glad to get back to Paris – at least there one doesn't have to constantly explain oneself. If I clear £100 by my trip I shall be jolly pleased.

Harley has fifty sketches and two heads hanging up. He claims one in every ten sold as his right. Mean brute. Then I am sending about thirty drawings to Glasgow; they look damned good but perhaps Glasgow won't agree. I feel inclined to give up trying Edinburgh ever again and to seek a wider market. They want me to keep on doing the things I did ten years ago – and I can't.

Proudfoot is very anxious to see the still-lives I did this winter. He wants me to send them over. I am determined he shall not get them for nothing. I wish I could make my own terms with these brutes. They know I want money so take advantage of it. But I'm not afraid of the future, darling. I know my last work is my best and the best is yet to come. If I can just get enough to live on for the next two or three years I am sure things will get better. I might have been wiser to have hung on and not sold these things but I am sick of them.

This house is a house of death – our house is a house of life – what a difference. What are carpets and curtains? I despise them, I hate them. I felt that

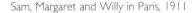

Sam, Margaret and Willy in Paris, 1911

too at the Harleys; the material, worldly ideal dwarfing the mind and soul. Oh, darling, we are free of that, thank God we may never be oppressed by possessions and luxury. (There is not much fear of it.)

I am glad you are seeing the Taylors and McNeals so much, but all the same, darling, you must be awfully lonely at times. If it weren't for my clothes I would come home at once. I went to the Bodega for lunch today – dirty, smelly hole, simply loathsome. Louisa the only bright spot in it. Old Parker is away at Gullane and I am not sorry; I feel I couldn't stand him now for more than ten minutes. I feel I am missing so much being away from Paris – the beautiful weather – here it is cold and rainy every day, like winter. I'm not exactly sure what date I shall get back. I may manage to leave here Friday night and cross Saturday arriving Saturday evening – oh, joy!

I'll certainly chaperone Jessie King's friend with pleasure, but I may not know the day till well on next week. I think I'll manage next Friday. Oh, darling, the journey will be an excitement – to think of seeing you again, and Bill. Oh, it thrills me to think of it. Oh, to feel you in my arms again, my love, to crush you tight, to feel your body against my body – to feel your lips against mine – oh, love, oh life . . . Six days and we shall be together; one. My love, it is good to be separate, to know the joy of being one. What does anything else matter when we love each other, my darling.

I got your letter this evening – yes, darling, by next Sunday I'll be back for certain. I have nothing to keep me here now but to see Ressich[34] and Reid and get my clothes. I was the centre of attraction at the tea-party yesterday – a little of that sort of thing goes a long way. Everyone was asking for you and Willy. Mabel Royds[35] was there – a great admirer of my work. I went out with the Harleys for supper and stayed the night, getting back to Braid Road at eleven o'clock. After lunch I went to see G. Porter – got full account of many affairs. They seem full of hopes. Then to see J. Ballantine at his office, then to tea at his house (I seem to be living in Murrayfield at the moment). Mrs Ernest was there and Gladys was very amusing, quizzing Mrs E. about me. They asked me to dine and so did Mrs E. but I refused and got home to dinner.

I got a letter from Nurse Flanagan – damned bore but I shall have to answer her. And yet I can't say for certain which day I shall be able to travel. I'd better say I am crossing on Saturday morning – will that suit you? I'm sick of the people here, Harleys etc; they don't seem serious like the people in Paris – you feel they are just playing, wishing to be amused. If I ever live here I would go out nowhere: there is no reality.

Harley has sold £13 of sketches to a man called Paton who also wishes me to paint his wife the same way I painted you on the sofa in white! As if it were

possible. How much happened before that could take place. I remember the day I did it – do you remember? It was the first time I kissed you after those bad months. And he thinks I could paint his wife in the same way. It is an exquisite thing in colour, perhaps the most powerful colour I ever painted, and it belongs to Harley for £4. I told him it was you. But he really appreciates it. I feel my new paintings will never attract the same people who liked the old; but I am certain I will find new people, new friends. It must be so and I shall be glad because the old are just a little tiresome; they cannot understand, and I feel there is no longer a sympathy between us. I have changed and they have remained the same. I shall be very glad to get back to Paris.

Tomorrow I have the dentist and I go to make my will at G. Porter's. Try on a suit – that's all I think.

This Wednesday or Thursday I go to Glasgow. (The National Exhibition opens Wednesday.) Friday I pack my bag and sail away: I'm afraid I won't make even £100 after all my trouble. I cannot rest, darling, till I am back to you. I am full of an untiring energy. I feel that all I've done will bear fruit some day – that the next show I have in Edinburgh will be accepted as my others were. I have paved the way. Yes, I think I have stimulated everyone I've met – I will keep it up till the end, but couldn't do it any longer. I must see you on Saturday night (dinner at eight). I can keep it up till then but no longer: oh, darling, I cannot.

How splendid about Willy's second tooth – how I am longing to see him also. It seems like years since I said goodbye that morning – it is all like a dream. Darling, wait till Saturday and I shall make up to you for all the longings and loneliness you have felt. What a lot we will have to talk about and to be in my own place again and steak and potatoes washed down with Pas Teurign will seem food for the Gods. You know what is best, darling, for both of us; whether we live in Edinburgh or stay in Paris, time will make clear. The next thing to do is to get to work again then a good summer in the open air. Every day will seem like years till I get home to my wee darling. My darling, I love you, I am longing for you, hungering for you. I am full of love for you.

Just got your note. I've just got back from Glasgow; it's 9.30; had a tremendous day. Ressich was awfully kind. I've had two huge steaks and a big sole and omelette *fines herbes* and cheese twice and champagne and port and liqueurs, so I feel I don't want to see food for a week. I met George Burrell;[36] we dined with him. He is very nice. How different these Glasgow people are from Edinburgh people. Plenty money. I also saw Reid. But I'll tell you all about it on Saturday. I'm awfully tired and sleepy; I've been talking all day and shall have a busy day tomorrow. I have to touch up my French sketches and order frames for them and

Moustique, 'La Peur', c.1911
Conté on paper
24.2 x 15.2 cm (9.5 x 6 in)
PRIVATE COLLECTION

Moustique

' La peur '

label them and see George Porter about business – a dreadful lot to do. Oh, but tomorrow night I come to you, my own darling! Do you not feel me coming nearer to you! I am coming nearer and soon you will be in my arms. It is for you I have been working; it is you I am longing for. I cannot wait another moment.

In the earliest studio work done in Paris such as *Jug and Yellow Fruit* (Plate 49), which belongs to the winter of 1910–11, the fluid freedom of brushwork typical of York Place is sustained but is in danger of incoherence. The palette remains predominantly white but the strong colours are no longer notes and less part of an elegant scheme.

In the summer of 1911 the family moved to Brittany, where Peploe painted at Ile de Bréhat, a small island two kilometres off Pointe de l'Acrouest, near Paimpol on the north Breton coast. Peploe was struggling to find a new pictorial language; shorter, frenetic marks leave the paint surface in furrows, a technique close to that of Van Gogh. His previous preference for an enamel-like medium was replaced by normal oil paint or paint from which much of the oil was extracted by spreading it on blotting paper. Ile de Bréhat is a rocky island, dotted with picturesque, four-square holiday homes, small fields and gardens; its simple geometry lent itself to planar analysis. The family stayed also at Santec, a village inland near Morleaix, but no work by Peploe is known to have been made there.

The artist's progress in the summer in Brittany in front of a new landscape was used to move the studio work forward in a similar direction. The same tremendous energy is

evident in the paint surface of more ambitious works such as *Tulips in Two Vases* (Plate 56). The palette is dominantly pastel in blue, green and pink and the drama delivered by the oranges and flower blooms. A new surface structure is realised by use of dark-coloured outlines, containing the furrowed areas of paint. Tulips were for the first time his favourite subject, the flower-heads tight or expanded, creating different shapes of brilliant colour against a schematic backdrop of blue, green and yellow. Peploe was in a period of intense experimentation; some of his experiments led to conclusions, but were not the way forward.

The *Still-life* (Plate 59) which he showed at the Society of Scottish Artists annual exhibition in 1912 in Edinburgh is a powerful, successful painting. Described as 'cubistic' by *The Scotsman*'s critic, it is rather cloissonist — more like a glorious piece of stained glass than analytic cubism. For colour Peploe is more inclined to use pure pigment rather than the paint being mixed with white as before. In a letter written in 1939 to T.J. Honeyman, by this time director of Glasgow Museums, E.A. Taylor identified the French painter and poet Auguste Chabaud (1882–1955) as an influence on Peploe: 'While in Paris Peploe was tremendously taken up with an artist's work, an artist named Chaubad [*sic*], very strong stuff, thick black lines and flat colours . . .'[37] Fergusson, writing about the 1909 Salon d'automne for *Art Review*, had praised the same artist. Elizabeth Cumming wrote:

> Much of Chabaud's work of 1906–12 depends on bold outlines to define the composition. His scenes of Parisian life . . . display this combination of thick paint and strong tonal contrasts, partially derived from the Fauves with whom he was to exhibit at the Galerie Sargot in 1910 and in the Armory Show in New York in 1913. Chabaud's rationalised interpretation of everyday life combined with a bold and decorative use of paint, a clarity of vision which he called *poésie pure, peintre pure*, had strong appeal for Fergusson, whose paintings of the period to 1910 were largely direct interpretation of his surroundings.[38]

It is unrewarding to try to pin down the influences which were significant in certain paintings and on the general development of S.J. Peploe. He was certainly aware of much that was going on, living as he was at the centre of an art world in flux, full of the possibilities for radical change. We know he admired Picasso and owned a copy of Guillaume Apollinaire's *Les Peintres cubistes*, published in Paris in 1913, and Edward McKnight Kauffer's *Dodice Opere di Picasso*, published in Florence in 1914 and presented to him by the author. We can conclude that it was not fear or scepticism that prevented him from pursuing the extremes of the avant-garde but that he had a clear vision for his own art. He could suffer great doubts about what he was doing and enforce upon himself radical change, but it always came from within.

THE PRECISE DATE of the family's return to Edinburgh is not known, but by June 1912 Peploe was installed in a new studio at 34 Queen Street. At the same time he rented a first-floor flat at 13 India Street in the heart of the New Town; this was to be the family home for the rest of his life.[39] For the SSA exhibition in September 1912 his address was given as Queen Street, a studio he was to keep until 1917. He had given the boulevard Raspail address when he showed one picture at the RGI[40] in the summer.

Peploe was returning from Paris in the expectation of a one-man-show at The Scottish Gallery. However, a studio visit and considerable heart-searching confirmed to Peter Dott that Peploe was a lost cause: the new work was simply too radically different for the dealer to accept. One should bear in mind that Dott had had considerable success with the earlier work, and had bought much that the gallery would still have had in stock. He was also on the verge of retiring and perhaps had neither the vision nor the energy to embrace such a radical departure in the work of an artist for whom he had the greatest personal respect. Margaret recalled, in notes she prepared for Stanley Cursiter: 'Mr Dott was still somewhat concerned about Sam's "changes". He was afraid about the influence life in Paris, "French Art", might have on him and on his art. He wrote me a very kind letter, full of advice: my husband was an Artist, one of the few: "There was a responsibility, a duty," he made me feel both very keenly. Poor Mr Dott. I'm afraid there was another shock coming to him.'

There were to be exhibitions in 1912, but not in Edinburgh: The Scottish Gallery had consigned thirty-five works from their stock to John Nevill of the Stafford Gallery at 1 Duke Street in St James's, London. Nevill put on two shows: small paintings in February and drawings in June; by the end of the year eighteen works had been sold and the balance returned to Edinburgh. The exhibitions drew excellent critical notices, all of which Peploe would have seen since he used a cuttings agency. The *Morning Post* critic, writing on 19 February 1912, said:

> Mr Peploe has mastered the scales of his art. There is no 'fake' in his 'impressionism'. He understands the quality of his medium, of paint for paint's sake more than for what it can say. But he makes us long for something more than epigrams, for something sustained, permanent and perfected. His jolly little sketches are perfect decoration for a bungalow by the seaside. An artist of his undeniable accomplishment might surely give us an example of what he might do for, say, a collector of modern paintings in which he would command an honourable place.

This must have been somewhat galling for the artist since he had had no say in the mounting of an exhibition made up of earlier works, all essentially leftovers. Shortly

thereafter, Peploe was in direct contact with the Stafford Gallery and some of the fifty drawings shown in June were the ones framed up 'for Glasgow' the previous April; others may well have been amongst the works consigned from The Scottish Gallery. Five surviving reviews are full of the highest praise. The *Sunday Times* wrote:

> The collection of Peploe's work now being shown at the Stafford Gallery, Duke Street, is sure to attract the attention of all those who appreciate what is best in modern draughtsmanship. There are over fifty works on display and not one of them but will repay a close study. For Mr Peploe has something to tell us: he has a temperament that can only express itself in one way: and he sees the human form with clear eyes, noting the beauty that lurks in every corner of nature, and is determined to set it down for us. The subject of each drawing does not seem deliberately chosen, as is so often the way in drawings that are exhibited. Every one strikes one as having been done just because it happened in life under the artist's observation. There is no deliberate posing of the model in evidence anywhere and the result is a record of indisputable facts.

In October Peploe was one of nine artists showing new work again in the Stafford Gallery. The exhibition included J.D. Fergusson and his girlfriend at the time, Anne Estelle Rice, as well as Jessica Dismorr.[41] The critic for the *Daily Chronicle*, writing on 16 October, chooses to review two current exhibitions: one at the Stafford and the other, obviously containing earlier work by Peploe, at the Grosvenor Gallery at 51 New Bond Street. He wrote:

> . . . he [Peploe] is a strong man and has entirely changed his aims and execution as only a strong man can. He has forsaken his Manet–Velasques phase: he has become an ardent practitioner of what may be called the Peploe–Fergusson branch of post-impressionism. [And further down his column, of the second exhibition:] Mr Peploe's group of landscapes and still-lives is the outstanding feature of the show. He paints with radiant decision. His centrepiece composed of pot, flowers and fruit sings from the wall. Why was this branch of British post-impressionism ignored by the directors of the Grafton Gallery[42] – this branch which is so fresh and alive?

Reviewers in the *Morning Post* and the *Standard* both identify Peploe as the 'leader' or 'master' of the group while the critic for the *Sunday Times*, very impressed by Anne Estelle Rice, writes also of Peploe:

> Mr Peploe paints because he is forced to by the strength of the feelings stirring within him. His *Landscape, Brittany* gives not merely the outward aspect of the

subject; it is more than a representation of paintable concrete objects. In it moves something of the abstract beauty that springs out of the deep heart of poets. Whether it is landscape or still-life, in all the artist's work this quality abides.

In June 1912 Margaret went to visit her relations in Lochboisdale and Peploe wrote to her from Queen Street:

> I am very lonely. I have no one to talk to. I can't bother other people with my enthusiasm. No one can call me a bore. As I wired you I have unpacked my French things and the studio is like a conservatory. They stand all round the room – the place is flooded with them. I was quite excited opening the bundles and coming on the canvases. I wished to have someone with me to see them. And this morning I was busy looking out more drawings – at present there are sixty lying on the floor and they look quite well – make quite a show. But I don't think I'll send them all to Nevill . . . as I told you he sold four at the private-view day. I wonder what price he got. When I look around my studio just now I feel rich – I can't help believing that some day these things will bring in money, only I must be more businesslike and not chuck them away. Ressich sent me £4 for a drawing; it was priced at £3 so at any rate he is honest.

There are no studio notes which record production and paintings are very seldom dated so we do not know if Peploe did much work in his new studio in the winter of 1912–13; but it must have been chiefly French work that he exhibited at the New Gallery in Shandwick Place from 2 to 24 May 1913. The New Gallery was the home of the Society of Eight,[43] which had been formed the previous year by eight artists including F.C.B. Cadell. Although the youngest, Cadell (whose friend and lawyer Ted Stewart was secretary) was very active and may well have helped persuade Peploe to put the show on. This was the exhibition which The Scottish Gallery would have had and Peploe felt an obligation to himself and the public to show the work. He sent out invitations, hung his paintings but could not bear to turn up to the private view; Margaret had to stand in.

It is not known exactly when Peploe gave up his Paris studio; he may have been back in the early summer of 1913, which would give credence to Fergusson's recollection of how the Peploes decided to go to Cassis on France's Mediterranean coast:

> One year we went to Royan, where Bill, Peploe's elder son, was born. Another year we went to Brittany. But I had grown tired of the north of France; I wanted more sun, more colour; I wanted to go south, to Cassis. I told S.J., but he didn't think it was a good idea – too hot for young Bill. I was sorry, but decided to go without him. One day in the boulevard Raspail, S.J. saw on the pavement near

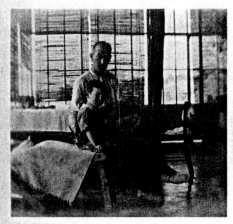

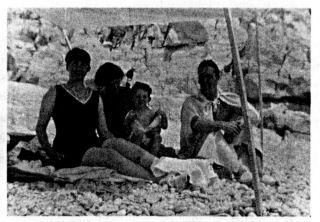

Sam and Willy in the Hotel Panorama, Cassis, 1913

Anne Estelle Rice, Margaret, Willy and J.D. Fergusson at Cassis, 1913

his door a paper with the word 'Cassis' on it. He decided to take the risk. We arrived to find it quite cool and Bill didn't suffer at all. We had his birthday party there and after a lot of consideration chose a bottle of Château-Lafite instead of champagne. Château-Lafite to me now means that happy lunch on the veranda overlooking Cassis Bay, sparkling in the sunshine.[44]

In the summer of 1913 the Peploe family met Fergusson and Anne Rice in Cassis, a village between Marseille and Toulon surrounded by a landscape covered in pine and *maquis* with dramatic mountains behind. .The coast to the east is one of deep fiords, called *callanques*. There is a good natural harbour which could take sizeable schooners, and picturesque three-storey buildings on the front. In 1913 it was a fishing village and quiet resort with only two hotels – not the playground of today where wealthy Marseillais might have a second home. Many different subjects appealed to Peploe: the harbour with its long walls, breakwater and the castle and mountains behind; the narrow streets behind the old front; and the wild, wooded landscape behind the town. This was his first visit to the Mediterranean and his first exposure to the brilliant light that had inspired Matisse and Derain eight years before, along the coast at Collioure, to paint in the way that earned them the title 'Fauves'. Virginia Woolf, staying in Cassis with her sister twelve years later, wrote of how the structure and solidity of the limestone massif 'lent a sharp profile to the visible' and served as inspiration and analogy for the 'hard muscular' structure of *The Waves*.[45]

Once again Peploe walks a tightrope. He tries to evoke the character of a new, exciting locality but uses non-naturalistic colour and simplifications of form which align him closely with fauvism. In *Square, Cassis* (Plate 63) under a hot, yellow, evening sky, women sit in the small town square in rose and lilac dresses, by a palm, dense and rich in red and

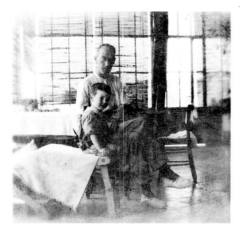

Sam and Willy in the Hotel Panorama, Cassis, 1913

Anne Estelle Rice, Margaret, Willy and J.D. Fergusson at Cassis, 1913

his door a paper with the word 'Cassis' on it. He decided to take the risk. We arrived to find it quite cool and Bill didn't suffer at all. We had his birthday party there and after a lot of consideration chose a bottle of Château-Lafite instead of champagne. Château-Lafite to me now means that happy lunch on the veranda overlooking Cassis Bay, sparkling in the sunshine.[44]

In the summer of 1913 the Peploe family met Fergusson and Anne Rice in Cassis, a village between Marseille and Toulon surrounded by a landscape covered in pine and *maquis* with dramatic mountains behind. The coast to the east is one of deep fiords, called *callanques*. There is a good natural harbour which could take sizeable schooners, and picturesque three-storey buildings on the front. In 1913 it was a fishing village and quiet resort with only two hotels – not the playground of today where wealthy Marseillais might have a second home. Many different subjects appealed to Peploe: the harbour with its long walls, breakwater and the castle and mountains behind; the narrow streets behind the old front; and the wild, wooded landscape behind the town. This was his first visit to the Mediterranean and his first exposure to the brilliant light that had inspired Matisse and Derain eight years before, along the coast at Collioure, to paint in the way that earned them the title 'Fauves'. Virginia Woolf, staying in Cassis with her sister twelve years later, wrote of how the structure and solidity of the limestone massif lent a sharp profile to the visible' and served as inspiration and analogy for the 'hard muscular' structure of *The Waves*.[45]

Once again Peploe walks a tightrope. He tries to evoke the character of a new, exciting locality but uses non-naturalistic colour and simplifications of form which align him closely with fauvism. In *Square, Cassis* (Plate 63) under a hot, yellow, evening sky, women sit in the small town square in rose and lilac dresses, by a palm, dense and rich in red and

umber against the sky. In another panel, *Schooner, Cassis Harbour* (Plate 64) Peploe has divided the composition theatrically with unusual colour masses. An afternoon sky, the heat just beginning to ebb, is mauve and blue over a limpid green sea on which floats the black hulk of a schooner with orange masts and furled sails in cream. The stone of the breakwater and harbour wall are white, but yellowed in the glare of the sun, while the dramatic diagonal of the wall in shadow is a deep ultramarine blue. Just as in the studio paintings, he is constructing a new language with which he can move his viewer by revealing the potential drama in the very ordinariness of his subjects.

The return to Edinburgh and the lack of any enthusiastic response to his French work may have felt like a defeat, but the success of the trip to Cassis must have confirmed to him that he was on the right path. The Baillie Gallery put on their own show in March 1914 which included thirty-nine paintings and nineteen drawings. More than half of the paintings were of Cassis; only one was a still-life, perhaps showing how little productive studio time the artist had enjoyed since his return from Paris. The show was reviewed in *The Studio*:

> Among English painters who have been affected by post-impressionism, Mr S.J. Peploe holds one of the first places. It would seem that the theory of post-impressionism is too strong for an English artist's head. Mr Peploe affords us the rare instance of an artist whose head is stronger than the theories he has embraced, he uses them rather than artificially succumbing to them. Consequently he gets the best out of them, gaining from them what licence for freedom of line and abandonment of colour he may require, but preserving always

evidence of contact with life as well as theory, retaining vitality and the power to convince where so many under the same influence have entirely lost these.[46]

We do not know how successful the exhibition was but the prestige and good coverage must have gone some way to help galleries and the public to accept the new work.

After his return from Cassis and before the end of 1913 Peploe made a trip to Arran about which we know nothing beyond the information gleaned from two known panels: it must have rained. In *Arran* (Plate 60) the mountainous subject is grim, rendered in green, burnt sienna, black and grey, while the vigorous brushstrokes suggest waves of wet weather being blown across the picture-plane.

Peploe had an open invitation from Jessie King and E.A. Taylor to visit them in Kirkcudbright after they settled there in 1915, and the south-west of Scotland was to be a very productive painting ground over the next few years. In the autumn of 1914 he may well have been on his way to Kirkcudbright when he stopped at Crawford, now bypassed by the A74 before Beattock Summit. It is a rather bleak, godforsaken place: a few houses, an inn and an obelisk memorial, surrounded by moorland. He stayed perhaps a few days and, painting landscape for the first time since Arran, produced work of uncompromising modernism, still in his Van Gogh technique. The stolid geometry of Kirkcudbright, its tollbooth, castle and harbour, provided inspiration and the type of subject-matter which lent itself well to the geometrical analysis which was still the artist's dominant concern. These works are also some of the last where colour is pushed beyond naturalism into the territory of fauvism.

Peploe was in Kirkcudbright again in 1917 and would have used it as a base to visit Douglas Hall and Dalbeattie where he painted *Laggan Farm Buildings* (Plate 73). The light he records is brilliant, the colour positive and unmuddied. For the first time he was preparing his panels with a gesso ground. Gesso absorbs the paint immediately – requiring confident, *alla prima* application. He was using a lot of turpentine and drawing with his trademark confidence onto the gesso with dark blues. The relatively thin paint on a white ground resulted in a characteristic dry, chalky finish, which can never be varnished, and gave these works a brilliant tonality and a fresh, direct quality.

His new studio in Queen Street was bright, like boulevard Raspail, and he painted the walls white and kept the room as light as possible. The squaring-off of forms characteristic of the work of 1912–13 was carried forward in Edinburgh over the next few years, but the artist was no longer so concerned with making a surface pattern out of his subject and analysing it in terms of circle, square and cone – which briefly allied him with cubism – but rather with depicting a real space wherein objects have plastic reality as in *Anemones* (Plate 66). Now he would very often employ a straight line to divide his composition into table-top and background drape. He was still interested in rich pattern-making but this was exercised in the choice of a piece of drapery or a Japanese print as objects within his still-

life composition. Peploe never allowed his experiments with colour and structure to consume his lifelong concern with his *matière*: the substance of the paint itself. By 1916 when he painted *The Blue-and-White Teapot* (Plate 70), however, he has reduced the evidence of the brushmarks, still apparent in *Flowers and Fruit (Japanese Background)* (Plate 69), perhaps of the previous year, in favour of a more graduated, smoother application of the paint. In addition, the rigour with which the building blocks of his composition are heavily outlined and his objects squared off is abandoned in favour of greater naturalism. This naturalism was allied with an ambition of composition manifest in two works which are perhaps two finest paintings done in the autumn of 1917 in Queen Street. In one painting, *Still Life* (Private Collection), seventeen apples and oranges are arranged on an incongruous red-and-white tablecloth against an abstract background. In *Dish with Apples* (Plate 72) the table-top is at an acute angle to the picture-plane so that its far corner gives a particular depth to the space. While there are brilliant colour notes in the oranges, Peploe paints the half-tones in the shadows and models his objects to effect a monumentality which will return in another ten years but which in the immediate gives way to pure colour.

The external influences which work upon any artist are sometimes clear and acknowledged but are more often subtle in their working; they are absorbed over a period and assimilated alongside more ordinary or technical influences on stylistic development. A similar set of concerns might lead one artist down a similar path to another. Paul Cézanne's investigation of the underlying structure of the visual world in terms of its geometry while at the same time trying to reveal its truth and charm chimed well with Peploe at this juncture. For the rest of his life, in both still-life and landscape, there is a real connection with Cézanne. Peploe wrote to another painter in 1929: 'There is so much in mere objects, flowers, leaves, jugs, what-not – colours, forms, relation – I can never see mystery coming to an end.' In similar vein, Cézanne, writing to his son a few weeks before he died, described a view by a river: 'The same subject seen from a different angle gives a motif of the highest interest, and so varied I think I could be occupied for months without changing my place.' Both men were inspired by an infinity of relationships in nature all worthy of close examination. The influence should not be overemphasised, however. Towards the end of his five years at Queen Street, Peploe did paint some still-life which seems clearly to acknowledge the master of Aix. But Peploe had a restlessness in his quest for meaning in his art and from about 1918 he moved quite consciously away from the solidly modelled fruit and ornaments, which might have been drawn from Cézanne's simple, rustic world, towards painting in which pure colour, stretched in high tension, becomes his subject.

Peploe was shocked to be turned down for War Service when he volunteered in 1914 and he suffered some anxiety over his general health from then onwards. Sam and Margaret's second son, Denis, was born on 25 March 1914, and there must have been a genuine concern about how the family would manage. There was to be a limited art

life composition. Peploe never allowed his experiments with colour and structure to consume his lifelong concern with his *matière*: the substance of the paint itself. By 1916 when he painted *The Blue-and-White Teapot* (Plate 70), however, he has reduced the evidence of the brushmarks, still apparent in *Flowers and Fruit (Japanese Background)* (Plate 69), perhaps of the previous year, in favour of a more graduated, smoother application of the paint. In addition, the rigour with which the building blocks of his composition are heavily outlined and his objects squared off is abandoned in favour of greater naturalism. This naturalism was allied with an ambition of composition manifest in two works which are perhaps the final paintings done in the autumn of 1917 in Queen Street. In one painting, *Still-life with Fruit* (Private Collection), seventeen apples and oranges are arranged on an elaborately folded white tablecloth against an abstract background. In *Dish with Apples* (Plate 74), the table-top is at an acute angle to the picture-plane so that its far corner gives a triangular depth to the space. While there are brilliant colour notes in the oranges, Peploe paints the half-tones in the shadows and models his objects to effect a monumentality which will return in another ten years but which in the immediate gives way to pure colour.

The external influences which work upon any artist are sometimes clear and acknowledged but are more often subtle in their working; they are absorbed over a period and assimilated alongside more ordinary or technical influences on stylistic development. A similar set of concerns might lead one artist down a similar path to another. Paul Cézanne's investigation of the underlying structure of the visual world in terms of its geometry while at the same time trying to reveal its truth and charm chimed well with Peploe at this juncture. For the rest of his life, in both still-life and landscape, there is a real connection with Cézanne. Peploe wrote to another painter in 1929: 'There is so much in mere objects, flowers, leaves, jugs, what-not – colours, forms, relation – I can never see mystery coming to an end.' In similar vein, Cézanne, writing to his son a few weeks before he died, described a view by a river: 'The same subject seen from a different angle gives a motif of the highest interest, and so varied I think I could be occupied for months without changing my place.' Both men were inspired by an infinity of relationships in nature all worthy of close examination. The influence should not be overemphasised, however. Towards the end of his five years at Queen Street, Peploe did paint some still-life which seems clearly to acknowledge the master of Aix. But Peploe had a restlessness in his quest for meaning in his art and from about 1918 he moved quite consciously away from the solidly modelled fruit and ornaments, which might have been drawn from Cézanne's simple, rustic world, towards painting in which pure colour, stretched in high tension, becomes his subject.

Peploe was shocked to be turned down for War Service when he volunteered in 1914 and he suffered some anxiety over his general health from then onwards. Sam and Margaret's second son, Denis, was born on 25 March 1914, and there must have been a genuine concern about how the family would manage. There was to be a limited art

market during the war years. The Scottish Gallery, for its part, had an active commercial relationship with several London firms and they continued to consign earlier work by Peploe to the Stafford and Baillie Galleries. On 24 November 1913 The Scottish Gallery received nine oils and thirteen drawings from Peploe of which all the oils and eight of the drawings were consigned to the Baillie Gallery in November 1913. They were not yet convinced of the merit of the new work, most likely acting as handling agents as there are no consignment terms recorded, and the exhibition at the Baillie Gallery in March 1914 was certainly arranged directly with the artist. The balance of the drawings was returned to the artist.

Significantly, there is an entry in The Scottish Gallery's day-book for 13 July 1915: 'Received from Mr Peploe 6 framed pictures on sale, £20 less 25%. 4 Cassis, 2 Crawford.' Of these, one, *Cottages, Crawford*, was sold, representing the first sale through the gallery of a new painting since the artist's return from France. On 3 November there arrived: 'Four landscapes in white frames, 3 Flower Studies.' Of these it is noted that one went to Alexander Reid, and all the rest were returned to Peploe in August the following year.

In November Reid put on his first Peploe one-man show in his Glasgow gallery, La Société des Beaux Arts. There were only two sales but both were to very significant purchasers. Reid wrote to John Blyth of Kirkcaldy urging him to 'consider the Peploes more seriously'.[47] He bought a work entitled *Town in Brittany* for £12, the first of the eighty-five paintings by Peploe he eventually acquired. William McInnes bought a work called *Roses, Black Background*.[48] It was at this time that Reid offered Peploe £200 a year of guaranteed picture purchases; Peploe was grateful but rejected the offer, not wishing to feel beholden to Reid.

Also in November 1915 Colnaghi & Obach took sixty-two drawings in conté and sanguine on approval from The Scottish Gallery of which fifty-six came back and were passed back to the artist.[49] These works were unmounted and were most probably sent for the London dealer to make a selection for stock rather than for an exhibition. Eighteen more went down in February 1916.

The Scottish Gallery was taking new work but as yet with very limited commercial success. In 1916 Duncan MacDonald joined the firm and his enthusiasm for Peploe's new work is credited with re-igniting interest in the artist in George Proudfoot and The Scottish Gallery. However, the only transaction involving the artist's work between February 1916 and October 1919, admittedly a depressed period, was the disposal of five stock paintings through the auctioneers J. & R. Edmiston in March 1917.

Peploe felt somewhat isolated at this time: Fergusson was in London for most of the First World War and Cadell, with whom Peploe had formed a close relationship, was in France serving with the 9th Highland Division. Peploe wrote to him several times; in January 1917 he is able to report on the transformation of Cadell's studio as occupied by

James Paterson (1854–1932), bemoan the grim Edinburgh winter and supply some gossip about mutual acquaintances. In June 1918 he writes:

Dear Cadell,

I am still in the art business not yet having had my call to serve King & Country! But it won't be long now, I suspect. I wish it were over as the present situation is disturbingly not good for painting.

I've been trying to paint a landscape from a sketch and succeeding badly. It cultivates perseverance and other virtues but shows how much I am suffering from lack of new material. I'm finished for good with the colour block system that interested me for a long time and await new development. What it will be I do not quite know. Something I think more free and fluent. (Did you know W.Y. MacGregor[50] was married. To his nurse. Amazing!)

I can see that this habit of yours of living in dugouts must inevitably result in a new development in your painting. I see you will absolutely give up flake white. After all, why shouldn't one? Is it not quite unnecessary for a colourist? And at the present price it would also be an economy.

We miss very much the daily sight of James Paterson's glowing nasal organ, he having moved to Martin Hardie's house. Do you ever see 'Colour'[51] in the trenches? M. is sending you the June number. There are things of Fergusson's in it; I wonder what you will think of them.

By 2 August when Peploe writes again Cadell has been injured and his wristwatch smashed; he is in hospital:

I have been up for my medical exam for the army and have been graded 3. I felt very depressed for a week. I thought I was fitter than that. The doctor found that my heart was murmuring – I didn't know of it; so that makes me grade 3. I am really very glad because I don't think I would like the army. The only 2s are Ross, the portraitist, and Gavin.[52] I haven't heard of any 1s. So the 45s etc are a rotten lot of crocks.

I had a spell of painting lately, thinking to be called up, wishing to leave something to provide money for my poor orphans. Since then the excitement has died down.

I saw a good deal of Lintott[53] – he is quite amusing when you get to know him. Kauffer, a Californian, has been staying in Edinburgh, one of the London Group, cubist, interesting. He proposes having a show of the Group's work in the New Gallery. Leslie Hunter[54] was through here for a day lately talking of nothing but the Italian primitives whom he admires, though one wouldn't know it from

his work. I wish you were back in your studio. I feel isolated here, alone – one just keeps going like a machine. I *have* to paint otherwise I don't think I would at present. Did you ever use your sketchbook? Nash[55] has brought out a book of war drawings, very good I think. So has Lavery.[56] His is feeble.

The price of paint is getting prohibitive, also scarce. Canvas almost unobtainable. Pictures are also to be taxed: 2d in the shilling – so you see life is getting precarious and difficult.

When the war is over I shall go to the Hebrides, recover some virtues I have lost. There is something marvellous about those western seas. Oh, Iona. We must all go together next summer.

How is Rouen? I always think of it as a hot, stuffy sort of place. It always reminds me of Galashiels – I don't know why.

Let me know how you go on. Wishing you the best of health and a slow recovery. S.J.P.

It was a beautiful watch.

By December he had received a letter from the normally ebullient, optimistic Cadell describing his hatred of the war. Peploe responds by celebrating the power of hatred as a creative force. But he is depressed at the prospects for artists at the end of war, a time of national cynicism about authority:

I'm afraid art is not one of the 'pivotal' trades in a modern state but rather condemned as 'some foreign substance like dirt, on the rim of the wheel liable at any moment to be dropped off'.

F.C.B. Cadell, c.1918
Conté on paper
15.2 x 17.5 cm (6 x 6.8 in)
PRIVATE COLLECTION

So be it, it is an idiotic world. It is a long way off, the new millennium. Still we hope, strive, continue.

There is perfection.

Yours, S.J.P.

BEFORE THE ROYAL SCOTTISH ACADEMY'S annual exhibition in the spring of 1918, Peploe had again moved studio, this time to 54 Shandwick Place. The Great War was soon to be over and, after decorating the new studio meticulously, Peploe made a fresh start in his new surroundings. In the summer months he had found the light in Queen Street to be tinged with a problematic green, reflected from the trees in the gardens which border the north side of the street. Shandwick Place had been occupied by James Paterson[57] and was a large, bright space which Peploe again painted white.

In his studio Peploe surrounded himself with brightly coloured props: fruit, flowers, blue-and-white vases, patterned drapes and boards painted with strong, pure colours. He dedicated himself to intense, sometimes pseudo-scientific, investigation of still-life composition and with tireless, almost obsessive, energy tried to construct the significant out of the commonplace. Stanley Cursiter, a distinguished painter himself, analyses Peploe's experimental paintings of an arrangement of two flower-pots:

> The first point for consideration was the relative areas of red, black and white, and then the amount of light and shade necessary to give the pots their full value as shapes. The more closely the direction of light followed the line of vision the broader the lights and narrower the shadows would be, and consequently the greater the expanse of red. If the light fell at right angles to the line of vision there would be broad areas of shadow and less red; somewhere between these two extremes there was a direction of light which would give the greatest sense of volume with the least sacrifice of local colour. The position of the two pots produced a series of lines sloping from left to right; where the line of the table edge cuts the picture edges it divides these sides in agreeable proportions, as, also the edges of the flower-pots. The areas of black and of white on either side of the pots make balanced masses of varied shape, and if for instance the line bounding the area of black is followed round its silhouette, the length of each section of the line between changes of direction will be found to offer an interesting and varied series. The silhouette of the pots has variety in the relief each has against the areas of black and white and of one pot against the other. All these are variables, so that

in a composition, apparently so simple, there are many variations. A problem of this kind had a great attraction for Peploe: he recognised its strictly limited appeal and, as a general rule, these studies were never exhibited or even shown to anyone outside a small circle of intimate friends, but the time and care he devoted to them was characteristic of the wholehearted devotion he had to matters which he believed to be of real importance. It was by these stern exercises that he trained himself and acquired the rare command he ultimately obtained over his material and his method of expression. In one of his flower-pot pictures he evidently felt that he had achieved a satisfactory synthesis, and he was tempted to send it to the Academy. It was, however, beyond the immediate comprehension of his fellow academicians, and they hung it in the Sculpture Hall![58]

Peploe often reused canvases, turning and restretching them, and one of two flower-pot studies form the verso of later still-lives.

In 1918 he was elected an Associate of the Royal Scottish Academy. We know that he had been proposed at least once before and his failure to be elected was bittersweet. One artist, Robert Traill Rose (1863–1942), wrote giving his congratulations and Peploe responded in a letter surprisingly likening joining the RSA to the sense of impending loss of freedom he had experienced before marrying: 'I know now that if there are chains of bondage there are also chains of love. Real freedom is being bound. Giving oneself up to a purpose, an idea, something greater than self. The other freedom ends only in self-destruction.'[59]

Peploe loved the company of fellow artists with whom he had a genuine sympathy, but he was never a 'club' man and would have been distinctly shy of any administrative or committee work. He did have strong supporters in the Academy which was still dominated by the senior figures of the Glasgow School. Sir James Guthrie (1859–1930) was president between 1902 and 1919 and W.Y. MacGregor was a tremendous supporter,[60] as was Charles Hodge Mackie, his proposer. Two other Associates were elected at the same time, both older than Peploe. One, David Gauld (1865–1936), was a skilled painter of calves – limited and rather sentimental and in every sense a painter whose vision belonged in the nineteenth century. The other, Alexander Garden Sinclair (1859–1930), was a lyrical landscape painter who, with his wife Louie, was a great friend of the Peploes. The election of the three on the same day demonstrates the upheaval within the RSA. As the senior organisation for professional artists, coming to terms with the dramatic changes in the development of the visual arts in the early twentieth century, its members fought over selection of work for the annual exhibition and the election of new members, according to their acceptance or rejection of the New. By 1918 Peploe's seriousness and stature could no longer be overlooked by his peers, though his election would still have been controversial.[61]

In the RSA summer show in 1919 Peploe exhibited two works with the intriguing titles: *Composition, Centre Focus* and *Study, Volumes Depth*. These titles have no doubt become detached from the paintings which were most probably still-lives of the type of *Tulips and Fruit* (Plate 75) and *Still-life with Tulips* (Plate 76). The titles give an indication of the analysis which concerned Peploe beyond the surface of the subject. These paintings are as much about colour as form, however, and represent a very distinct change from the Cézanne-influenced works of the previous winter. In the latter there is a scheme of colour masses dominated by a cobalt-blue backdrop and sandy-yellow tablecloth, on a plane tilted left to right. Brilliant vermilion and scarlet in the chair are picked up in the tulips, the green seat in the stems. The central focus is upon the most powerful tonal contrast in the picture between the white interior and ultramarine glaze of the bowl.

Flower paintings dominated his work for the next few years and in tulips Peploe found wonderful subject-matter. Their heads, of such satisfying geometrical outline when closed or open, could each be an area of pure pigment, while their curving, inquiring stems allowed them to make their entrance unencumbered by the pot in which they must be arranged. His composition was often conceived in three colours – say, blue, orange and yellow – each given similar weight to an area of white. Against these masses, bowls, oranges and the tulips form the composition, each area of colour placed against a background to give the most dramatic tonal contrasts, shapes and colour combinations. His subject was never solely of dry, academic interest to him. He wrote to a friend a few months before he died:

> Flowers, how wonderful they are: I have a bunch of tulips, so gay, of so many
> colours: orange, pink, different pinks, a strange one – pure brick red – which is
> my favourite; so sensitive to warmth; the tulip with the strange hot smell which
> seems to stir deep memories, long-forgotten cities in a desert of sand, blazing sky,
> sun that is a torment; mauve ones, cool and insensitive. Living their closed,
> unrevealed life; unexposed, but keeping their beauty of form till the very end,
> longest of all, dark ones, opening and closing in slow rhythm.[62]

Ion Harrison, who built up a large collection of Peploe's work, recalled that the origin of his enthusiasm for the Colourists was a Peploe show in 1921 or 1922:[63]

> Mr Peploe had an exhibition of mostly flower pictures, mostly, so far as I
> remember, of tulips – red, yellow and white – painted against blue backgrounds
> with different-coloured draperies. I had never seen anything in art similar to these
> pictures, and I did not understand them. They really startled me for, to my eyes,
> they were so ultra-modern. The formal way in which the tulips were painted, and
> their brilliant colour against equally strong draperies, were at that time beyond my

comprehension. A tulip picture of this phase of Peploe's work is one of his pictures which I now cherish most highly.[64]

After the difficult years of the Great War, things were beginning to change. At the end of 1919 Peploe showed at Alexander Reid in Glasgow and again in February 1921. At the same time, however, starting in November 1919 with seven works and then a further ten before May 1921, The Scottish Gallery were aggressively buying works directly from the artist. In October 1921 the firm reached an agreement with Alexander Reid that the dealers should purchase work jointly, directly from Peploe, and between them manage the artist's career.

The first purchase was of eighteen works for £500, all still-lives. The galleries were gaining exclusive representation while spreading the risk. They also made very considerable mark-ups on the work. By owning works jointly, the mutual interest in each other's exhibitions was maintained, and direct competition both for pictures and for clients was eliminated. At first both galleries also took work on sale or return from Peploe so that he did not lose touch with the actual results of the dealers' endeavours on his behalf. Peploe had little interest in the commercial aspects of the art world and the arrangement suited him. The gallery representatives, usually Proudfoot, MacDonald and McNeill Reid, would visit his studio and make their selection while Sam went for a walk.

Between October 1919 and the same month in 1933 The Scottish Gallery and Reid & Lefevre between them bought 241 paintings directly from the artist for a total of £6,130. The income was not entirely regular but it did afford the Peploe family some

Self-portrait, c.1920
Conté on paper
20.4 × 16.5 cm (8 × 6.5 in)
PRIVATE COLLECTION

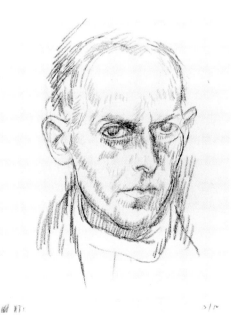

comfort and gave them the confidence in August 1924 to buy the flat on the first floor at 13 India Street which they had been renting for a decade.

The market that the dealers were creating was perhaps not very wide, but it was deep: collectors of Peploe would never restrict themselves to just one work. Prominent amongst his new patrons was John Blyth of Kirkcaldy, a passionate collector and advocate of his favourite artists.[65] He contributed an introduction to The Scottish Gallery's Peploe memorial exhibition catalogue. As has been noted, by the end of his life he owned eighty-five works and happily some of the best are now in Kirkcaldy Museum and Art Gallery.[66] Robert Wemyss Honeyman had considerable manufacturing interests in Kirkcaldy and through his wife, Gertie Nairn, he inherited a large collection of important European paintings.[67] The best of the collection could be seen at Derculich, their country house at Strathtay, and included Boudin and Monet as well as McTaggart and Peploe. In Edinburgh J.J. Cowan had collected Peploe's work in depth until, in 1926 at the time of the General Strike, he was obliged to sell 260 of his paintings at auction, including examples of Whistler, Manet, Cadell and Peploe.[68] In Glasgow Reid sold to several shipping magnates: Sir William Burrell, who made a second, prodigious fortune out of the war and who had met Peploe in 1911, built up a collection of the artist's work in the 1920s, four of which are now in the Burrell Collection.[69]

William McInnes was a partner in Harrison & Gow and bought Peploe's work as well as important impressionist paintings from Reid. Major Ion Harrison of Helensburgh, starting slightly later, was encouraged by McInnes and demonstrated great discernment in building up a large collection of Peploe, Hunter and Cadell, getting to know all three artists and contributing his memories as a preface to Honeyman's *Three Scottish Colourists* in 1950.

The exhibition which took place in February and March 1922 was Peploe's first with The Scottish Gallery since 1909. The gallery organised a second venue in Dundee (the exact location is not known) which yielded a further £408.15 for the artist. Dundee was home to several significant collectors, including William Boyd, the owner of the Keillor jam business, Matthew Justice and William Tattersall, all dedicated Dundonian collectors of the Colourists. Tattersall had a short-lived business relationship with Alexander Reid and most likely had a hand in encouraging The Scottish Gallery to try exhibiting in Dundee.

There were to be several other important exhibitions over the next few years. In January 1923 Peploe showed twenty-six works at the prestigious Leicester Galleries in London. This exhibition brought together Peploe, Cadell and Leslie Hunter, who were collectively known thereafter as the Three Scottish Colourists.[70] It was the first significant exposure for Peploe in London since the war and reviewers generally identified him as the leader or strongest of the three. All three artists were benefiting from the experience of Alexander Reid and the enthusiasm of McNeill Reid, who was increasingly running the business and looking to expand the market for these artists into London.

Ten of the works exhibited at the first show at the Leicester Galleries were of a new subject: Iona. It may well have been Cadell who persuaded Peploe to go to Iona to paint. He had been a regular visitor since before the Great War. At any rate, Peploe's first visit in 1920 was a very significant introduction and he was to return most years until his death.

Iona is a tiny island off the west coast of the larger island of Mull, and is less than five kilometres long and three across. It was the first Scottish landfall for St Columba and has a fine abbey as well as Iron Age sites. At the beginning of August 1920 Margaret and the boys set off for Lochboisdale to visit relations. Peploe left for Iona a few days later and wrote to the family in South Uist:

Dearest wife,

I was delighted to get your two letters and the letters from the boys. What a time it seems since you started from Edinburgh! I am glad the boys travelled so well. You must have been ill. I am amazed Denis was not worse.

I have seen most of Iona now. It is a beautiful place; of course the weather has not been any use for painting; even if it had, I could not have done anything as I have a bad cold – my head feels like it is stuffed with straw. I am really terribly badly off for clothes and boots. I am fairly comfortable here – the food is quite good, plenty eggs, fresh butter and milk. But my bed! I rarely sleep at all. It is of the knotty variety with deep chasms here and there. I miss you all very much. It is as if I were alone in the world and that you were all dead. My finger is bothering me again; I'm afraid it will need to be lanced again.

Cadell has a nice house. He has got his man out[71] and means to use him as a model. He has been very nice to me. I have dined with him I think four times already. He has done a few sketches and got other big things started but so far sold nothing. Nor has Duncan,[72] who is rather depressed about the weather keeping him from working. I have met Cadell's friend Service[73] who seems quite a pleasant man. Tomorrow evening I am going to call on the Ritchies. Where I stay is about two miles from anywhere. I come home from dining with Cadell after eleven o'clock, crossing a large *machar* which would not be easy if he didn't lend me his electric torch. The most beautiful part of the island is the north end: white sands and beautiful rocks, looking across to Mull; but it is too far from where I am here.

Tell Willy and Denis I enjoyed their letters very much. I am just looking forward to the end of the month when we will all be together again.

The girls, Dorothy Johnstone and the others[74] are away. They walked through Mull, sleeping out on the heather, and you should have seen the place they lived in here!

I shall wire Reid tomorrow. Pity the old man has retired.[75] If the weather is good tomorrow I shall take out my box and make a start at something. I got it

ready after dinner today but luckily didn't take it out as the weather suddenly changed. I met Duncan who had walked over from the other side carrying all his painting stuff. Nothing doing; he just had to walk back again.

This letter won't go off till Wednesday afternoon so goodness knows when you will get it. I don't know when you will get here if you come by the *Dunara*.[76] She leaves Glasgow on the 19th and 30th for her nine-day trip so if you leave by the last in August you won't get here till the 5th or 6th of September. However, it can't be helped, and by that time I shall be quite resigned and accustomed to living alone. It is really an awful change from our home life. I hope you found your mother well. Remember me to your sister and everybody. You must certainly be enjoying being with them all again. I'm glad of that but I miss you awfully, my dearest, and I shall never let you go away again. My love to the boys. Have they been riding the ponies yet?

Goodbye, yours, Sam

Peploe was undoubtedly back in Iona the following summer, staying nearer the north end, which provided all the inspiration he needed to work very hard. His first choices

Merle Taylor, S.J. Peploe, Denis, Margaret, Mrs Taylor (Jessie M. King) and Willy at La Rotonde, Paris, c.1921

for subject-matter were the massive, craggy rocks, including the distinctive 'Cathedral Rocks' which emerge from the white sands. These pink-hued rocks, defined with decisive dark lines, have an architectural stature. Sometimes there is a view through to Mull or the Treshnish Isles beyond. As his vision mellowed and a greater naturalism took hold in subsequent years, the intensity of colour he observed in the waters of the Sound of Iona in bright sunshine, varying over shallow reefs and sand bars, darkening out to the deep blue of the Atlantic, provided endless subject-matter.

The Iona paintings were instantly popular and did much to secure the artist's commercial success, at least paying the school fees. But the island was of far more significance for Peploe. It was a sanctuary. He felt in tune with this place. He was a spiritual man without having orthodox Christian belief. On a midsummer's night some years after his first visit he led family and friends to one of the ancient sites of the island to incant his 'Ode to the Elementals', composed especially for the occasion:

O Earth, our Mother, we, thy children, have come tonight to pay thee homage and
 to give thanks for all thy benefactions, to praise thee for thy manifold gifts.
For the sweet grass which feeds our flocks and herds. The corn and grain for our
 sustenance, for thy fruits in their seasons and the flowers which gladden our eyes.
We have entered into the secret places, we have descended into thy very womb that
 we may be fructified and strengthened and renewed.
We art thy children; Thou art our Mother, feeding and clothing us out of thy bounty.
To thee we kneel in praise and thanksgiving, thee we embrace and kiss, O Earth our
 Mother . . . (pause)
. . . Spirit of place, spirit of this particular place, lonely and barren, harsh and bitter is
 thy dwelling: encompassed by moor and rock and sea.
Strong and enduring thou art, the framework of Earth, her very structure and
 ultimate strength.
Here in ages gone by, races of man have dwelt. They are all vanished and are no
 more. In this place men have lived and toiled and suffered.
Their bones enrich the ground, changed by thy sacred alchemy to herb, leaf and
 flower.
For a while we endure and are no more. Our lives are as the wind that passes over the
 grass and is gone.
O spirit of Earth, older than Earth or sea, thou hast taken on this form that we
 might be born.
At one time thou were the Divine Fire, part of the Divine Essence. Thou art
 everlasting to everlasting.
In thy secret heart still burneth the Divine Fire. In our deepest soul ever liveth the
 Divine Flame.

Thou art in us as we are in thee. Born of the same Father, Creator of all things –
 Almighty God.
(silence)
And now, O Earth, would we rest for a little while in silence. Then shall we depart . . .
 in . . . peace.

From 2 to 15 June 1924 Peploe, Cadell and Hunter were joined by J.D. Fergusson for an exhibition, organised by the firm of Alexander Reid at the Galeries Barbazanges, a private gallery in the fourteenth *arrondissement* in Paris, under the heading *Les Peintres de l'écosse moderne*. The French nation acquired an *Iona* panel, featuring a view of Ben More.[77]

The 1923 show at the Leicester Galleries was to be repeated, in January 1925, and this time also included Fergusson. Peploe had already shown in February and March of 1924 in Edinburgh and Glasgow.

The simple lists which were published to accompany Peploe's exhibitions gave titles only. Very often these were no more informative than *Roses* or *Iona*, and sometimes *Painting* or *Landscape*! Neither can one assume that a work was necessarily produced around the time of its exhibition. This was particularly the case before 1920. After the contractual arrangement with the Glasgow and Edinburgh galleries was in place in the 1920s, Peploe no longer took the intense interest in the presentation of the work which he did in 1903 and 1909: paintings were taken away unframed and the artist had little input into what was selected for exhibition or the details of how the works would be presented. He was solely concerned with the picture then on the easel rather than with how a body of work would look in a show of new paintings. In trying to unravel the chronology and work out what was painted when, it is clear that while there are some key stylistic indicators of date, Peploe could paint very different works within a short period. There are several reasons for this: he was seldom satisfied with what he had done and while he could find stimulus from changes in the composition of a few simple props, the process might be exhausting and require a complete change in direction for his next subject. He was in charge of what he chose to paint but a new subject often meant that he selected very different means to be truthful to its demands.

In 1922 he exhibited *Old Duff* (Plate 84) as *Painting of an Old Man* at the RSA and showed it again at the RGI the following year as *An Old Man*.[78] It is painted on an unusually large canvas, 40 × 30 inches, so that the figure is almost life size, with no other detail included. In a touching depiction of old age, the sitter supports himself with a stick and his eyes do not engage the viewer; the cheeks are sunken and the colour is an essay in grey and brown, as if the colour has been drained away by the careworn decades of the old man's life. It is a work in stark contrast to the dashing figure paintings of York Place and the brilliant, jazz-age still-lives that are associated with the early 1920s. The particular

grey and brown, as if the colour has been drained away by the careworn decades of the old man's life. It is a work in stark contrast to the dashing figure paintings of York Place and the brilliant, jazz-age still-lives that are associated with the early 1920s. The particular psychological demands of the subject have been answered in the muted colour and even, uniform brushstrokes.

Boy Reading (Plate 83) is a portrait of Willy in his school uniform aged perhaps eleven, which would date the work to the same time as *Old Duff*. Again the subject is observed rather than engaged and the handling is broad but uniform. In 1919 William Burrell bought *Girl in a White Dress* (Plate 77) from Alexander Reid. In another bare interior, in flat, dingy light, a woman sits in a contemplative or even defensive pose on a divan, as if awaiting an outcome. While Cézanne's single-figure paintings might be recalled in Peploe's approach, the atmosphere created is closer to the domestic nihilism in the work of Walter Sickert.

These works punctuate the flow of brilliantly coloured still-lives, some of the most sumptuous, heady paintings of Peploe's career. *Peonie Roses* (Plate 80) uses the theatrical device of different-coloured drapes and a vase with flowers centre-stage. They look almost spotlit, so luminescent are the white, tight flower-heads, somehow fully modelled without any half-tones. A variety of blue-and-white pots are used as vases; a fan with a long, black ribbon, a low dish with a blue rim, favourite French paperbacks, picked up at the *bouquinistes* on the Left Bank before the war,[79] accompany the fresh-cut flowers and fruit of these compositions. *Roses* (Plate 86) was one of five 24 × 20-inch identically titled paintings bought from the artist by his dealers in December 1922 and is a sumptuous essay in whites in front of brightly coloured drapes. A new device used here in *Still-life with Mixed Roses* (Plate 85) was the disposition of an oval mirror on a white backdrop using the curving shape (invariably cut by the top of the picture-plane) and the reflection from the mirror to enliven the composition.

Throughout Peploe's career there was a seasonality about his choice of flowers and fruit and he was never totally reliant on them for his still-lives. For many years he kept an aspidistra in his studio and sometimes its distinctive, sharp green leaves form part of a still-life composition, but the artist struggled to find in this Mr Pooter of plants a subject worthy of high discourse. He eventually achieved this in *Aspidistra* (Plate 104). Without disguising the dusty colours and familiar form, he painted a monumental portrait of the plant. Against a pale, monochrome background, the tough leaves curl outwards and in, creating a design almost mannerist in its complexity.

FROM THE SPRING of 1924 the Peploe family were in Cassis from where the artist wrote to Margaret and the boys after they had returned for the beginning of the summer term at the Edinburgh Academy:

My dear people,

I do hope you got on all right and got the train in Paris and by this time are on the road to London. Mrs Clarke only got into London at 9.30, so I shall be glad to hear when you have arrived. It was very strange coming back to Cassis after I saw you off. It didn't seem the same place; it was as if I had been away for a week at least. Everything seemed different. I got back in time for dinner. I cannot believe it was only yesterday you went off. Today the usual Marseille crowd. I painted morning and afternoon, subjects quite close at hand. I miss you all very much, but I shall stick it out and look forward to seeing you on the 15th. Cadell was lunching with Miss Oliver today; her Marseille advocate was there. She was looking very ill and ate nothing at all. I shall continue this tomorrow as there is nothing more to relate at the moment. A strong wind today, very bright. I hope the Channel was calm for old Denis. How glad you will be to get to London.

Today, Monday. I got your wire when I came in at *déjeuner* and was very glad you had arrived safely. The Pat Fords were in and were very nice and cordial.[80] They had a most sumptuous lunch – langouste etc – and before they were finished I went off to paint. The two children bathed and when I came home to tea at five they had nearly finished! I liked Mrs Ford. Cadell had Pat up to see his pictures and I gather from what he said that he bought some. They are just away to Marseille in their motor car. The weather here is very fine and hot and I am working. Cadell said after Ford left: 'I don't suppose you've finished any yet,' to which I replied, 'Oh, yes, several.' I started one this afternoon in the grounds of the villa near the hotel. If I can finish all I have started I shall be pleased. It is just the same here but I cannot believe that you and the boys were ever here; it is like a dream. I hope you will get to Wembley today. I hope that Denis travelled well. I shall be curious to see how you got on. Well, goodbye, my dears, and see you don't get bad colds. Rather a change, it will be. I shall write with the news occasionally.

And a few days later:

Gruelling hot today; it is a good deal hotter than when you were here. I have left off planning altogether for next week. I got your long letter from Edinburgh and was glad you got home all right. Splendid that Denis travelled so well. And about

the £700.[81] Life here goes on just the same. An English family, three small girls with mother and grandmother, have been here but went off today. The Comnys are still here and of course Mrs Robertson, in a new jumper every evening. She has been coming down to dinner without a hat and spending most of the day either in the garden or on the terrace so she's certainly bucking up. I started a picture in the garden of the villa near the hotel, in a quiet shady place, but this afternoon the owners turned up, which may dish me altogether. Bad luck. Cadell and I get on very well and play billiards at night (tell Denis I beat him by four the other night) or go down to the Liautaud[82] for a drink. We shall only have one more Sunday here and shall leave on Wednesday of the following week. I shall be glad to get home and see you all again. I am beginning to see how to paint Cassis. If I were here for a while I think I might do something good but I should not care to stay alone. I had a talk with Miss Oliver yesterday and she is looking much better.

Tell Willy and Denis that one of those big moths came in at dinner one night and fixed itself to my trouser-leg where it laid a row of eggs: oooooo, like that. I am bringing a few of them home. Most amazingly beautiful moth. No mosquitoes yet, though I have a spider as big as a florin in my bedroom. Cadell works away in his bedroom persistently: his work is painful to look at and photographic in realism. After lunch today it was almost too hot to move, but this evening it has got cool and blowy. We had wind for three days last week, making painting impossible. Pea soup two days ago: both Cadell and I felt heavy as lead after it. He talked of his illness next day so I gave him a blue and rhubarb [herbal

S.J. Peploe at Cassis, 1924

remedy]. There was certainly something bad about it. No more news but all my love to my dear wife and boys,

S.J.

Cassis would not have changed much since Peploe's previous visit in 1913. There was an expatriate community, some of whom were known to the visiting artists, and some weekenders came from Marseille but there was still limited hotel accommodation. Peploe and Cadell got to know a Colonel Teed there. Frances Spalding in her biography of Duncan Grant records that the Colonel was a former Bengal Lancer who had left a wife in India in order to cohabit with an ex-nurse who was a great friend of the New Zealand artist Frances Hodgkins.[83] He lived in a small *château* a mile or so inland and in 1928 rented a cottage, La Bergère, to Grant and Vanessa Bell. Cassis was thoroughly unpretentious and inexpensive and had long been attractive to artists: Paul Signac was there in April 1889, when he wrote trying to persuade Van Gogh to join him. Francis Picabia, the doyen of Dada, painted there in 1910. By the time of Peploe's next visit in 1928, Roland Penrose had bought the Villa des Mimosas and around him gathered a bohemian group of artists escaping from Paris, notably Yanko Varda and Wolfgang Paalen. Other known visitors included Braque, Derain, Pascin and Max Ernst as well as all the principal members of the Bloomsbury Group, among them Clive Bell and Roger Fry.

The Peploes were staying at the Hotel Panorama. This seems to have been a somewhat eccentric establishment, run by a Russian, M. Georges, who collected his guests from

Willy, Sam and Denis at Cassis, 1924

70

F.C.B. Cadell, Mrs Penny, Jean Cadell,
Captain Penny, Margaret, Denis and
S.J. Peploe at Cassis, 1924

Cassis station, high above the rocky coast and sheltered harbour, in an American limousine – a car which spent the winter months as a chicken coop. The cooking was very basic; Cadell and Peploe were laid low by a soup which turned out to have been made with a chicken rescued from the hotel's feral cats. Painting was blighted for the last ten days of his stay by muggy weather and then the mistral and, by the end, he was desperate to get home. It was nevertheless a place he could paint and he was to return twice more.

Landscape, Cassis (Plate 94) may well be the painting referred to in the letter to Margaret on page 69. The sense of being in shade is brilliantly realised as the dappled light comes through the leaves and branches of the trees. The tree trunks are described in blues and purple, rich, cool and in shadow. The dramatic tonal leap through to the sky and red roofs is made with colour in the same spectrum. *Landscape at Cassis* (Plate 92) uses the same subject and compositional device of the angular trees but is quite different in character: the colours are muted, earthy and local. Perhaps the mist has come and banished the strong light so that the atmosphere seems cool and damp; as a *pleine air* painter, even one whose observations are so far from literal, Peploe had always to make the best of the conditions.

Peploe showed two of the new Cassis paintings amongst the ten included in the group show at the Leicester Galleries in January. The show took place in the Hogarth Room while Walter Sickert showed next door in the Reynolds Room. Sickert wrote an introduction to the Scottish group's catalogue in which he places the Scottish painters in the camp 'not licensed by Mr Fry', and none the worse for it. He congratulates Peploe on his stylistic *volte face*, believing that: '[it] has been an intellectual process and it is probably for this reason that, obviously beautiful as his earlier quality was, Mr Peploe's present one will establish itself as the more beautiful of the two.'

The following summer saw Peploe once again in Iona. On his way there he almost certainly visited Morar, producing a few panels of the famous white sands and demonstra-

ting the extraordinary value he could give to his white painted on an absorbent ground with unmixed blue and yellow highlighting its purity. On Iona in such works as *Iona, Mull and Ben More in the Distance* (Plate 91), the same intense white lent the brilliant colour notes a jewel-like quality, while the coast of Mull beyond gives a rich band of mid-tone and local colour beneath a bright sky.

At his exhibition with Reid & Lefevre[84] in London in December 1926 he showed thirty-one paintings including eighteen still-lives; of these, twelve have titles that identify the subjects as other than roses or tulips, with two titled simply *Still-life*. He used a statuette of the Venus de Medici, a black teapot, a pewter jug, a wicker basket and other new props for his principal subject and, as with his figure compositions, the different subjects demanded a new treatment. White is still often dominant but the absence of primary colour does not mean that these paintings are without zest; they are handled with the same brisk confidence. The still-life props have textures which challenge the artist to find their equivalent in paint using colours in the green, grey, brown range. The resulting paintings are in the spirit of Chardin: still, demanding contemplation; having a simplicity, even a nobility.

The show was reviewed in *The Studio* where the writer has the same mixed feelings which so often characterise criticism of Peploe:

> Mr Peploe, a painter of somewhat perverse originality . . . his technical methods are a little too casual, but underlying them there is a foundation of sound knowledge of nature which saves his work from incoherence and gives it a satisfying measure of creditability.[85]

In May 1926 Sam and Margaret had ventured to Cornwall, staying at Looe, but there is no record of any work being done there. They returned to Scotland via Richmond in

Sam, Denis and Margaret at Iona,
c.1925

Yorkshire, again without results. In Dumfriesshire, staying at the Commercial Inn, New Abbey, Peploe at least managed to paint *New Abbey, Dumfriesshire (Summer)* (Plate 100) and *Summer, New Abbey* (Plate 101). They were both most likely exhibited at Reid & Lefevre in London in December as *Summer, New Abbey* and *Summer in the Village*. His impasto is thick and broadly handled, while the palette is cool: an essay in green, white and brown, full of subtlety. In *Summer, New Abbey* the result is a lyrical, classical painting with a white sky over monumental, mature trees surrounding a simple whitewashed cottage. It is the way forward for his landscape painting, both technically and in spirit. It was not, however, a productive summer. Cadell wrote to Margaret from Iona in response to her letter perhaps bemoaning her husband's lack of progress in the south-west, supplying all the local gossip and asking why they had not come to Iona.

The next summer they were certainly back on the island. The nature of weather systems on the west coast of Scotland means that Peploe had an ever-changing subject. Perfect blue sky was anathema to him. He wrote to his friend William Macdonald[86] in November 1923:

> . . . We had miserable weather in Iona this year – worst in living memory – gales and rain the whole time. I got very little done. But that kind of weather suits Iona: the rocks and distant shores seen through falling rain, veil behind veil, take on an elusive quality, and when the light shines through one has visions of rare beauty. I think I prefer it these days to your blue skies and clear distances.[87]

Indeed Peploe was not just a summer visitor; he spent several winter months on the island in addition to his summer visits. In *The Rainbow* (Plate 90) he paints looking across a bay sparkling in sunshine after rain, to a high horizon with its partial rainbow. The new lyricism of *New Abbey* is carried forward in Iona where the artist's deep knowledge of the land-scape makes his an intuitive response. Cursiter identifies a visit in 1927 with a patch of bad weather which inspired Peploe to paint the Atlantic, in its grim, fierce majesty, in a manner which is close to that of McTaggart, for whom he had great regard.[88] In Iona he is a painter of atmosphere, of wind and of weather, which, in *Iona, Cloudy Sky* (Plate 106) has blown a considerable quantity of sand across his wet canvas. These works may well belong to a winter visit which is looked forward to in an undated letter from Cadell writing from Mull to Edinburgh:

> Wednesday night. Torosay Castle
> Dear Mrs Peploe,
>
> What an experience! Rain pouring in the Muckle Glen and further up HAIL!! Sat in a puddle of water half the way. Kilt, pulp! WWP[89] and Glass[90] at inn – only two rooms available, so I came here for the night and am now in great comfort.

D.V.,W.P.,[91] we all meet on *Lochinvar* [92] tomorrow. Hope you will all enjoy the winter on Iona. I may return for Christmas and paint St Martin's Cross with snow and a robin on it (don't give the idea away to Denis).[93]

 Yours, F.C.B. Cadell

In October 1927 The Scottish Gallery bought twenty-five paintings from Peploe, as usual selling a half share on to Reid & Lefevre, and then nothing else until February 1929. However, 1928 was not an idle period for the artist; he was to complete memorable work in France and Scotland. By early February Sam and Margaret were in Antibes, staying at the *pension* Roches Fleuries. Their sons were deposited, not for the first time, with the Beggs, a couple who ran a boarding-house for boys, while they attended school.

At the end of the previous year, thirty-two paintings were packed and dispatched to the C.W. Kraushaar Galleries, 650 Fifth Avenue, New York, for a show which ran from 21 January to 3 February. Mr Kraushaar had bought two still-lives some years earlier and had also mounted a Fergusson show in New York. At the last minute Peploe had penned an 'autobiography' for the catalogue:

> Born Edinburgh, 1871, son of a banker, educated there, Edinburgh Collegiate School and University. Thought in terms of being a soldier, minister, indigo planter, lawyer, farmer and other pursuits, but preferred doing nothing as long as possible; the ideal life is the lounger.
>
> At the age of 20 (though not really tired of doing nothing), reading Carlisle and Ruskin, was 'awakened' to Art (a nice, easy, out-of-doors life). Got enthusiastic and worked hard; went to Paris – Julian's under Bouguereau (damned old fool), then in Life School in Edinburgh. Took studio in Edinburgh; produced some masterpieces and a lot of failures. Continued like this until 1910 when married; had to work hard. Family appeared – had to work harder still. At this time in Paris (1911), a very lively time. Came home again, more family appeared – had to work really hard. This has gone on till present time.
>
> There is no end to Art.

While the New York show was on, Sam and Margaret, of course, were in Antibes, seeking some winter sun after the wilds of Iona. They were to stay until mid-May, the boys joining them for the Easter holidays, before going on to Cassis for a few weeks before their return. For a stay of such length, it was not very productive; Peploe suffered some ill-health and the weather was unreliable for the landscape painter. He did produce a few ambitious canvases, however, and two were eventually to be acquired by J.W. Blyth and another by Ion Harrison. *Palm Trees, Antibes* (Plate 108) is another essay in heat and shade. It is a portrait of a majestic palm, the brilliant sky seen through its dark fronds and the rough

bark of its massive trunk a compelling dusty brown. *Trees, Antibes* (Plate 107) depicts a file of huge trees, this time pines, and in the very simplicity of its conception is the antithesis of classical landscape. His impasto is again very full – the plastic equivalent of the monumentality of his subject. *Blue Water, Antibes* (Plate 110) observes another stand of great trees, their trunks this time forming a Cézannesque geometric pattern and affording a view through to the blue of the Mediterranean in bright, chill spring light.

It is difficult to identify which paintings of Cassis belong to 1928 and which to the artist's next visit in the summer of 1930. Few were exhibited during his life, Iona and still-life continuing to be the dealer's preferred choice. He had one work, *Church at Cassis*, in New York, but the timing of the show indicates that the painting belongs to the previous visit in 1924. *The Aloe Tree* (Plate 93) was exhibited in Reid & Lefevre in London from December 1929 to January 1930 in an exhibition of thirty-four 'New Paintings'. (In fact the only other French work was of the Ile de Bréhat, which would have been painted in 1911.) Its subject is a sidelong view of the front of the Hotel Panorama, a highly sophisticated composition of triangular and oblong blocks rendered in brilliant white, blue and red with rich greens and purples for the shadows and half-tones. It was acquired by the City of Manchester from the exhibition. The director, Lawrence Haward, asked the gallery to supply any details of the painting they could. His letter was passed on to Peploe who replied on 6 February:

Dear Sir,

I thank you for your letter. The picture *Aloe Tree* was painted at Cassis in 1925.[94] It is on a gesso-primed canvas and therefore should not be taken off its stretcher nor rolled up (I don't suppose that is likely).

It might be varnished safely but I don't think that necessary.

This seems a short account of its early years, but I feel its real life is just now beginning and under the most lucky and happy circumstances. As its father I am very pleased to know it is going to be well cared for now that it is out in the world on its own.

Paintings are funny things; they have a life of their own with their moods and changes, dependent too on so many things, they need looking after and being loved, like children.

That's why I am so pleased about this one. I don't need to bother any more. It is safe.

Yours sincerely,

S.J. Peploe

In the summer of 1928 Peploe had painted *Sweetheart Abbey* (Plate 111). Perhaps for the first time the use of a palette knife is predominant, most evident in the pale-blue sky which

is swept in with broad gestures. His palette is unusual in response to the soft, summer colour of the south-west of Scotland and in complete contrast to the brilliance of the Mediterranean.

In July and August Kirkcaldy Museum devoted their second 'Inaugural Loan Exhibition' to Peploe. In early December the previous year he replied to the invitation to the museum director, Thomas Corsan Morton, expressing his pleasure and honour at being selected. He was writing in midwinter and was seldom inclined to be optimistic about his work and he finishes in not untypical downbeat fashion:

. . . These dark days one sits and wonders how one ever came to paint at all, light and colour seem so remote and strange.
 Very best wishes,
 Yours sincerely,
 S.J. Peploe

While Peploe's star was still in the ascendant, the economy of the art world was deteriorating. In his next exhibitions in London and Edinburgh, only six works were sold; the four from The Scottish Gallery in March 1930 all went to Robert Wemyss Honeyman. In addition to the depressing effect of general economic trends upon his sales, the preponderance of flower paintings to other still-lives and landscape perhaps made his exhibitions less instantly commercial than those of the early 1920s. Peploe at this point was almost certainly painting far less, already suffering from periodic bouts of ill-health which prevented sustained effort in the studio. What he managed to produce is not without ambition, though. Perhaps the time he was able to spend in the studio was sharpened by a sense of urgency and the knowledge that his journey was not unending.

IN EARLY 1930 the family returned once again to Cassis, the boys joining Sam and Margaret for the Easter holidays. Denis would then have returned to the Beggs' boarding-house and Willy, now in his first year at Magdalene College, to Oxford. Their parents stayed until early June. Peploe is attracted to some of the same subjects as in previous visits, including the hot, dusty streets and sun-baked buildings. The subject of *Cassis* (Plate 118), which was to be acquired by George Proudfoot, is most likely the lane at the back of the Hotel Panorama; a good subject would not be scorned just because it was outside the back door. The paint vehicle is again rich (but not lush) and conveys the dryness and retained heat of wall and stone under an intense sun. He has had to work harder to reach his vantage-point for *Bird's-eye View, Cassis* (Plate 119) where a noon sun's

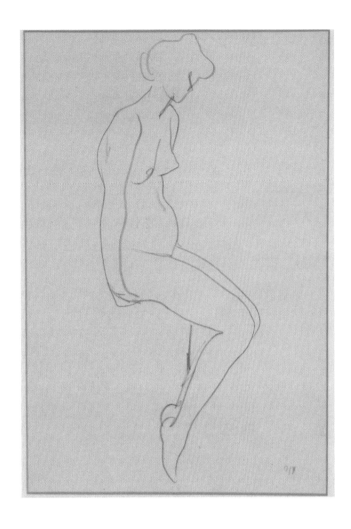

Seated Nude, c.1929
Conté on paper
35 × 25 cm (11.6 × 9.8 in)
FIFE COUNCIL MUSEUMS; KIRKCALDY
MUSEUM & ART GALLERY

rays preside over a parched, mineral landscape, the red roofs of the villas the only colour not bleached to pale shades.

Peploe exhibited at Galerie Georges Petit, in the Rue Seze in Paris, in the second showing for *Les Peintres écossais*, between 1 and 14 March 1931. The exhibition would come to the important Barbizon House in London in the spring of the following year. The four Colourists were joined by George Telfer Bear (b.1874) and Robert Ossory Dunlop (who was in fact English).

Peploe had ten works in the show: three were entitled *Paysage*, three were *Roses* and the remaining four were *Le repos du modèle*, *Nature morte, panier et pommes*, *Mer et rochers* and *Nu*. *La Forêt* (Plate 112), one of the *Paysages*, which was acquired by the French state, was probably painted in the summer of 1929 in woods around Shambellie House between Kirkcudbright and Castle Douglas which was then owned by Ted Stewart, Cadell's friend and lawyer. It is one of several light-toned, Cézannesque compositions which carry on the theme of great trees which the artist embraced in Antibes, and looks forward to his most monumental forest painting: *Boat of Garten* (Plate 113), one of the

works Wemyss Honeyman acquired from The Scottish Gallery in their exhibition of March 1930. It is his only known painting of the location and was most likely painted in the autumn of the previous year. We have seen how the majesty of mature trees has become for Peploe the most compelling subject (apart from Iona) in nature. Here the Scots pines of the ancient Caledonian forest are lent a sense of scale, awe and mystery without parallel in Scottish painting.

The two figure compositions in the Paris exhibition of 1931 were from a group of recent life paintings including *Nude in Interior, with Guitar* (Plate 116). A sophisticated design of balanced, dynamic diagonals is allied with a cool palette, very broadly handled paint and the same sense of monumentality the artist is seeking in his landscapes. In a painting of Willy, the model is both son and languid aesthete in a portrait posed in a composition strikingly similar to the *Nude in Interior.*

In the late spring of 1931 Peploe had gone to Kirkcudbright and was staying in the Selkirk Arms inn. In letters to Margaret and Denis (Willy was away at Oxford) he revealed the usual mixed fortunes of the artist trying to paint:

> My darling M. and Denis,
>
> Got your letter this morning. The rain is coming down hell for leather – cats and dogs this morning; what an awful week it's been, and when I was looking forward to something better. It can't go on surely for another week. Very nice of Mrs Sinclair – every little helps. I thought she was going to Iona in June.
>
> I had supper with the Taylors, a most magnificent meal. Grapefruit, delicious cooked sole, a really marvellous omelette and the best custard pudding I have ever tasted, with pears. The food here in the hotel is not good; one gets fish swimming in wet grease and the meat is always cold or lukewarm. I have indigestion frequently due to the awful cooking. And tea and coffee with every meal . . .
>
> . . . I expect to be home by the end of next week but I do want to finish two things and there has been no chance of painting at them lately. I seem to have the devil's luck with weather always. I am beginning to feel really like painting but get no chance. I should like a whole summer in the country with you and Denis.
>
> Love S.J.

> Dear M and D,
>
> Sassoon[95] has just left me. Spotted me in the street the other day – luckily I haven't been asked to dinner. I am getting awfully sick of Kirkcudbright. There is absolutely nothing to paint. I have a few things that I shall try and finish: then home. And I shall be glad. I am pretty lonely here and at times get awfully depressed. Mac has bad headaches again – the climate here is enervating and makes one dull and listless . . .

I have been sleeping badly lately. The food here does not suit me. Tea and coffee with every meal. And greasy fish. I think Mac's headaches are due to bile. He has a huge plate of ham and eggs every morning, a thing I never touch.

The hawthorn is coming into flower now, so this is the perfect week of June that I have been waiting for. I hope the weather will be fine – it is most unsettled: dull skies, occasional sun.

I return Willy's letter which is identical with the one he wrote me.

The Mac baby is splendid, a fine little boy, very playful and bright. Beatrice continues her portrait of Jessie King. I feel that I should lose my soul if I lived in this place. Lush grass and green trees, you can see nothing for leaves – no distance, nothing for the imagination. Rather English than Scottish. I'll get this off with the post now.

Love and xx from S.J.

Dear Mother and Denis,

Weather has turned fine again after some very cold and miserable days. I got a beastly cold on Thursday evening, stupidly going out to paint. Got my feet very wet in the long grass – came home, couldn't eat anything, drank a lot of hot coffee, then a hot whisky before bed. Friday I ate nothing at all and felt pretty bad chill on stomach and liver. Today I am much better, out in the sun and able to enjoy my food again. But this weather is most treacherous. My painting does not go at all but I hope for better luck next week. Mrs Mac has a sore throat and Mac is not too bright.

The admiral and lady Duff have gone today. They became quite pleasant. She was a nurse. A man, Bruce, a friend of Taylor, is coming today, I believe. He paints.

I heard from Honeyman. I wrote him. They sold ten which he thinks pretty good in these bad times.[96] It will certainly pay him all right. Five to new buyers. Taylor has been in Glasgow but is back. I had tea with Jessie K on Thursday at 11.30. She was very nice. Then he came along to the hotel in the evening because I had promised to go and see them but couldn't owing to my chill.

I am trying to read *Five Red Herrings*. What a silly, dull book – full of padding. I fear I won't finish it. I can't remember one of the characters to the others. This chill has been rather a check to my work in the last two days which have been paintable but I couldn't risk going out to work. I have got over it pretty easily. It is getting grey again as I sit in the garden writing – halo round the sun which means rain tomorrow.

I'll write again perhaps Sunday

Love from S.J.

Dearest wife,

A dull, wet morning so I take up my pen. Pen impossibly bad so pencil. This climate makes painting outside impossible. It is always windy or cold or wet, rarely good. I would really be doing more in my studio, is it not wasting time here?

I find seeing so much of the Macdonalds rather tiring – he is terribly long-winded and pedantic – really boring. The Taylors have been awfully kind, offering to put one up at their house. I looked round for rooms but none to be had. I spent an evening with them, very peaceful and home-like, so different from the hotel. (I hate hotels.) Beatrice is in a strained state of nervous worry and anxiety about something or other – they don't improve on nearer acquaintance. Cleghorn Thomson is coming down here this weekend to do some broadcasting or something, so Taylor tells me. Opp[97] arranged it when he was in Edinburgh. Opp and I are just on nodding terms now. What a relief! He won't bother me any more.

My eyes have been and are rather bad I think due to the cold winds: but I don't even read here at night so that they may feel better. I am using borain lotion. Dr Sinclair made an awful mess of Mrs Mac's eye prescription – put the right eye glass where the left should have been. She had to go back and even now it's far from satisfactory. She has lost faith in him.

We start the morning with stewed apples or prunes or porridge. I've been taking prunes – excellent thing in the morning. And the food is good. I had better stay on here till Clark's place is vacant and, if my painting is going well, continue for a bit. If not, I had better come back to the studio. I can't waste the summer waiting on the weather. The blossom is coming out, but oh, the lack of sun.

I get terribly bored here at times, nothing to do then this talk of the Macdonalds to listen to – there's no doubt I am quite unfit for normal social life.

The subject of the Doctor's house is certainly very handy. I hope I can make something of it; the trees are coming out fast, so probably it will be quite different the next time the sun shines. I bought a pair of scissors yesterday to cut my hair – 1/6 – so I won't get too shaggy.

I haven't any more news, I fear things are too dull for words.

Wastle sent me the summer-term form for signature this morning. Edinburgh Academy was spelt Accademmy; ask Denis if this is the posh way.

It is coming on to rain. Macdonald is away golfing without a coat. How shall I fill in the day? One longs for a studio when the weather gets bad.

What a spate of visitors you had on Sunday. Rather too many. But glad I missed Murdoch. Mrs Sinclair describes him: 'a strident, bullet-headed person,

Denis, Willy, Sam and Margaret at North Berwick, c.1931

convinced we are a public meeting, thirsting for information . . . deaf too'. So that's all for the time being.

 xx S.J.

And finally:

Dear M and D,

 Glad to get your letter with interesting enclosure. The weather!! This morning cleared up, it would have been wonderful on Iona; but amongst these awful green trees the sky was too fine. I expected to have a good afternoon (four o'clock) at a canvas. Got to my place. Sky immediately covered over with cloud which kept on till seven o'clock when I came home disgusted.

 I will give it one more chance tomorrow and then come home on Thursday. I am only wasting time here. Very keen to paint but absolutely nothing to do. It has been a disastrous experiment. Heartbreaking. Fairlie[98] and Murdoch must have been pretty trying.

 Does McColl ever come to the house? Very nice of Maggie Lamond sending the eggs. The strawberry season will be beginning.

 The hawthorn is nearly over here, rotten with rain; trees getting a loathsome heavy green. This is no place for me as a painter. I wish I had stayed in Edinburgh – I should certainly have painted more and better things.

Oppenheimer was in today asking the Macs to a musical evening. He *just* talks to me and no more, for which thanks. Needless to say I haven't been to see the Davisons – what a dreadful place to live in this would be.

It will be nice to be home again – here am only half myself, isolated. After all, the Macs have counted for something. She is very well now, quite different. They came back out of form, and go back to France in September.

Love from S.J.

It was back to Iona in the summer, staying until the end of August. In Iona, as in France and elsewhere in Scotland over the past few years and in the studio paintings of still-life and figures, the artist's works have a greater richness. There is less reliance on strong colour absorbed onto gesso ground; quieter hues are carried in a full, rich vehicle. Stanley Cursiter remarks how 'his work has a richness and fullness due in great measure to an increased acceptance of the muted harmonies of quieter and more broken colour. There is no longer the slightest suggestion that the colour was being searched for and accentuated for its own sake, but rather that the whole surface was a web of some rich material in which notes of colour emerge and forms take shape.'[99]

By the end of 1931, Peploe's health was deteriorating. He contracted many minor ailments from which he recovered slowly and often suffered from a general lassitude; this lack of his normal energy could be attributed to his weak heart. His uncertain health was greatly frustrating to him and in any work he was able to complete there is a sense of urgency which perhaps stemmed from this anxiety. It is likely that the pressure he felt was the decisive factor which led him to move studio again, seeking to propel himself into hard, urgent work in a new environment. He found a satisfactory room on Queen Street, on the corner of Castle Street. This was closer to his home in India Street and had only one flight of stairs. As usual, he applied himself to the arrangements, which included some structural alterations, before he decorated and furnished his new studio. Sadly, he was to start and finish only two new paintings here.

One of these is *Tulips in a Brown Jar* (Plate 124), which is a typical, powerful example of his last phase. The application of paint is brisk and confident, the drawing decisive and the paint finish is a rich impasto. While the character of these late paintings is very different from his style of 1906–9, Peploe has returned to a more tonal construction, naturalistic colours and broad, gestural painting. There is nothing showy about *Tulips in a Brown Jar*, however; it is less studied – less the sum of its sophisticated parts and more a direct emotional response to the subject.

GIVEN PEPLOE'S SHY and somewhat diffident nature and his variable health, it is perhaps surprising that he agreed to teach at Edinburgh College of Art in October 1933. Hubert Wellington was the principal at that time and Stanley Cursiter records his recollection of the appointment:

I was told Peploe would never consent, had always refused ruthlessly to consider teaching of any kind. However, I approached him quite simply and quietly with the suggestion of two days a week to take charge of advanced students of life painting, with no shackles of forms and regulations nor restrictions from 'above' or 'outside' on his teaching. Obviously if he found that it upset his own work or if things didn't go smoothly it would be useless to continue, but I felt sure, and told him so, that he could be a real living influence on young Scottish artists who looked up to him in a quite special way.

To my great satisfaction Peploe was quite interested and after some consideration – and dread, no doubt, of some sinister imprisonment in the 'machine' – he consented to try it out.

I believe that on the whole Peploe enjoyed the experience, found students and his young colleagues more interesting than he expected. No doubt he felt bored at times by the regular dates and times, and the dull individual he was bound to encounter, and no doubt found a day's teaching in the life rooms tiring, as we all do. His influence was admirable, his standards high, his criticism acute, often unexpected, not to be anticipated by any formula, and there was a general rise in the keenness and effort of his class. Probably his insistence on a grasp of the essential planes of the subject – whether head, figure or still-life, and the placing of these in absolutely the right relationship, area by area, without smudging or fudging, made the greatest impression on his students.

Naturally no general college duties fell to him – he was the artist whose work was known to all, who came to give his experience and advice to advanced students and post-diploma scholarship-holders, and this he did seriously, courteously, occasionally flashingly, unobtrusive but with authority. At the annual judging of diploma work in June he took his part with the appointed assessors, Philip Connard RA being the outside assessor in 1934. He was in great form, acute in his comments and occasionally outrageous in discovering unexpected qualities, leading the assessor up on questionable slopes and keeping the judging out of too obvious and conventional ruts. Unhappily he fell ill during his second year of teaching, and ultimately had to give up. This was a bad blow to the painting school, for Peploe had brought fresh life and the critical standards as I had hoped. I should say that he never consciously imposed his own attitude or

style on a student – he would have disliked intensely such interference with another individual – though no doubt some students (as they will do) took on superficial resemblances of his manner of painting. It took some intelligence to reach the full meaning of his sometimes allusive approach and comments, and not all senior students are gifted, but the general result of his teaching was tonic and astringent, discouraging to any too facile or slovenly effort.[100]

Warm, personal letters of reference written for students still surface occasionally, showing clearly how Peploe valued the contact with young artists, whom he viewed as his fellow professionals. His brief association with the college came about because of his sense of owing something to his profession and of his wishing to give something back, without didacticism; sharing, rather, a lifetime's accumulation of knowledge and wisdom without restraint.

In the summer of 1933 the Peploes went to stay in Calvine in Perthshire at the invitation of Louie Sinclair and, after his usual scouting inspection of the area, Peploe found several subjects he felt he could paint: a few remnants of the Caledonian forest, a river with deep pools and banks of white shingle and a road of a pale pinkish yellow meandering through the trees. He returned in August and made several paintings but felt he was too late in the year to get the best out of the subjects, the leaves having taken on the heavy black-green of late summer. He determined to return the following summer.

In March 1934 he was at St Fillans on Loch Earn, near his old haunt of Comrie, but no work is known to have been made. Landscape painting is very demanding and could be profoundly frustrating, particularly to someone of Peploe's sensibility. When he returned with great expectations to Calvine the year following his first visit, one of the subjects he was looking forward to painting, the rolling country road, had been tar-macked. It was sufficient discouragement to persuade him to move, to Rothiemurchus, at the recommendation of his son Denis, who was already at Edinburgh College of Art and becoming a considerable landscape painter himself. Here he completed his last painting.

He did manage to get to Iona the following August but it was for the last time and he was not able to work. He was admitted for an operation from which he did not recover sufficiently to be allowed home and died in a nursing home on 11 October 1935, aged only sixty-four. He had said before his operation that whatever happened would be for the best but that if he had another ten years he might paint something of real importance. As ever, it was the next picture that was the most important.

There were two memorial shows. The first was organised by The Scottish Gallery between April and May the following year and included eighty-three paintings. The year after that Reid & Lefevre put on an exhibition in the McLellan Galleries in Sauchiehall Street which featured 123 paintings. It was mounted in collaboration with Pearson &

Westergaard, Glasgow-based dealers whom Reid and MacDonald had arranged would be agents for their Scottish artists in the city.

Between obituary notices and reviews of the memorial shows there was huge newspaper coverage, all of which was consistent in its praise of an artist who had become recognised as one of Scotland's greatest. The *Observer* obituary chooses to emphasise Peploe's international status under the headline 'A Franco-Scottish Painter':

> There is deep regret among lovers of art in the passing of Mr S.J. Peploe RSA of Edinburgh, the distinguished Scottish painter. Although a Scot by birth he was not in the Scottish tradition. From his early years he was strongly influenced by the French Impressionists and Post-Impressionists, and his work is consequently divided into two distinct groups. Rich colour characterises his heads, still-lives and landscapes of the first period, and austerity combined with a wonderful sense of design the second, the influence of Cézanne being marked. His fame is not confined to Scotland and England, for he is represented in the Luxembourg, Paris, and is regarded by French art critics as a disciple in their own tradition.

The Times entitles Peploe's obituary 'The "Fauve" Movement in Painting' and the writer is again concerned to link Peploe with post-impressionism as well as noting that there is a painting, *Tulips*, in the Tate Gallery permanent collection.

Another notice, found stuck in a scrapbook in family papers without a reference but most probably from the Aberdeen *Press and Journal*, describes Peploe as Scotland's pre-eminent Colourist with a circle of intensely enthusiastic admirers beyond Britain. It also notes, for the interest of local readers, that he would be missed in the Highlands and Islands and that his wife came from Lochboisdale . . .

The reviews of the memorial shows wonder at the artist's range of styles, telling the story of his conversion to modernism, around 1910, and generally placing him in the position of the leader of the modern movement in Scotland. One reviewer tries to sum up his impression of The Scottish Gallery exhibition:

> Perhaps the most insistent impression which one receives in this exhibition is one of inexhaustible variety. Peploe's work in exhibitions is easily recognised. One might say it has a very definite character, and one might be led to think that it is largely repetitive. In this memorial exhibition one is struck by the variety of the painting. Here is no mere subjective formula imposed upon different subject-matter, making all more or less akin, but a sensitive reaction to the varying qualities and suggestiveness in each of the subjects under scrutiny.

It is clear that Peploe's reputation and place in Scottish painting were assured, and his

S.J. Peploe and students, Edinburgh College of Art, Easter 1934

position in a wider art world recognised as unusual and of significance, enhancing the reputation of Scottish painting in an international context.

We can see now that this moment was the pinnacle of his reputation. James Caw, who had reviewed Peploe's first show in the same venue in 1903, recalled in his introduction to The Scottish Gallery memorial exhibition catalogue the qualities in the artist's earliest work and how, 'in the developments which followed, these were transformed rather than changed. To watch them as, from year to year, they attained fuller expression, was one of the truest pleasures which painting in Scotland afforded in the ensuing years.'

Peploe had many great supporters in his lifetime who were able to influence taste and make reputations, like Stanley Cursiter who went on to write his book on Peploe and who as director of the National Galleries of Scotland acquired several important works by the artist for the nation. This generation knew the man and understood how his life's work, devoted to the serious pursuit of his objectives in the development in his painting over the years, built a significant *oeuvre* which put him at the forefront of Scottish painting.

The dealers were initially active. Both Reid & Lefevre and The Scottish Gallery had quite a quantity of owned stock, but also acquired more from the artist's widow. Willy Peploe decided against the Civil Service and joined Reid & Lefevre in 1937 where he eventually became a partner, after being stranded in Africa during the war. When he was not looking after Dalí and his wife Gala when they visited London, or in New York learning

the American end of the trade at Bignou,[101] Willy certainly took an interest in the promotion of his father, firstly at the Glasgow memorial show and then the firm's own exhibition of 'Three Scottish Painters' in January 1939 in London which included fifty-one Peploes.

In 1935 there was a dearth of important work being made in Scotland. The Glasgow School was in terminal decline and the promise of the younger figures of the Edinburgh School, in particular William MacTaggart and William Gillies, was still to be realised. The war years did not see complete inactivity in the art world and the National Galleries defiantly put on a fine programme of exhibitions including a Peploe show in March 1941, but it was little more than a time of making the best of things. Reputations were not to be made; the market was depressed; and so many were away on more 'essential' duties.

At the end of the Second World War it took some time for the art world to regenerate itself; Peploe's dealers, though, now with the addition of the tenacious Ian MacNicol in Glasgow who put on a Peploe show in April 1947, were already prepared. From August to September of the same year The Scottish Gallery showed seventy-four paintings and twenty-six drawings, only thirteen of which had been borrowed. The show was in direct collaboration with Reid & Lefevre who put on a very similar show the following May. However, these exhibitions were chiefly an exploitation of the estate as well as a running down of the owned stock the dealers had acquired during the artist's lifetime; they no longer had the will to find new markets and clients for their artists. In Edinburgh George Proudfoot had died. He was replaced first by his sister and then by his young French wife as senior partner and, while they continued always to have Peploes in stock, there was no longer the active management and promotion required to build a significant market. In London the brilliant triumvirate of McNeill Reid, Duncan MacDonald and T.J. Honeyman retired (or, in the case of Honeyman, crossed over to become director of Glasgow Museums). New partners had little interest in Peploe, and Willy was personally more concerned with the new English painters and blue-chip European paintings.

One of the most positive outcomes of the restoration of culture after the war was the birth of the Edinburgh Festival, and as part of the 1949 programme the National Galleries mounted an ambitious exhibition of work by the Scottish Colourists which included forty-three works by Peploe. Ion Harrison showed his entire collection (which included forty-four Peploes) in aid of the Thistle Foundation at the McLellan Galleries in 1951. Two years later the newly formed Arts Council's Scottish Committee invited Denis Peploe to select works for a travelling exhibition of his father's paintings; fifty-seven were chosen. There was not to be another one-person exhibition for thirty-two years.

With the passing of the man and his strongest supporters, the art world would look to the next generation to find its stars. As far as the market was concerned, there was little inflation in art prices until the late 1970s; in addition, there were few important collections coming for sale to rekindle interest in Peploe. It was the market which led the revival of interest in Peploe and indeed the other Colourists. The Fine Art Society and its

far-sighted director, Andrew MacIntosh Patrick, often featured works by the Colourists in its annual Scottish shows; after the Society opened permanent premises in Edinburgh it mounted an exhibition entitled 'Three Scottish Colourists' which ran from February to March 1977. A substantial part of the Wemyss Honeyman collection was auctioned by Christie's in June 1979 and the prices far exceeded expectation. From then until now there has been steady, dramatic inflation, mirroring fairly accurately the index of values in the Impressionist and Modern markets on a more modest scale.

During the 1950s and 1960s London-based artists, critics and curators dominated an art world riven by the development of various 'isms'. There was a sense, causing intense resentment in some quarters, that nothing worth while could be achieved in the visual arts outside London. Finally, in the 1980s it was no longer tenable (or indeed outrageous) to maintain that 'painting was dead'. The art world still had its cliques and powerbrokers but, based on a hugely expanded market, it was much more pluralist. The enjoyment of easel-painting was allowed again and curators of important survey exhibitions were able to rediscover artists such as S.J. Peploe and give them a proper place in the history of twentieth-century British and European painting.

Peploe was a passionate and serious artist who devoted himself to work but who also had a powerful personal influence on a surprisingly wide circle of people, including many artists of the next generation. Final remembrance should fittingly be from a fellow artist, E.A. Taylor, who found the right words in the introduction to his Glasgow memorial exhibition catalogue:

Even be Peploe's motif a single rose, he gave to it by his significant design and colour a more enduring bloom than by any yet produced by the superficial formula of academic cosmetics. Vividly I recall some adherents to that fixed mode of silken complacency, shaking their heads pityingly, and questioning his sanity in departing from the easeful and prosperous position he had attained. A critic must always remember to endeavour to keep himself ever in the vanguard to be able to eliminate merely superficial shadows from their approaching realities. The intense pleasure I have in writing the foreword to this memorial exhibition of the work of Peploe is veiled with a certain sadness in thought; that one will never meet again his lithe and distinguished figure stepping along Princes Street, a Paris boulevard, or the less populated country places that attracted him, and that I may not see his humorous smile of welcome, nor hear him enthusiastically praise some sunlit aspect of nature, or with the same sincerity express his likes and dislikes; more than I realise the loss to Scottish art which his passing really meant, and means. Never have I known a man more true to himself, his home, his friends and his inspiration – all attributes which make memory of him lasting and his art enduring.[102]

1 **Landscape**, c.1894
 Oil on panel
 29.2 x 42.9 cm (11.5 x 16.75 in)
 PRIVATE COLLECTION

2 **Nude in Studio Interior**, 1896
 Oil on canvas
 91.4 x 71.1 cm (36 x 28 in)
 EDINBURGH COLLEGE OF ART

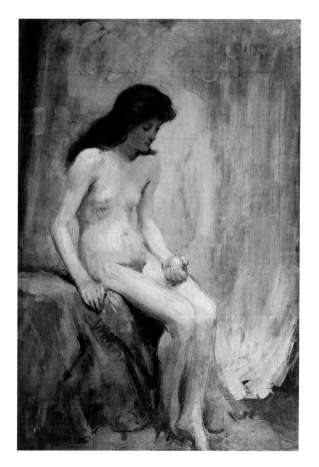

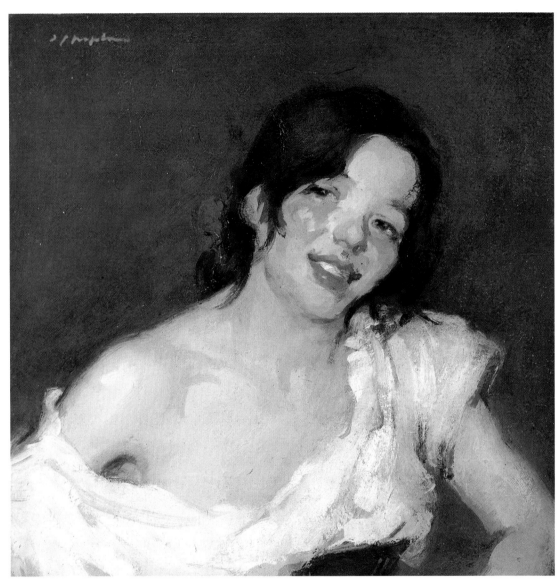

3 **Gipsy**, c.1896
Oil on canvas
38.1 x 38.1 cm (15 x 15 in)
PRIVATE COLLECTION

4 **North Berwick Sands**, c.1896
 Oil on canvas
 38 x 31 cm (15 x 12.25 in)
 KIRKCALDY MUSEUM & ART GALLERY

5 **Painting Materials**, c.1897
 Oil on canvas
 31.8 x 38.1 cm (12.5 x 15 in)
 ABERDEEN ART GALLERY & MUSEUMS

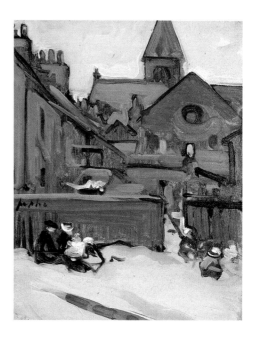

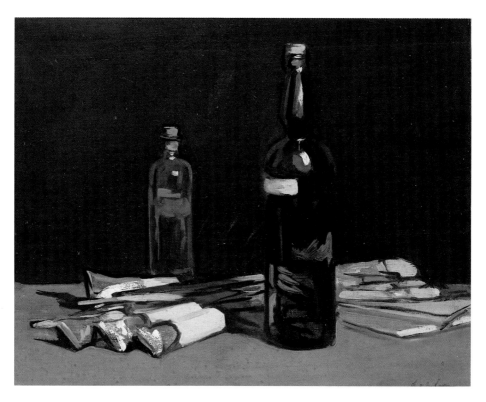

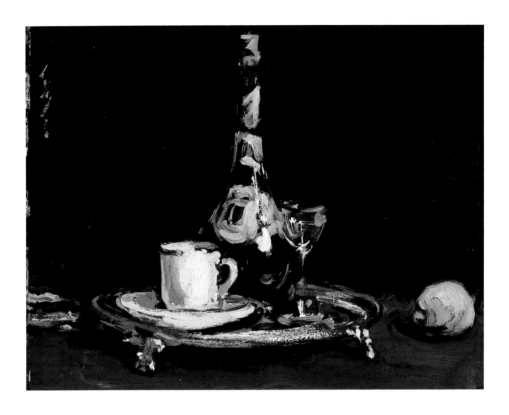

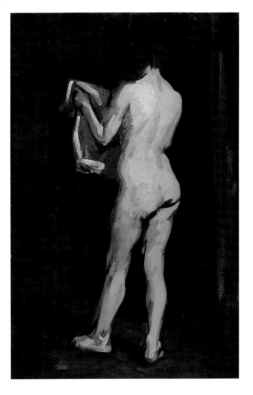

6 **Coffee and Liqueur**, c.1898
 Oil on panel
 26.7 x 34.3 cm (10.5 x 13.5 in)
 GLASGOW MUSEUMS, BURRELL
 COLLECTION

7 **Standing Nude**, c.1898
 Oil on canvas
 91.5 x 61 cm (36 x 24 in)
 PRIVATE COLLECTION

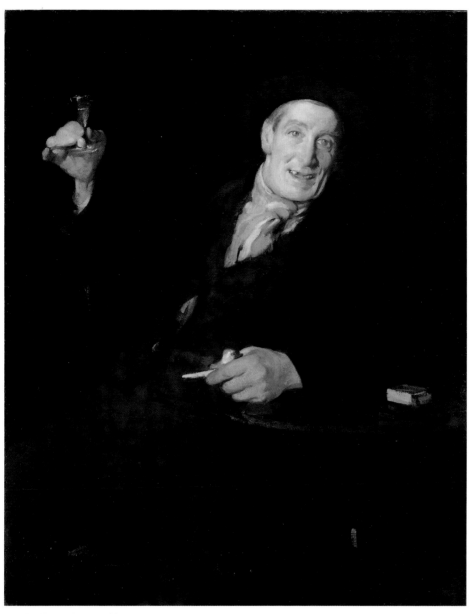

8 **Old Tom Morris**, c.1898
 Oil on canvas
 127 × 101.6 cm (50 × 40 in)
 GLASGOW MUSEUMS

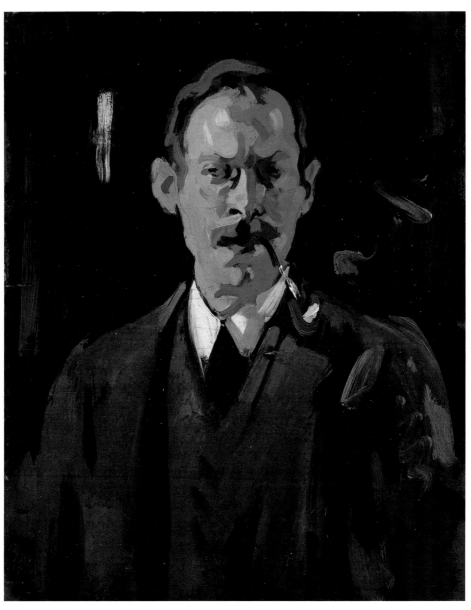

9 **Self-portrait**, c.1900
 Oil on canvas
 50.8 x 40.6 cm (20 x 16 in)
 SCOTTISH NATIONAL PORTRAIT GALLERY

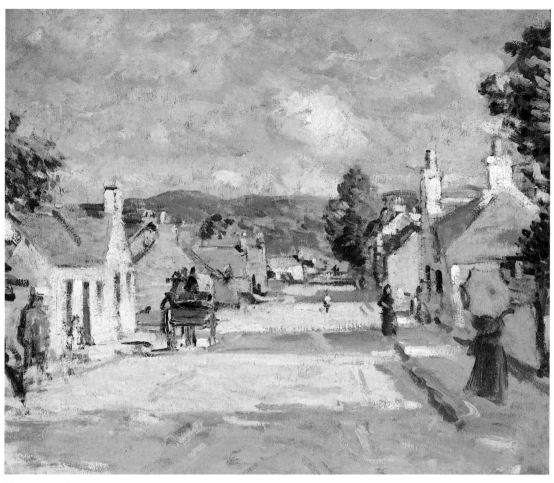

10 **A Street, Comrie**, c.1900
Oil on canvas
63.5 × 76.3 cm (25 × 30 in)
PRIVATE COLLECTION

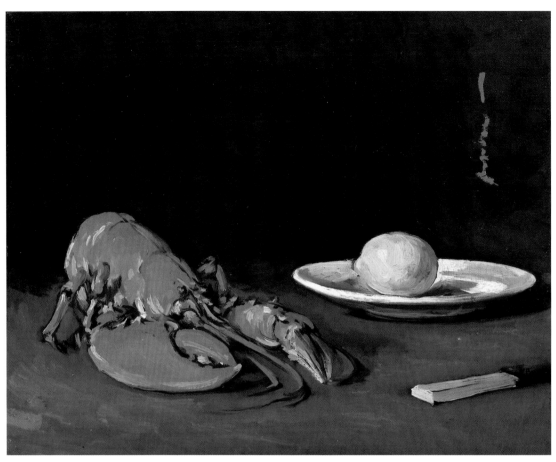

11 **The Lobster**, c.1901
 Oil on canvas
 40.7 x 50.8 cm (16 x 20 in)
 PRIVATE COLLECTION

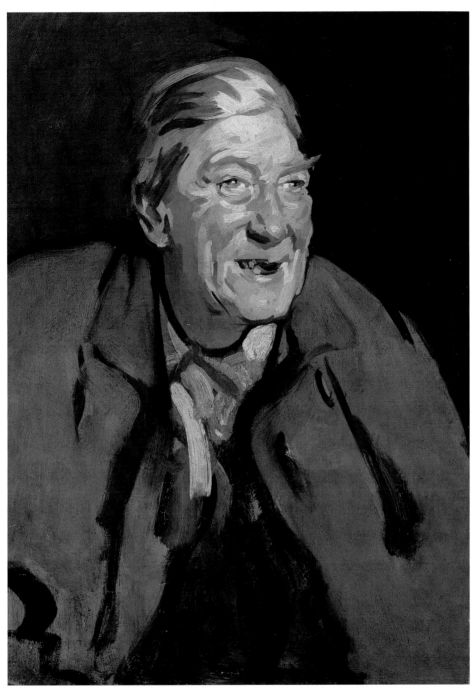

12 **Man Laughing**, c.1902
Oil on panel
71.1 × 50.8 cm (28 × 20 in)
SNGMA

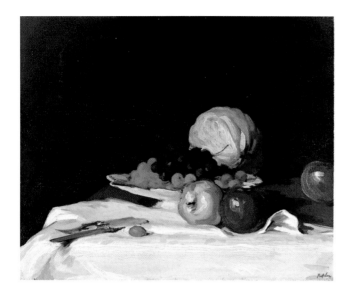

13 **Still-life, Melon, Grapes and Apples, Black
 Background**, c.1902
 Oil on canvas
 40.6 × 50.8 cm (16 × 20 in)
 PRIVATE COLLECTION

14 **Spring, Comrie**, c.1902
 Oil on canvas
 41 × 51 cm (16 × 20 in)
 FIFE COUNCIL MUSEUMS; KIRKCALDY
 MUSEUM & ART GALLERY

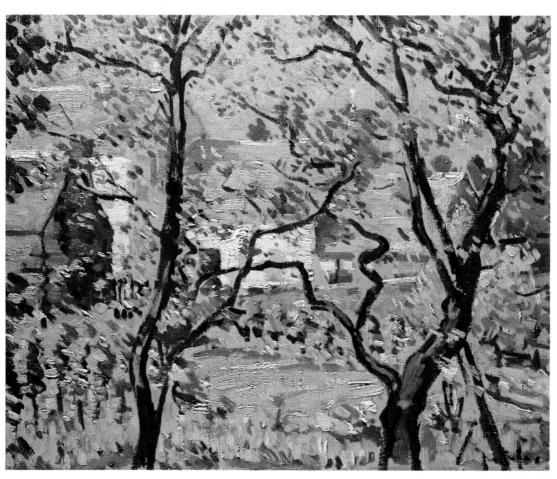

15 **Landscape, Barra**, c.1903
 Oil on panel
 19.6 x 30 cm (7.75 x 11.75 in)
 PRIVATE COLLECTION

16 **Evening, North Berwick**, c.1903
 Oil on panel
 16 x 23.8 cm (6.5 x 9.25 in)
 GLASGOW MUSEUMS

17 **Landscape, Barra**, c.1903
 Oil on panel
 27 x 35 cm (10.5 x 13.75 in)
 FIFE COUNCIL MUSEUMS; KIRKCALDY
 MUSEUM & ART GALLERY

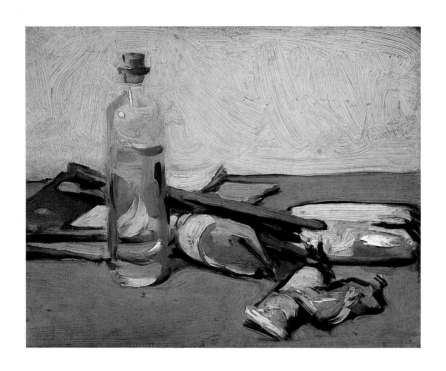

18 **Still Life, Paint Tubes**, c.1903
 Oil on panel
 18.7 x 25.4 cm (8 x 10 in)
 GLASGOW MUSEUMS

19 **Souvenir**, c.1904
 Oil on canvas
 33 x 43.2 cm (13 x 17 in)
 ABERDEEN ART GALLERY & MUSEUMS

20 **The Green Blouse**, c.1904
 Oil on panel
 50.8 × 50.2 cm (20 × 19.5 in)
 SNGMA

21 **Still-life with Flowers and Fan**, c.1904
 Oil on canvas
 40.8 × 40.8 cm (16 × 16 in)
 PRIVATE COLLECTION

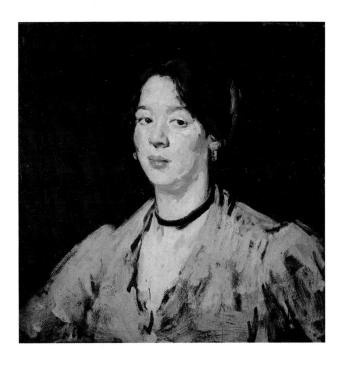

22 **Margaret**, c.1904
 Oil on panel
 25.4 × 21.7 cm (10 × 8.5 in)
 PRIVATE COLLECTION

23 **Farmyard, Northern France**, c.1904
 Oil on panel
 16 × 23.5 cm (6.25 × 9 in)
 PRIVATE COLLECTION

24 **Horse and Cart, Islay**, c.1904
 Oil on panel
 16.2 × 23.3 cm (6.25 × 9 in)
 PRIVATE COLLECTION

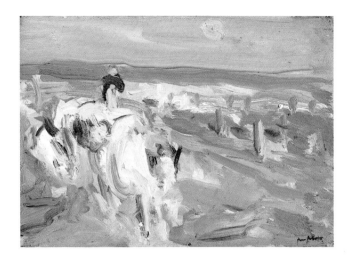

25 **Etaples**, c.1904
 Oil on panel
 19 × 24.1 cm (7.5 × 9.5 in)
 PRIVATE COLLECTION

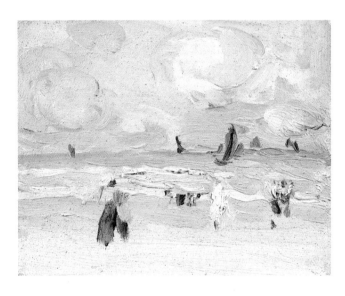

26 **Wind**, c.1905
 Oil on panel
 18.3 × 24 cm (7.2 × 9.5 in)
 FIFE COUNCIL MUSEUMS; KIRKCALDY
 MUSEUM & ART GALLERY

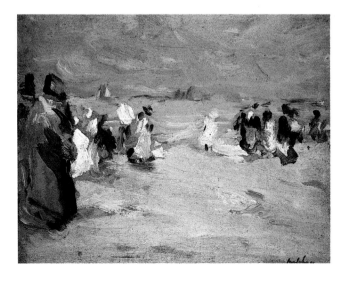

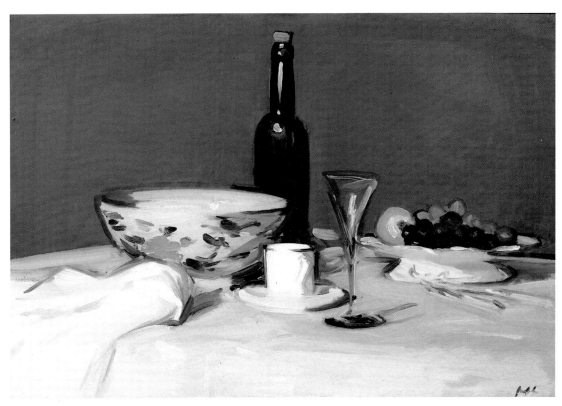

27 **The Black Bottle**, c.1905
 Oil on canvas
 50.8 × 76.2 cm (20 × 30 in)
 PRIVATE COLLECTION

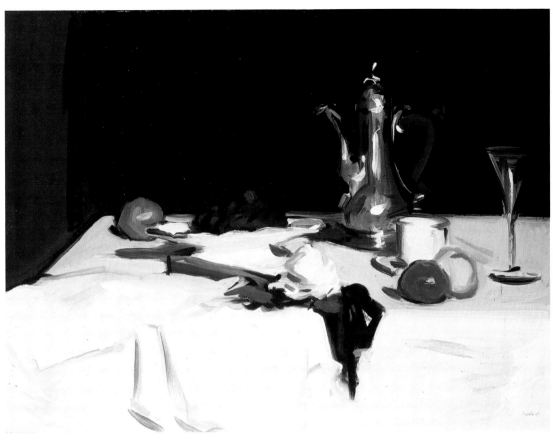

28 **Still-life with Coffee-pot**, c.1905
 Oil on canvas
 61 x 82.5 cm (24 x 32.5 in)
 PRIVATE COLLECTION

29 **Still-life**, c.1905
Oil on panel
27 x 35 cms (10.5 x 13.8 in)
PRIVATE COLLECTION

30 **Game of Tennis, Luxembourg Gardens**,
c.1906
Oil on canvas
16.1 x 23.6 cm (6.5 x 9.25 in)
SNGMA

31 **Still life with Bananas**, c.1906
Oil on panel
26.1 x 34.3 cm (10.5 x 13.5 in)
CITY OF EDINBURGH COLLECTION

32 **Pink Roses in Blue-and-White Vase, Black Background**, c.1906
Oil on canvas
40.6 × 45.7 cm (16 × 18 in)
PRIVATE COLLECTION

33 **Girl in Pink**, c.1906
Oil on canvas
46 × 40.8 cm (18 × 16 in)
PRIVATE COLLECTION

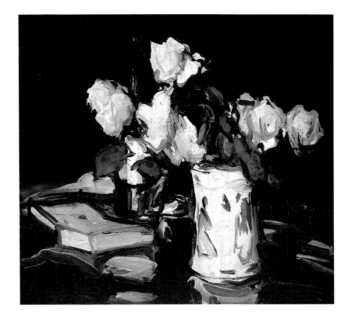

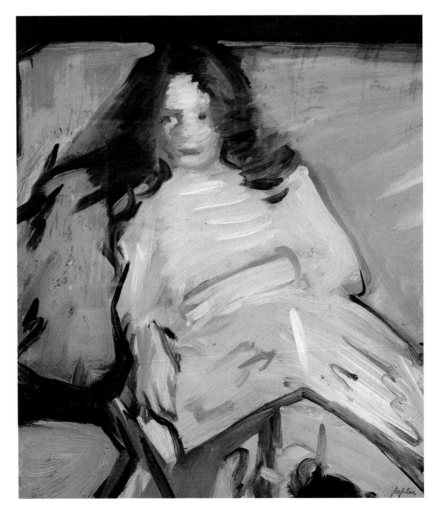

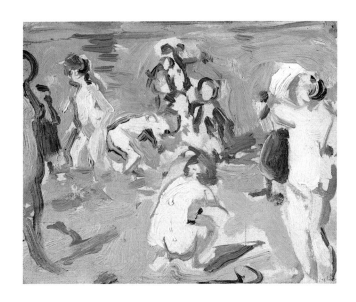

34 **Bathers, Etaples**, c.1906
 Oil on panel
 18.2 x 23 cm (7.25 x 9 in)
 UNIVERSITY OF GLASGOW, HUNTERIAN
 ART GALLERY

35 **Paris-Plage**, c.1907
 Oil on panel
 26.7 x 21.6 cm (10.5 x 8.5 in)
 PRIVATE COLLECTION

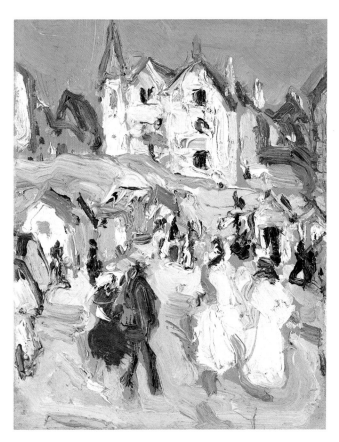

36 **Afternoon, Paris-Plage**, c.1907
 Oil on panel
 24.1 x 19.1 cm (9.5 x 7.5 in)
 PRIVATE COLLECTION

37 **Plage Scene**, c.1907
 Oil on canvas-board
 22 x 27 cm (8.5 x 10.5 in)
 FIFE COUNCIL MUSEUMS;
 KIRKCALDY MUSEUM & ART
 GALLERY

38 Portrait of Mrs Peploe, c.1907
 Oil on canvas
 61 x 50.9 cm (24 x 20 in)
 ABERDEEN ART GALLERY & MUSEUMS

39 Lady in Black, c.1907
 Oil on canvas
 61 x 40.7 cm (24 x 16 in)
 PRIVATE COLLECTION

40 **A Girl in White**, c.1908
Oil on canvas
122 × 108.6 cm (48 × 42.75 in)
PRIVATE COLLECTION

41 **Elegance**, c.1908
Oil on canvas
33.5 x 30 cm (13.25 x 11.75 in)
FIFE COUNCIL MUSEUMS; KIRKCALDY
MUSEUM & ART GALLERY

42 **Park Scene**, c.1909
Oil on panel
19 x 24 cm (7.5 x 9.5 in)
FIFE COUNCIL MUSEUMS; KIRKCALDY
MUSEUM & ART GALLERY

43 **Sunlit Street, Royan**, 1910
 Oil on board
 26.7 x 35.5 cm (10.5 x 14 in)
 PRIVATE COLLECTION

44 **Royan**, 1910
 Oil on board
 26.7 x 35.5 cm (10.5 x 14 in)
 PRIVATE COLLECTION

45 **Royan**, 1910
 Oil on board
 29 x 33 cm (10.5 x 14 in)
 LORD & LADY IRVINE OF LAIRG

46 **Boats at Royan**, 1910
 Oil on board
 26.7 x 35.5 cm (10.5 x 14 in)
 PRIVATE COLLECTION

47 **Luxembourg Gardens**, c.1910
Oil on panel
35.5 × 26.8 cm (14 × 10.5 in)
THE FLEMING WYFOLD ART
FOUNDATION

48 **Sunlit Street, Royan**, 1910
Oil on board
26.7 × 35.5 cm (10.5 × 14 in)
PRIVATE COLLECTION

49 **Jug and Yellow Fruit**, c.1910
 Oil on panel
 33.5 × 41 cm (13.25 × 16 in)
 FIFE COUNCIL MUSEUMS;
 KIRKCALDY MUSEUM & ART
 GALLERY

50 **Ile de Bréhat**, 1911
 Oil on board
 33 × 40.6 cm (13 × 16 in)
 PRIVATE COLLECTION

51 Street Scene, France, c.1911
 Oil on board
 34.3 x 26.8 cm (13.5 x 10.5 in)
 PRIVATE COLLECTION

52 The House in the Woods, c.1911
 Oil on board
 26.8 x 34.3 cm (10.5 x 13.5 in)
 PRIVATE COLLECTION

53 **Veules les Roses**, c.1911
Oil on board
35.6 x 26.7 cm (14 x 10.5 in)
SNGMA

54 **Luxembourg Gardens**, c.1911
Oil on board
33 x 26 cm (13 x 10.25 in)
FIFE COUNCIL MUSEUMS; KIRKCALDY MUSEUM & ART GALLERY

55 **Tulips**, c.1911
 Oil on canvas
 45.8 × 40.8 cm (18 × 16 in)
 PRIVATE COLLECTION

56 **Tulips in Two Vases**, c.1912
 Oil on canvas
 47 × 56 cm (18.5 × 22 in)
 PRIVATE COLLECTION

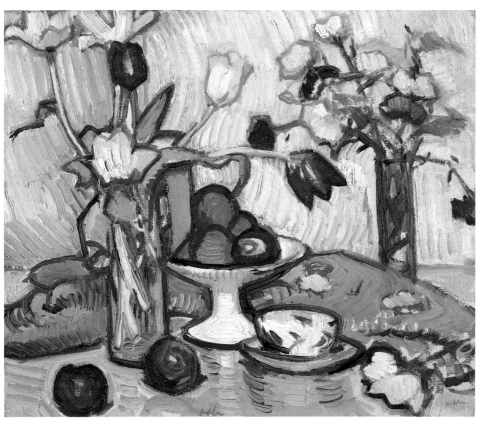

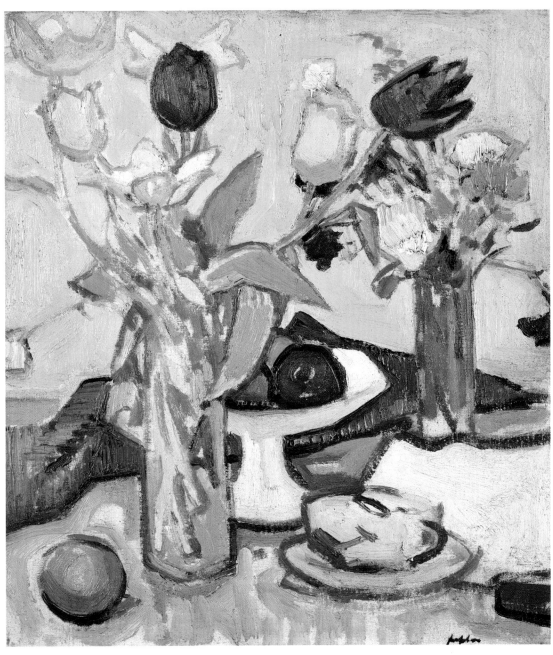

57 **Tulips and Vases**, c.1911
Oil on canvas
45.6 x 40.6 cm (17.75 x 15.75 in)
UNIVERSITY OF GLASGOW, HUNTERIAN ART GALLERY

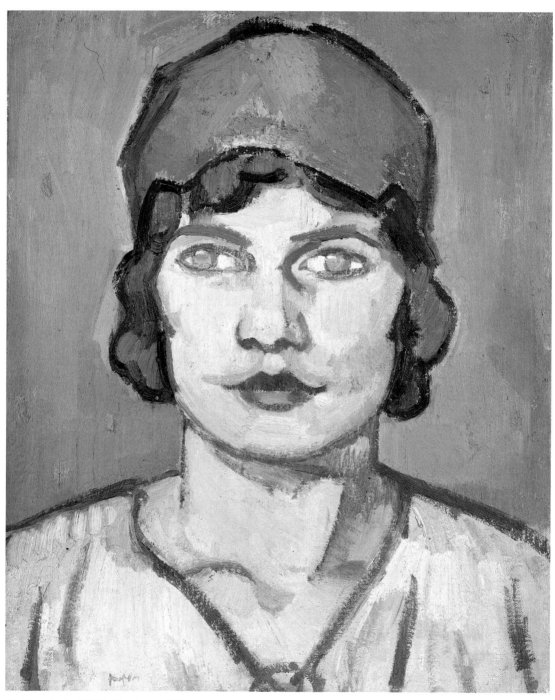

58 Portrait of a Girl, Red Bandeau, c.1912
Oil on canvas
45.7 x 38.1 cm (18 x 15 in)
PRIVATE COLLECTION

59 **Still-life**, c.1912
 Oil on canvas
 55 x 46 cm (21.75 x 18.25 in)
 SNGMA

60 **Arran**, 1913
 Oil on board
 30 x 39 cm (12.5 x 15.5 in)
 PRIVATE COLLECTION

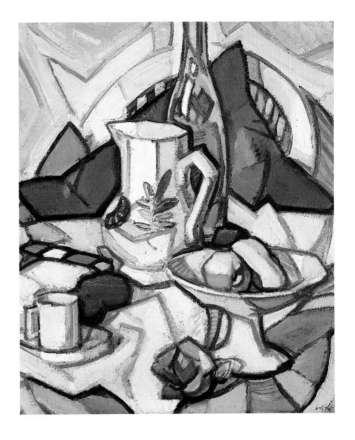

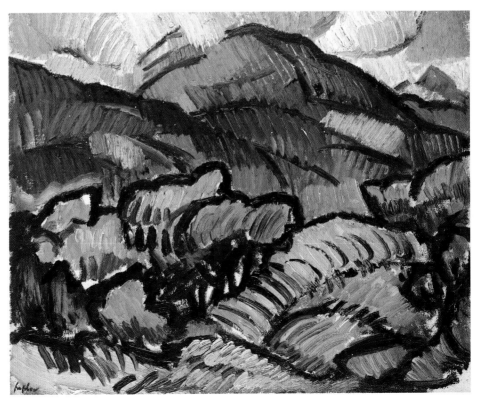

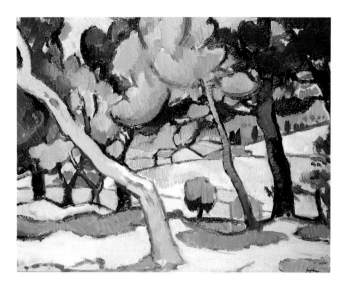

61 **Landscape, Cassis**, 1913
Oil on panel
31.8 x 45.7 cm (12.5 x 16 in)
PRIVATE COLLECTION

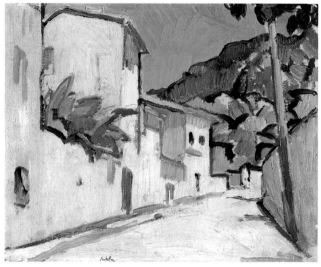

62 **Street in Cassis**, 1913
Oil on panel
32.8 x 45.8 cm (12.75 x 16 in)
PRIVATE COLLECTION

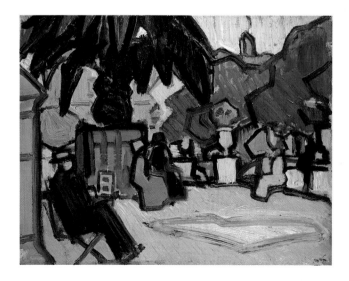

63 **Square, Cassis**, 1913
Oil on panel
33 x 46 cm (12.5 x 16 in)
PRIVATE COLLECTION

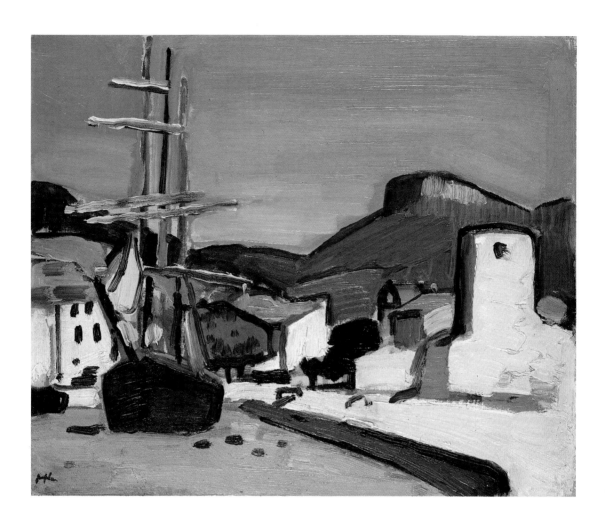

64 **Schooner, Cassis Harbour**, 1913
 Oil on panel
 32.7 x 45.6 cm (12.5 x 16 in)
 PRIVATE COLLECTION

65 **Crawford**, 1914
 Oil on panel
 32.8 x 45.6 cm (12.75 x 16 in)
 PRIVATE COLLECTION

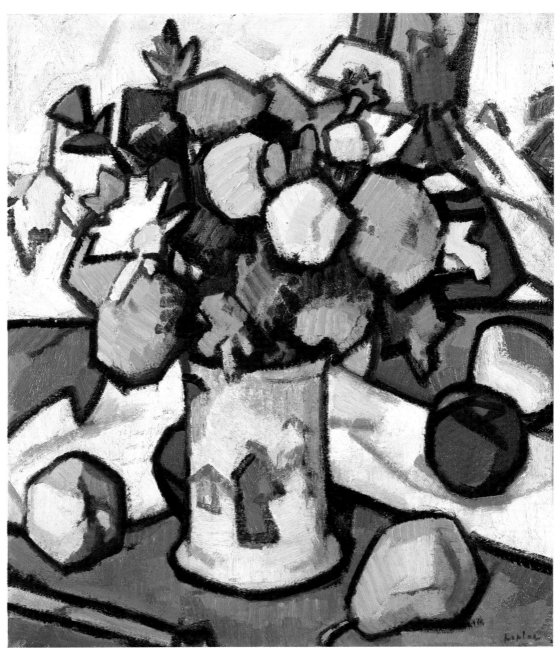

66 **Anemones**, c.1914
Oil on canvas
45.8 x 40.6 cm (18 x 16 in)
PRIVATE COLLECTION

67 **A Corner of the Studio**, c.1915
 Oil on canvas
 61 x 50.8 cm (24 x 20 in)
 PRIVATE COLLECTION

68 **Interior with Japanese Fan**, c.1915
 Oil on canvas
 80 x 62.2 cm (31.5 x 24.2 in)
 UNIVERSITY OF HULL ART COLLECTION

69 **Flowers and Fruit (Japanese Background),**
c.1915
Oil on canvas
40.5 x 45.5 cm (16 x 18 in)
FIFE COUNCIL MUSEUMS; KIRKCALDY
MUSEUM & ART GALLERY

70 **The Blue-and-White Teapot**, c.1916
Oil on canvas
48 x 57.5 cm (18.75 x 22.5 in)
FIFE COUNCIL MUSEUMS; KIRKCALDY
MUSEUM & ART GALLERY

71 **Still-life, Black Bottle**, c.1916
 Oil on canvas
 45.8 x 55.9 cm (18 x 22 in)
 PRIVATE COLLECTION

72 **Cornfield, Douglas Hall**, c.1917
 Oil on panel
 31.8 x 38.2 cm (12.5 x 15 in)
 GLASGOW MUSEUMS

73 **Laggan Farm Buildings, near Dalbeattie**,
 c.1917
 Oil on panel
 31.8 x 38.1 cm (12.5 x 15 in)
 GLASGOW MUSEUMS

74 **Dish with Apples**, c.1918
 Oil on canvas
 63.5 x 76.2 cm (25 x 30 in)
 PRIVATE COLLECTION, WITH ABERDEEN
 ART GALLERY

75 **Tulips and Fruit**, c.1919
 Oil on canvas
 58 x 50 cm (22.75 x 19.5 in)
 PRIVATE COLLECTION

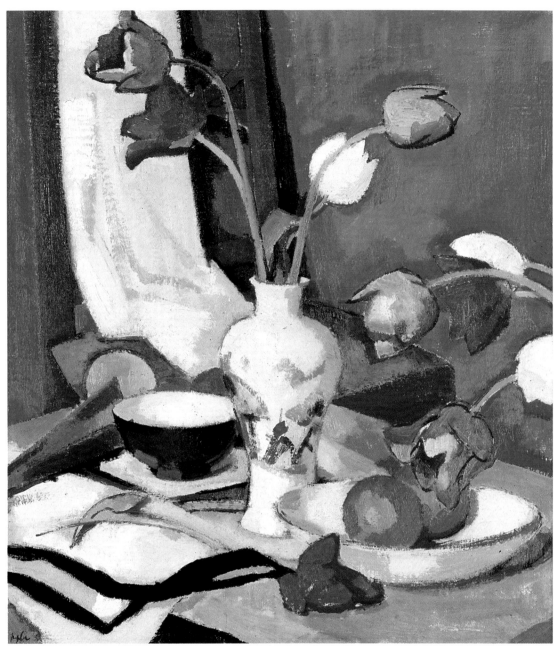

76 **Still-life with Tulips**, c.1919
Oil on canvas
56 × 51 cm (22 × 20 in)
PRIVATE COLLECTION

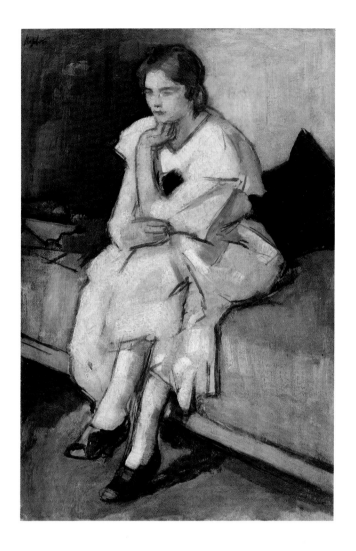

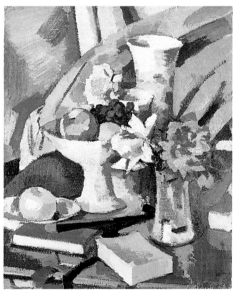

77 **Girl in a White Dress**, c.1919
Oil on canvas
61 x 40.6 cm (24 x 16 in)
GLASGOW MUSEUMS, BURRELL
COLLECTION

78 **Roses and Still-life**, c.1920
Oil on canvas
73.7 x 50.9 cm (24 x 20 in)
PRIVATE COLLECTION

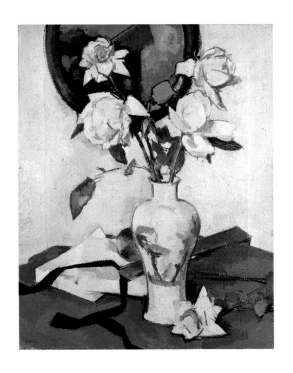

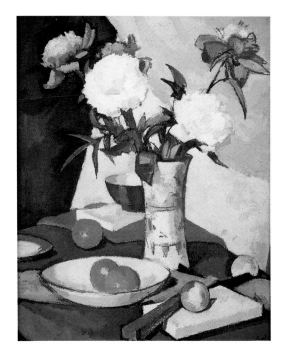

79 **Pink Roses in a Japanese Vase**, c.1920
Oil on canvas
50.9 x 40.7 cm (20 x 16 in)
PRIVATE COLLECTION

80 **Peonie Roses**, c.1920
Oil on canvas
55.9 x 45.7 cm (22 x 18 in)
PRIVATE COLLECTION

81 **Roses and Fruit**, c.1921
Oil on canvas
55.9 x 50.9 cm (22 x 20 in)
PRIVATE COLLECTION

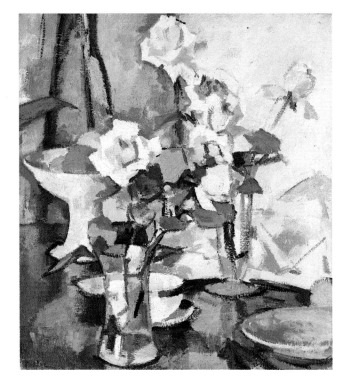

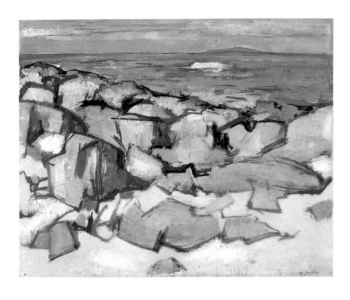

82 **Iona, North End**, c.1920
 Oil on panel
 32.4 x 41.3 cm (12.75 x 16.25 in)
 PRIVATE COLLECTION

83 **Boy Reading**, c.1921
 Oil on canvas
 76.2 x 63.5 cm (30 x 25 in)
 RSA, DIPLOMA COLLECTION

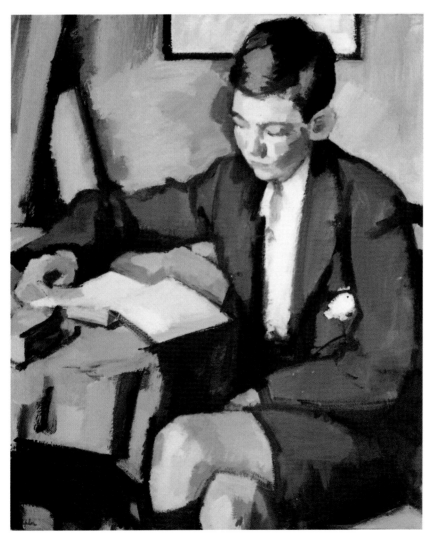

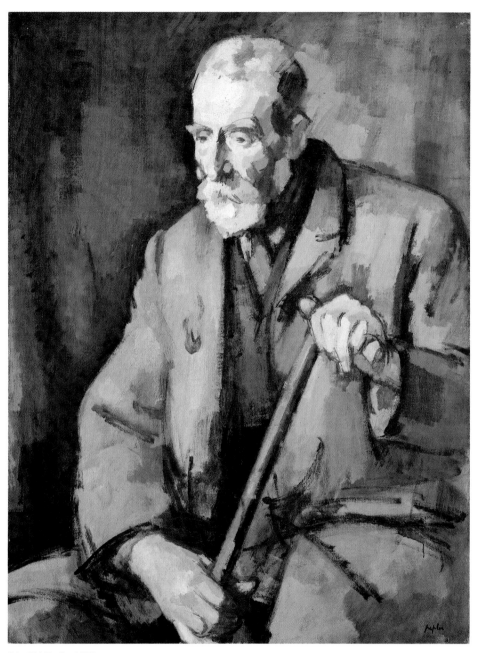

84　**Old Duff**, c.1922
Oil on canvas
101.6 x 76.2 cm (40 x 30 in)
GLASGOW MUSEUMS

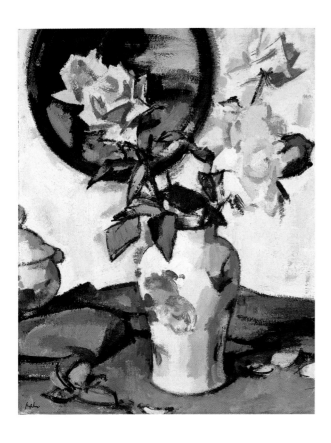

85 **Still-life with Mixed Roses**, c.1922
 Oil on canvas
 50.9 x 40.6 cm (20 x 16 in)
 PRIVATE COLLECTION

86 **Roses**, c.1922
 Oil on canvas
 61 x 50.8 cm (24 x 20 in)
 PRIVATE COLLECTION

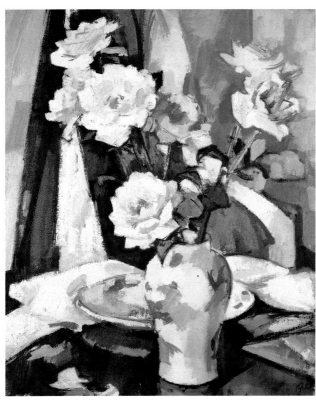

87 **Still-life with Roses**, c.1923
Oil on canvas
50.9 x 40.6 cm (20 x 16 in)
ABERDEEN ART GALLERY & MUSEUMS

88 **Still-life**, c.1923
Oil on canvas
55.9 x 45.8 cm (22 x 18 in)
PRIVATE COLLECTION

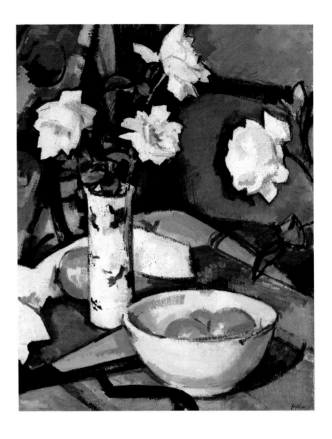

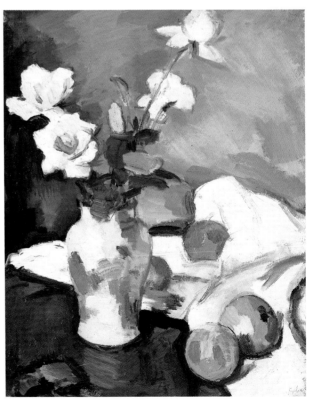

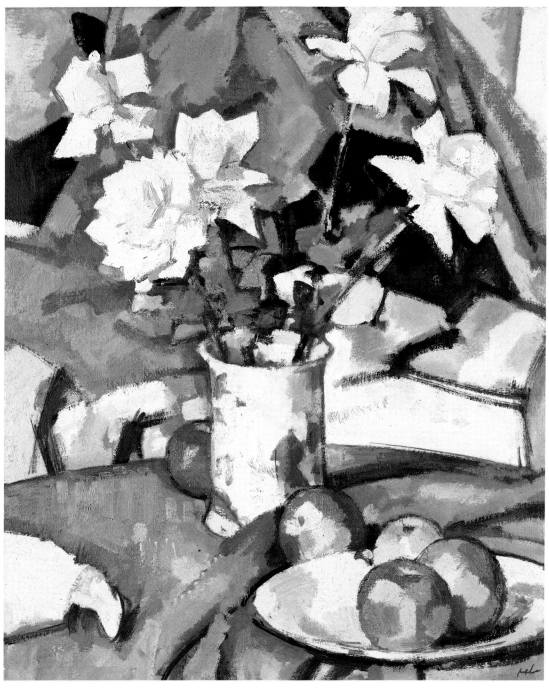

89 **Roses**, c.1924
Oil on canvas
61 x 50.8 cm (24 x 20 in)
PRIVATE COLLECTION

138

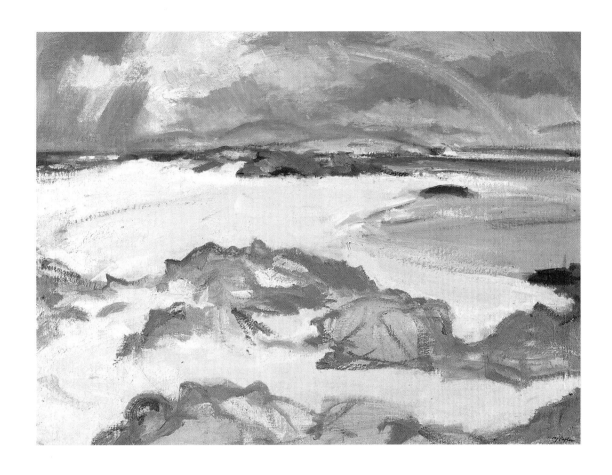

90 **The Rainbow**, c.1924
 Oil on canvas
 50.8 x 71.1 cm (20 x 28 in)
 PRIVATE COLLECTION

91 **Iona, Mull and Ben More in the Distance**,
 c.1924
 Oil on canvas
 50.8 x 61 cm (20 x 24 in)
 PRIVATE COLLECTION

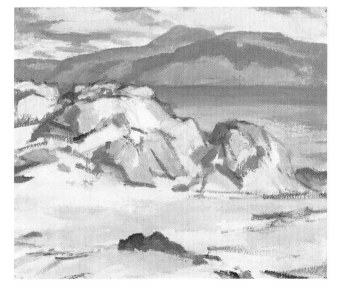

92 **Landscape at Cassis**, c.1924
Oil on canvas
55.4 x 45.7 cm (21.75 x 18 in)
SNGMA

93 **The Aloe Tree**, c.1924
Oil on canvas
61 x 50.8 cm (24 x 20 in)
MANCHESTER CITY ART GALLERIES

94 **Landscape, Cassis**, c.1924
Oil on canvas
63.5 × 53.5 cm (25 × 21 in)
ABERDEEN ART GALLERY & MUSEUMS

95 **Tulips**, c.1924
Oil on canvas
61 × 50.8 cm (24 × 20 in)
PRIVATE COLLECTION

96 **Michaelmas Daisies and Oranges**, c.1925
Oil on canvas
61 x 50.8 cm (24 x 20 in)
PRIVATE COLLECTION

97 **Lilies**, c.1925
Oil on canvas
51 x 41 cm (20 x 16 in)
FIFE COUNCIL MUSEUMS; KIRKCALDY
MUSEUM & ART GALLERY

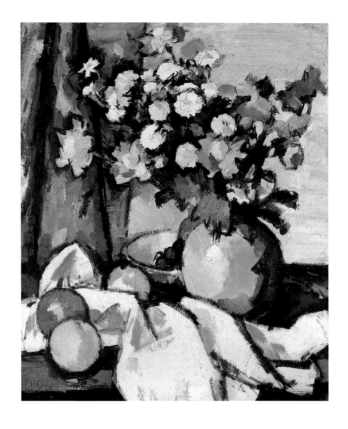

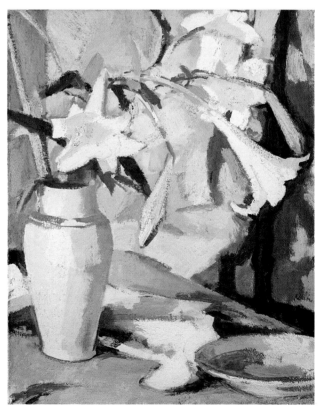

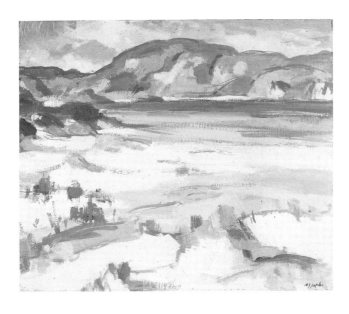

98 **Morar**, c.1925
Oil on panel
38.1 × 45.6 cm (15 × 17.75 in)
PRIVATE COLLECTION

99 **The Brown Crock**, c.1925
Oil on canvas
61 × 50.8 cm (24 × 20 in)
GLASGOW MUSEUMS

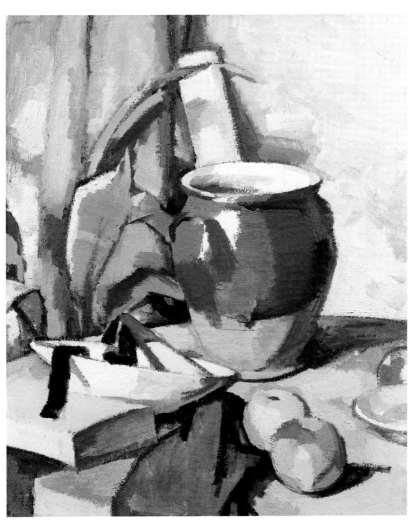

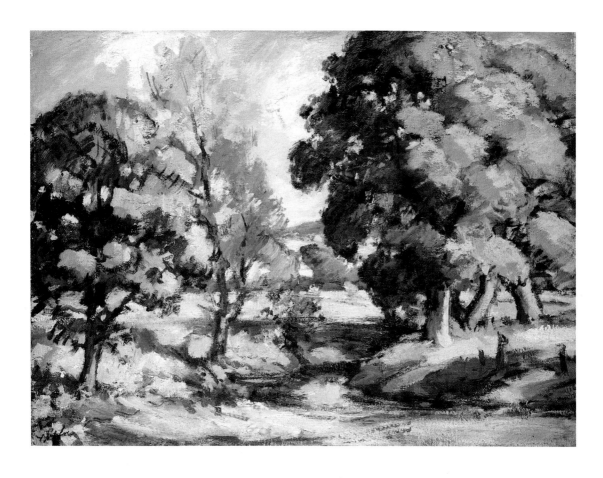

100 **New Abbey, Dumfriesshire (Summer)**,
 c.1926
 Oil on canvas
 56.4 x 78.5 cm (22 x 30 in)
 UNIVERSITY OF GLASGOW, HUNTERIAN
 ART GALLERY

101 **Summer, New Abbey**, c.1926
 Oil on canvas
 50.8 x 61 cm (20 x 24 in)
 PRIVATE COLLECTION

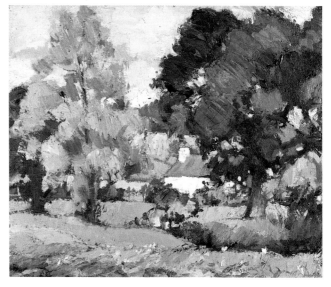

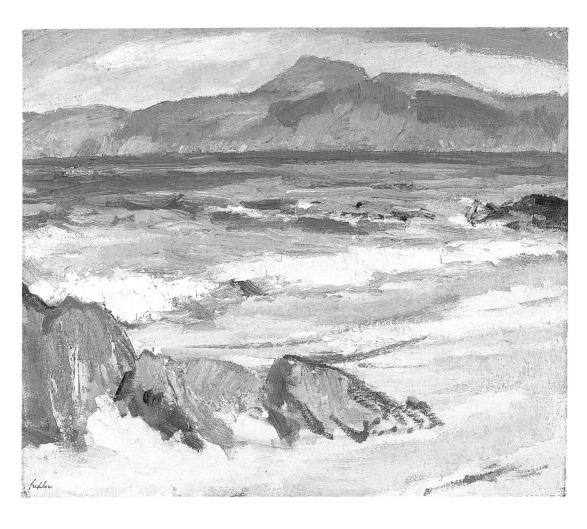

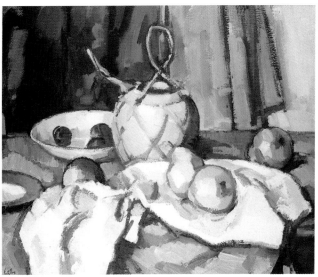

102 **North Wind, Sound of Iona,** c.1926
 Oil on canvas
 50.8 x 61 cm (20 x 24 in)
 PRIVATE COLLECTION

103 **The Ginger Jar,** c.1926
 Oil on canvas
 45.8 x 55.9 cm (18 x 22 in)
 PRIVATE COLLECTION

104 **Aspidistra**, c.1927
Oil on canvas
61 x 50.8 cm (24 x 20 in)
ABERDEEN ART GALLERY & MUSEUMS

105 **The Abbey, Iona**, c.1927
Oil on canvas
40.6 × 50.8 cm (16 × 20 in)
PRIVATE COLLECTION

106 **Iona, Cloudy Sky**, c.1927
Oil on canvas
45.8 × 56 cm (18 × 22 in)
PRIVATE COLLECTION

107 **Trees, Antibes**, 1928
 Oil on canvas
 63.5 × 76.2 cm (25 × 30 in)
 PRIVATE COLLECTION

108 **Palm Trees, Antibes**, 1928
 Oil on canvas
 61.5 x 51 cm (24 x 20 in)
 FIFE COUNCIL MUSEUMS; KIRKCALDY
 MUSEUM & ART GALLERY

109 **The Pink House, Cassis**, c.1928
 Oil on canvas
 61 × 50.8 cm (24 × 20 in)
 PRIVATE COLLECTION

110 **Blue Water, Antibes**, 1928
 Oil on canvas
 63.5 × 63.5 cm (25 × 25 in)
 PRIVATE COLLECTION

111 **Sweetheart Abbey**, c.1928
 Oil on canvas
 51 × 61 cm (20 × 24 in)
 FIFE COUNCIL MUSEUMS; KIRKCALDY
 MUSEUM & ART GALLERY

112 **La Forêt**, c.1929
 Oil on canvas
 63.5 × 76 cm (25 × 29.75 in)
 FRENCH STATE COLLECTION

113 **Boat of Garten**, c.1929
 Oil on canvas
 58.4 × 76.3 cm (23 × 30 in)
 PRIVATE COLLECTION

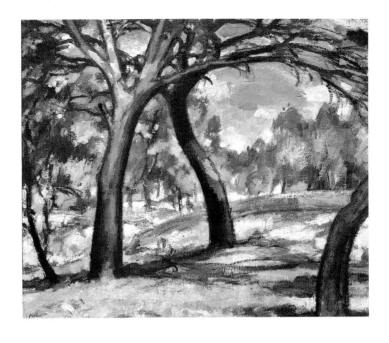

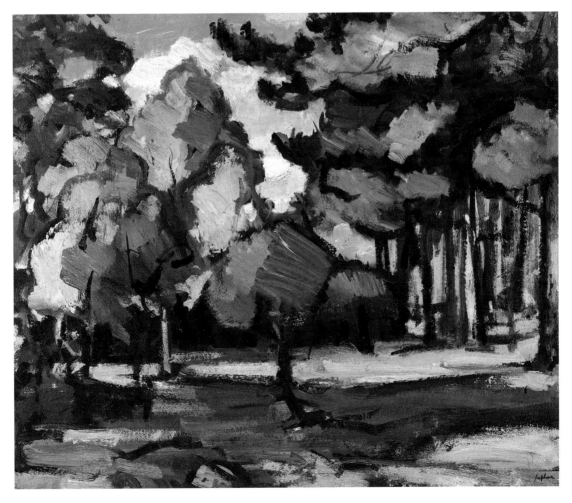

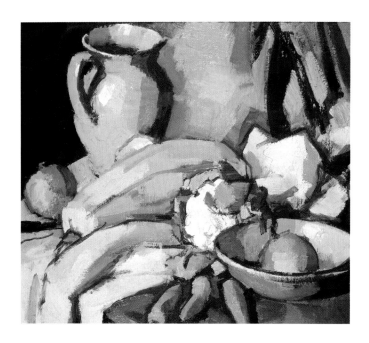

114 **Still-life with Yellow Jug and Vegetables,**
c.1929
Oil on canvas
50.8 x 53.4 cm (20 x 22 in)
PRIVATE COLLECTION

115 **Stormy Weather, Iona,** c.1929
Oil on canvas
50.8 x 61 cm (20 x 24 in)
ABERDEEN ART GALLERY & MUSEUMS

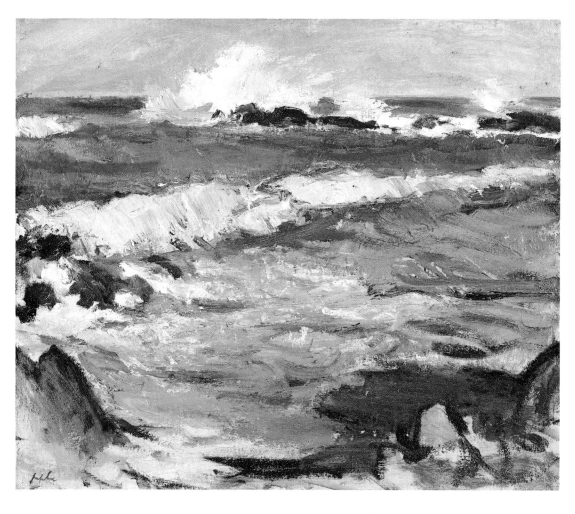

116 **Nude in Interior, with Guitar**, c.1929
 Oil on canvas
 101.6 × 76.2 cm (40 × 30 in)
 PRIVATE COLLECTION

117 **Willy Peploe**, c.1930
 Oil on canvas
 92 × 71.1 cm (36 × 28 in)
 PRIVATE COLLECTION

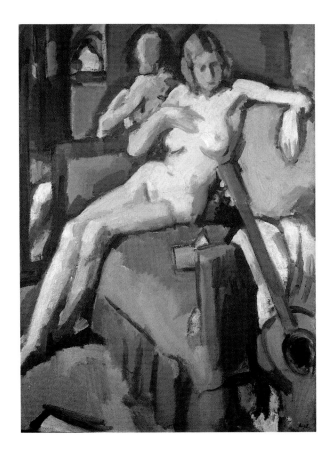

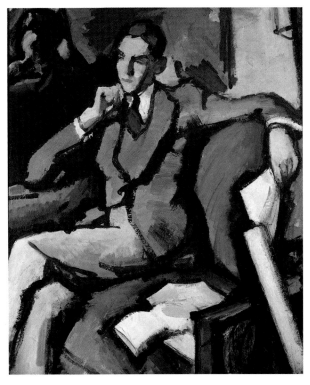

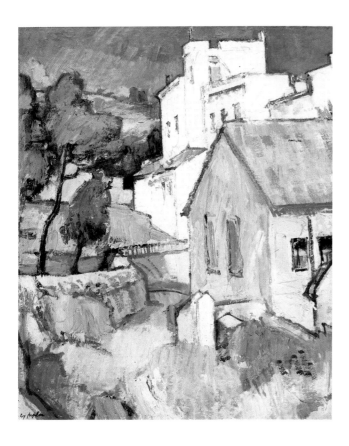

118 **Cassis**, c.1930
Oil on canvas
61 x 50.8 cm (24 x 20 in)
PRIVATE COLLECTION

119 **Birds-eye View, Cassis**, c.1930
Oil on canvas
50.8 x 61 cm (20 x 24 in)
PRIVATE COLLECTION

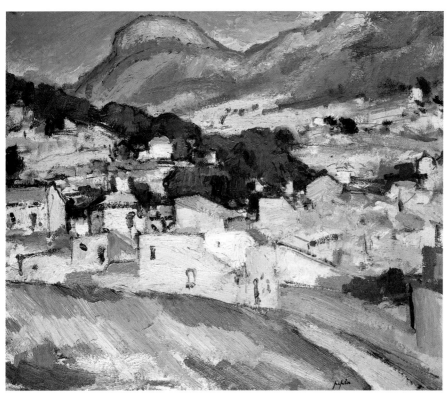

120 **Still-life with Chops**, c.1930
 Oil on canvas
 45.3 x 40.5 cm (18 x 16 in)
 ABERDEEN ART GALLERY & MUSEUMS

121 **Still-life with Plaster Cast**, c.1931
 Oil on canvas
 58.4 x 54.6 cm (23 x 21.5 in)
 SNGMA

122 **Iona**, c.1930
Oil on canvas
50 x 71 cm (20 x 28 in)
FIFE COUNCIL MUSEUMS; KIRKCALDY
MUSEUM & ART GALLERY

123 **Still-life (Fruit)**, c.1930
Oil on canvas
51 x 62 cm (20 x 24 in)
FIFE COUNCIL MUSEUMS; KIRKCALDY
MUSEUM & ART GALLERY

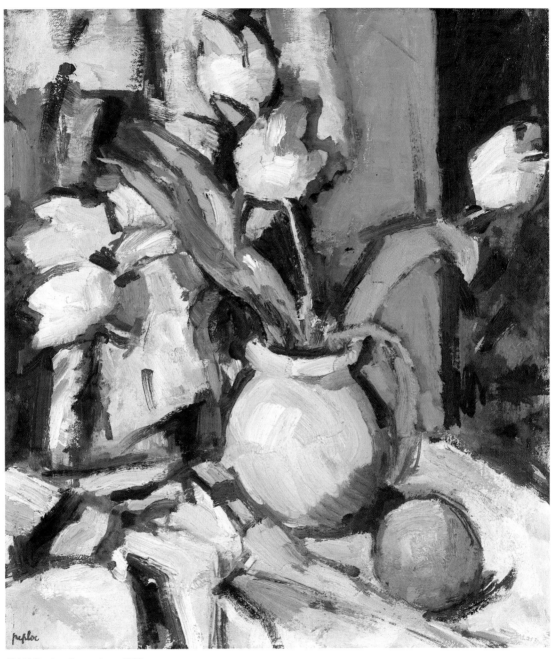

124 **Tulips in a Brown Jar**, c.1933
 Oil on canvas
 45.7 x 40.6 cm (18 x 16 in)
 ABERDEEN ART GALLERY & MUSEUMS

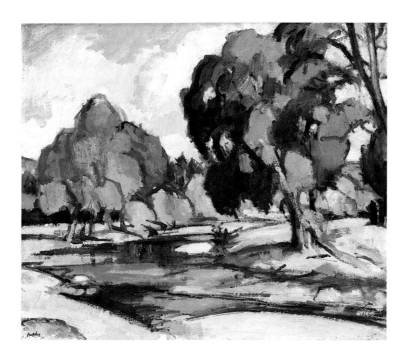

125 **River**, c.1933
Oil on canvas
53 x 63.2 cm (20.75 x 34.75 in)
ABERDEEN ART GALLERY &
MUSEUMS

126 **Rothiemurchus**, 1934
Oil on canvas
40.6 x 45.7 cm (16 x 18 in)
PRIVATE COLLECTION

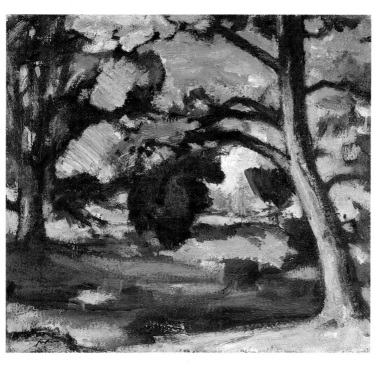

IMPORTANT EXHIBITIONS
Unless otherwise stated, all exhibitions are one-man shows

1903 3 November to 1 December
Aitken Dott & Son, The Scottish Gallery,
Edinburgh

1909 March
Aitken Dott & Son, The Scottish Gallery,
Edinburgh

1912 February, 'Small Paintings'
Stafford Gallery, London
June, 'Drawings'
Stafford Gallery, London
October, Paintings by S.J. Peploe and
eight other artists, including J.D.
Fergusson
Stafford Gallery, London

1913 2 to 24 May
New Gallery, Edinburgh

1914 April
Baillie Gallery, London

1915 November
Alex Reid, Glasgow

1919 November–December
Alex Reid, Glasgow

1921 February
Alex Reid, Glasgow

1921 December
Alex Reid, Glasgow

1922 February–March
Aitken Dott & Son, The Scottish Gallery,
Edinburgh

1923 January, 'Exhibition of Paintings by S.J. Peploe,
F.C.B. Cadell and Leslie Hunter'
Leicester Galleries, London
December
Aitken Dott & Son, The Scottish Gallery,
Edinburgh

1924 February-March
Aitken Dott & Son, The Scottish Gallery,
Edinburgh
March
Alex Reid, Glasgow
2 to 15 June, 'Les Peintres de l'écosse moderne',
F.C.B. Cadell, J.D. Fergusson, Leslie Hunter, S.J.
Peploe

1925 January, Exhibition of Paintings by S.J. Peploe,
Leslie Hunter, F.C.B. Cadell, J.D. Fergusson
The Leicester Galleries, London

1926 April-May
Alex Reid & Lefevre, London
December
Alex Reid & Lefevre, Glasgow

1927 December
Aitken Dott & Son, The Scottish Gallery,
Edinburgh

1928 23 January to 3 February
C.W. Kraushaar Galleries, New York
July to August, Second Inaugural Loan
Exhibition
Kirkcaldy Museum and Art Gallery

1929 May
Alex Reid & Lefevre, Glasgow
December-January, 1930
Alex Reid & Lefevre, London

1930 March
Aitken Dott & Son, The Scottish Gallery,
Edinburgh

1931 1 to 14 March, 'Les Peintres écossais', S.J.
Peploe, J.D. Fergusson, Leslie Hunter, F.C.B.
Cadell, Telfer Bear, R.O. Dunlop
April
Alex Reid & Lefevre, Glasgow

1932 April–May, Paintings by Six Scottish Artists,
Peploe, Hunter, Fergusson, Cadell, Bear, Gillies
Barbizon House, London

1933 12 January to 1 February, Society of Eight
Twenty-First Exhibition
New Gallery, Edinburgh

1934 February–March
Alex Reid & Lefevre, London
February
Aitken Dott & Son, The Scottish Gallery,
Edinburgh
April–May
Pearson & Westergaard, Glasgow

1936 April–May, Memorial Exhibition
Aitken Dott & Son, The Scottish Gallery,
Edinburgh

1937 February, Memorial Exhibition
Arranged by Alex Reid & Lefevre, London in
conjunction with Pearson &
Westergaard, Glasgow
McLellan Galleries, Glasgow

1938 April–October, Fine Art Section of the Empire
Exhibition
Palais of Arts

1939 January–March, Three Scottish Painters, S.J.
Peploe, Leslie Hunter, F.C.B. Cadell
Alex Reid & Lefevre, London
January–March, Exhibition of Scottish Art
Royal Academy of Arts, London

1941 March
National Gallery of Scotland, Edinburgh

1947 21 April to 7 May
Ian MacNicol Galleries, Glasgow
18 August to 13 September
Aitken Dott & Son, The Scottish Gallery,
Edinburgh

1948 May
Alex Reid & Lefevre, London
November, Paintings by four Scottish
Colourists
T.&R. Annan & Sons, Glasgow

1949 August–September, S.J. Peploe RSA, F.C.B.
Cadell RSA and Leslie Hunter Festival
Exhibition
Royal Scottish Academy, Edinburgh

1950 September, Exhibition of Paintings by Cadell,
Hunter and Peploe
Ian MacNicol Galleries, Glasgow

1951 2–27 March, Pictures from a Private Collection
Thistle Foundation at McLellan Galleries, Hon.
Organisers T.&R. Annan & Sons, Glasgow

1952 August-September, Festival Exhibition
Aitken Dott & Son, The Scottish Gallery,
Edinburgh
16 April to 7 September, Four Scottish
Colourists: Peploe, Cadell, Hunter, Fergusson
Saltire Society, Gladstone's Land, Edinburgh

1953 from April
Arts Council of Great Britain, Scottish
Committee, Touring Exhibition

1961 5 October to 30 November, Scottish Painting
Glasgow Museums and Art Gallery

1970 from May, Three Scottish Colourists, Cadell:
Hunter: Peploe
Scottish Arts Council, Touring Exhibition

1977 19 February to 19 March, Three Scottish
Colourists
The Fine Art Society
29 March to 22 April
The Fine Art Society, London

1980 March–June, The Scottish Colourists
Guildford House Gallery. The Show toured to
the City Museum and Art Gallery, Stoke-on-
Trent and the Ferens Art Gallery, Hull

1985 June–September
Scottish National Galley of Modern Art (the
first exhibition in the new John Watson's
building)

1988 November–December, Two Scottish
Colourists, S.J. Peploe and F.C.B. Cadell
Alex Reid & Lefevre, London

1989 October–November, The Scottish Colourists
Ewan Mundy & Celia Philo, Glasgow and
London

1990 April, S.J. Peploe, Drawings
The Scottish Gallery, London
7 September to 2 October, Paintings
The Scottish Gallery, Edinburgh

1993 May
Duncan R. Miller Fine Art, London

2000 May–January 2001 The Scottish Colourists
Royal Academy, Sackler Galleries, London, and
(from November) Scottish National Gallery of
Modern Art, Edinburgh

NOTES

1. George Henry (1858–1943)
2. Stanley Cursiter, *Peploe* (Thomas Nelson, 1947), p.9
3. Dr Frederick Porter, 'The Art of S.J. Peploe', *The New Alliance* (Vol. VI, No. 6, 1945)
4. The total receipts from the show was £229 and 20 shillings (including £6 for catalogues sold), the equivalent today of roughly £12,000
5. Sir James Caw, 'Studio Talk – Edinburgh', *The Studio* (Vol. XXX, 1904), pp.161, 346
6. In two other known examples including *Coffee and Liqueur* in the Burrell Collection, he signs with each letter below the other, making a rather exotic hieroglyph
7. Society of Scottish Artists, founded in 1894
8. J.D. Fergusson, 'Memories of Peploe', *The Scottish Art Review* (Vol. VIII, No. 3, 1962) (The article was written in 1945 and edited by Andrew McLaren Young)
9. Charles Hodge Mackie (1862–1920) was a landscape painter who had met Gauguin and was strongly influenced by the Nabis
10. Stanley Cursiter, *Peploe*, ibid, p.18
11. *Pall Mall Gazette*, 18 February 1907
12. He always referred diffidently to his paintings as sketches
13. Peploe accepted £450 for sixty pictures and before the end of April The Scottish Gallery had sold thirty-six pictures, including drawings, for £530
14. James Lawton Wingate (1846–1924)
15. The Scottish Modern Art Association was formed in 1903 to collect as the nucleus of a modern, National Scottish Collection; its holding was eventually gifted to the City of Edinburgh
16. Edward Arthur Walton (1860–1922) was another senior Scottish painter and 'Glasgow Boy'
17. George Proudfoot became a partner in Aitken Dott & Son, The Scottish Gallery in 1908 becoming senior partner with the retirement of McOmish Dott in about 1914. He had a significant collection of Peploes, including *The Silver Coffee-Pot* which was eventually sold by his widow in 1986 for £76,000
18. He had been proposed as an Associate of the Royal Scottish Academy
19. She did buy one, for £2
20. McNeill Reid eventually bought one of Van Gogh's portraits of his father from Theo's son. It had previously been wrongly described as a self-portrait
21. An expensive Edinburgh restaurant
22. Margaret, for a very short time, tried her hand at oil painting
23. Broadway is in the Cotswolds. Here he completed at least one panel
24. Unfortunately it was completely destroyed by allied bombardment before D-Day and none of its original splendour was recreated in its post-war reconstruction
25. By the time of the birth of the second son Denis in 1914 the baby subject had lost its appeal so that all the baby images are the elder brother
26. *Rhythm*, whose title the editor, John Middleton Murray, took from Fergusson's painting which was exhibited in the Salon d'automne in the spring of 1911, appeared irregularly from that summer of 1911 to March 1913. It was a rallying point for many young, avant-garde writers including Walter de la Mare, Catherine Mansfield, D.H. Lawrence and Rupert Brooke. Fergusson is credited as art editor until November 1912. The publication was in black and white, and the graphic, brush-drawings which Peploe contributed accord with the angular structure in his painting. In all, Peploe had thirteen works illustrated. Other contributors of drawings included Picasso (his made between 1900 and 1907), Gaudier Brzeska and Derain
27. J.D. Fergusson, 'Memories of Peploe', ibid
28. William Watson Peploe, his older brother, was living in the family house at 57 Braid Road. A bank manager by profession, he was also a poet and artist of some note. The Scottish National Gallery of Modern Art have two of his light-hearted 'futurist' drawings. A monograph by Colin Scott-Sutherland was published recently
29. His brother-in-law seems to have looked after much of the family affairs
30. Peggy Macrae, Peploe's model, eventually married and emigrated to California; she had a brief correspondence with Stanley Cursiter in 1954, complementing his book on Peploe
31. A.E. Harley had been a student with Peploe in Paris; by now he was a businessman in printing and publishing
32. Jessie M. King and her husband E.A. Taylor were artists and friends in Paris. They settled in Kirkcudbright after the outbreak of the First World War
33. Annie was the daughter of Jeannie Blyth and had also modelled for Peploe
34. John Ressich was an influential private dealer who did much to promote the new French work for a short time after Peploe's return
35. Mabel Royds (1874–1941) was a distinguished artist and illustrator who was married to the etcher E.S. Lumsden
36. There are works in the Burrell Collection

37. Letter from E.A. Taylor to T.J. Honeyman, 13 December 1939
38. Elizabeth Cumming, introduction to *Colour Rhythm Dance* (Scottish Arts Council, 1985), pp.7–8
39. The India Street property was not bought until August 1924. It cost £700 which the family could afford after a succession of successful exhibitions over the previous eighteen months. It was sold after Margaret's death in 1959 for £1,700
40. The Royal Glasgow Institute, established in 1861
41. Jessica Dismorr (1885–1939) had been a student of Fergusson's at the small art school, La Palette, and was one of the group which collaborated closely on *Rhythm*
42. The 'post-impressionist' exhibitions organised by Roger Fry at the Grafton Gallery in 1910 and 1912 were influential and controversial events
43. The Society of Eight was an exhibiting body with a fixed membership of eight painters, founded in 1912 and disbanded in 1938
44. J.D. Fergusson, 'Memories of Peploe', ibid
45. Mary Ann Caws, *Bloomsbury in Cassis* (unpublished)
46. *The Studio* (Vol. LXI, 1914), p.232
47. Alexander Reid to J.W. Blyth, 8 November 1915, quoted in Frances Fowle's Phd thesis, 'Alexander Reid in Context; Collecting and Dealing in Scotland in the Late Nineteenth and Early Twentieth Century' (Edinburgh University, 1994)
48. This work is most probably *Still-life, Pink Roses* now in Glasgow Museums; it was painted after the artist's return from France but in his early style – to see if he could still do it
49. The consignment terms were: £2 to be returned to Peploe and £2 ten shillings required from Colnaghi
50. William York MacGregor (1855–1923)
51. A visual-arts periodical published in London between 1914 and 1928
52. Malcolm Gavin (1874–1956)
53. Henry Lintott (1877–1965)
54. George Leslie Hunter (1879–1931)
55. Paul Nash (1889–1946)
56. Sir John Lavery (1856–1941)
57. Paterson, a good painter but whose later work was of little merit, once invited Sam and Margaret Peploe to his studio in the Dean Village in the hope of receiving some criticism. More and more work was pulled out but Peploe, considerably embarrassed, could not think of anything to say
58. Stanley Cursiter, *Peploe*, ibid, p.48
59. The letter is quoted in full by T.J. Honeyman, *Three Scottish Colourists* (Nelson, 1950), p.65
60. Peploe visited MacGregor at his studio and accepted a picture as a gift which was the only painting by another artist hanging in his studio for many years
61. Peploe's election to the Academy may have represented significant recognition from his peers but as a sales outlet it had never been relevant: between his return from France in 1912 and his death in 1935 he sold only three works from the Summer Exhibition; and of these, two were bought by The Scottish Gallery in 1919
62. This letter, dated 31 January 1935, was to Florence Drummond, who had been a great friend of his brother's. Willie Peploe had died in 1933
63. Peploe showed with Reid in February and December 1921
64. Ion Harrison, 'As I Remember Them', in T.J. Honeyman, *Three Scottish Colourists*, ibid, p.119
65. The town of Kirkcaldy, opposite Edinburgh on the other side of the Forth estuary, produced great wealth through its linoleum industry
66. His first was in 1915 but many were acquired during the Second World War when prices were very depressed
67. It was Gertie's father, John Nairn, who paid for the Kirkcaldy Museum and Art Gallery to be built in remembrance of his son who was killed in the Great War
68. Cowan bought two paintings from The Scottish Gallery in 1903, four in 1909 and two still-lives in 1923
69. In 1924 Burrell bought *Roses*, painted around 1906, from Reid & Lefevre; it had been sent to the Japan British Exhibition in 1910 before Peploe moved to France and for this reason escaped being sold to The Scottish Gallery with other earlier work in 1911
70. It is not known who coined the expression but it may well have been Tom Honeyman; he was to write his book *Three Scottish Colourists* in 1950, but worked for both The Scottish Gallery and Reid & Lefevre in the 1920s. The expression is now commonly understood to include J.D. Fergusson
71. Charles Oliver acted faithfully as Cadell's manservant until the artist's death in 1937
72. John Duncan (1866–1945) is best known as a Celtic revivalist but also painted pure landscape
73. George Service lived at Cove but was a regular summer visitor to Iona with his wife and (eventually) ten children, when he bought many Cadells, accumulating over fifty
74. Peploe would have known Dorothy Johnstone (1892–1980) and the others – most probably Cecile Walton (1891–1956) and Anne Finlay (1898–1963) – from Kirkcudbright and Edinburgh
75. Alexander Reid's son McNeill Reid took over as senior partner
76. The *Dunara Castle* was a Caledonian MacBrayne steamer
77. A rather Roman I on a hand-written label had

been misinterpreted as a Z so that until the author was able to correct it the work bore the enigmatic title *Landscape Zona*

78. The painting was eventually sold to Glasgow Museums by means of the Hamilton Bequest funds as *Portrait of an Old Man*; the title *Old Duff* first appeared when the work was shown in Reid & Lefevre in an exhibition in January 1939

79. An edition of Goya's *Disasters of War* was also a prized acquisition

80. Sir Patrick Ford was a Scottish MP and landowner, a great supporter of Cadell, but who bought Peploe's work also

81. This almost certainly refers to the offer which was accepted for 13 India Street on 2 August

82. This was the other hotel in the town, which still exists

83. Frances Spalding, *Duncan Grant* (Pimlico, 1997), p.278

84. The firm had recently amalgamated with the Lefevre Gallery and Duncan MacDonald had moved to be a partner of McNeill Reid

85. *The Studio* (Vol. XCIII, 1927), London Notes, pp.119–20

86. William 'Spanish' Macdonald (1983–1960) and his wife Beatrice Huntington (1889–1988), also a fine painter, were great friends of the Peploes

87. The letter is quoted in full in Stanley Cursiter, *Peploe*, ibid. pp.70–73

88. Stanley Cursiter, *Peploe*, ibid. p.52

89. WWP is Sam's brother, William Watson Peploe

90. William Mervyn Glass, a prodigious painter of Iona

91. 'D.V., W.P.' – '*Deo Volente* [God willing], weather-permitting'

92. The ferry to Iona

93. Denis Peploe, later RSA, then perhaps thirteen and already a precocious talent

94. The artist's memory has failed him. He was not in Cassis in 1925. The painting is more likely to belong to the trip of 1924 than that of 1928

95. David Sassoon was the brother of the poet Siegfried. He went to Kirkcudbright in the 1920s and was an enthusiastic if somewhat indifferent painter

96. The exhibition in April was the last that Reid & Lefevre held in Glasgow

97. Charles Oppenheimer (1875–1961) was a painter and long-term resident in Kirkcudbright.

98. Reginald Fairlie (1882–1952) was an architect member of the RSA

99. Stanley Cursiter, *Peploe*, ibid p.76

100. Quoted in Stanley Cursiter, *Peploe*, ibid, pp.81–83

101. Reid & Lefevre had a stake in Etienne Bignou's business which had galleries in Paris and New York, but where Scottish art was not actively promoted

102. E.A. Taylor, Foreword, *Memorial Exhibition of Paintings by S.J. Peploe RSA* (RSA, February 1937)

LIST OF COLOUR PLATES

Exhibition, Scotland, 1938; RA, London, 'Scottish Art', 1939; NGS, 'S.J. Peploe', 1941, No 6; British Council Exhibition, Cairo and Algiers, 1944; Ewan Mundy Fine Art, 'The Scottish Colourists', 1989, No 1, ill.; Duncan R. Miller, 'Samuel John Peploe', 1993, No 2, ill.
Ill. Cursiter, *Peploe*, Plate 5
PRIVATE COLLECTION

12 **Man Laughing**, c.1902
Oil on panel, s verso
71.1 × 50.8 cm (28 × 20 in)
Prov. D. MacDonald; George Proudfoot; Miss Proudfoot
Exhib. TSG, 'S.J. Peploe', 1903, No 32; Allied Artists Association, Royal Albert Hall, 1908; TSG, 'S.J. Peploe Memorial Exhibition', 1936, No 22; McLellan Galleries, 'S.J. Peploe Memorial Exhibition', 1937, No 41; NGS, 'S.J. Peploe', 1941, No 14; SNGMA, 'S.J. Peploe', 1985, No 18, ill.; SNGMA, 'Scottish Art Since 1900', 1989, and tour to Barbican Art Gallery, London, No 281; Kirkcaldy Art Gallery, 'The Peploe Show', 1998
Ill. Cursiter, *Peploe*, Plate 6
SNGMA

13 **Still-life, Melon, Grapes and Apples, Black Background**, c.1902
Oil on canvas, sbr and tl
40.6 × 50.8 cm (16 × 20 in)
Prov. Major Ion Harrison
Exhib. McLellan Galleries, 'S.J. Peploe, Memorial Exhibition', 1937; Reid & Lefevre, 'Three Scottish Painters', 1939, No 4; The Thistle Foundation, McLellan Galleries, 'Pictures from a Private Collection', 1951, No 16; SNGMA, 'S.J. Peploe', 1985, No 23, ill.
Ill. Dr T.J. Honeyman, *Three Scottish Colourists* (Thos. Nelson, 1950), Plate 2
PRIVATE COLLECTION

14 **Spring, Comrie**, c.1902
Oil on canvas, sbr
41 × 51 cm (16 × 20 in)
Prov. J.W. Blyth
Exhib. McLellan Galleries, 'S.J. Peploe Memorial Exhibition', 1937; RA, London, 'Scottish Art', 1939; NGS, 'S.J. Peploe', 1941, No 12; SNGMA, 'S.J. Peploe', 1985, No 26, ill.; Kirkcaldy Art Gallery, 'The Peploe Show', 1998
Ill. Cursiter, *Peploe*, Plate 4
FIFE COUNCIL MUSEUMS; KIRKCALDY MUSEUM & ART GALLERY

15 **Landscape, Barra**, c.1903
Oil on panel
19.6 × 30 cm (7.75 × 11.75 in)
Prov. The Scottish Gallery
PRIVATE COLLECTION

16 **Evening, North Berwick**, c.1903
Oil on panel
16 × 23.8 cm (6.5 × 9.25 in)
Prov. J.W. Blyth
Exhib. SAC, 'Three Scottish Colourists, Touring Exhibition', 1970, No 66
Ill. Roger Billcliffe, *The Scottish Colourists* (John Murray, 1989), Plate 11
GLASGOW MUSEUMS

17 **Landscape, Barra**, c.1903
Oil on panel, s verso
27 × 35 cm (10.5 × 13.75 in)
Prov. J.W. Blyth
Exhib. Guildford House Gallery, 'The Scottish Colourists', 1980, No 35; SNGMA, 'S.J. Peploe', 1985, No 25
Ill. Cursiter, *Peploe*, Plate 1; Billcliffe, *The Scottish Colourists*, Plate 12
FIFE COUNCIL MUSEUMS; KIRKCALDY MUSEUM & ART GALLERY

18 **Still Life, Paint Tubes**, c.1903
Oil on panel
18.7 × 25.4 cm (8 × 10 in)
Prov. J.W. Blyth
Exhib. Sheffield Art Galleries, Aberdeen Art Gallery, 'British Painting 1900–60', 1975–76; SNGMA, 'S.J. Peploe', 1985, No 27, ill.
Ill. Cursiter, *Peploe*, Plate 4
GLASGOW MUSEUMS

19 **Souvenir**, c.1904
Oil on canvas, sbr
33 × 43.2 cm (13 × 17 in)
Prov. Dr A. Hyslop
Exhib. McLellan Galleries, 'S.J. Peploe Memorial Exhibition', 1937, No 84; SNGMA, 'S.J. Peploe', 1985, No 28, ill.
ABERDEEN ART GALLERY & MUSEUMS

20 **The Green Blouse**, c.1904
Oil on panel, sbl
50.8 × 50.2 cm (20 × 19.5 in)
Prov. Mrs Peploe
Exhib. McLellan Galleries, 'S.J. Peploe Memorial Exhibition', 1937, No 65; RA, London, 'Scottish Art', 1939; NGS, 'S.J. Peploe', 1941 No 16; SNGMA, 'S.J. Peploe', 1985, No 30; SNGMA and tour to Barbican Art Gallery, London, 'Scottish Art since 1900', 1989, No 383
Ill. Cursiter, *Peploe*, Plate 10
SNGMA

21 **Still-life with Flowers and Fan**, c.1904
Oil on canvas, sbl
40.8 × 40.8 cm (16 × 16 in)
Prov. The Hon J. Bruce
Exhib. Duncan R. Miller Fine Art, 'S.J. Peploe', 1993, No 3, ill.
PRIVATE COLLECTION

22 **Margaret**, c.1904
Oil on panel
25.4 × 21.7 cm (10 × 8.5 in)
Prov. The Scottish Gallery
PRIVATE COLLECTION

23 **Farmyard, Northern France**, c.1904
Oil on panel, sbl
16 × 23.5 cm (6.25 × 9 in)
Exhib. TSG, 'S.J. Peploe', 1990, No 6, ill.
PRIVATE COLLECTION

24 **Horse and Cart, Islay**, c.1904
Oil on panel, sbr
16.2 × 23.3 cm (6.25 × 9 in)
PRIVATE COLLECTION

25 **Etaples**, c.1904
Oil on panel, sbr
19 × 24.1 cm (7.5 × 9.5 in)
Prov. The Scottish Gallery
Exhib. Duncan R. Miller Fine Art, 'S.J. Peploe',
1993, No 6, ill.
PRIVATE COLLECTION

26 **Wind**, c.1905
Oil on panel
18.3 × 24 cm (7.2 × 9.5 in)
Prov. J.W. Blyth
Exhib. SAC Touring Exhibition, 'Three Scottish
Colourists', 1970, No 68; Guildford House Gallery,
'The Scottish Colourists', 1980, No 51; Kirkcaldy
Art Gallery, 'The Peploe Show', 1998
FIFE COUNCIL MUSEUMS; KIRKCALDY
MUSEUM & ART GALLERY

27 **The Black Bottle**, c.1905
Oil on canvas, sbr
50.8 × 76.2 cm (20 × 30 in)
Prov. Robert Wemyss Honeyman
Exhib. McLellan Galleries, 'S.J. Peploe Memorial
Exhibition', 1937, No 12; Empire Exhibition,
Scotland, 1938; RA, London, 'Scottish Art', 1939,
No 2; Reid & Taylor, London, Bonn, Edinburgh,
'The Painter & The Weaver', 1988, No 6, ill.
Ill. Cursiter, *Peploe*, Plate 8
PRIVATE COLLECTION

28 **Still-life with Coffee-pot**, c.1905
Oil on canvas, sbr
61 × 82.5 cm (24 × 32.5 in)
Prov. C.W.G. Guest; George Proudfoot
Exhib. TSG, 'S.J. Peploe Memorial Exhibition',
1936, No 30; McLellan Galleries, 'S.J. Peploe
Memorial Exhibition', 1937, No 24; National
Galleries of Scotland, 'S.J. Peploe', 1941, No 21;
TSG, 'S.J. Peploe Paintings and Drawings', 1947,
No 36; SNGMA, 'S.J. Peploe', 1985, No 34
Ill. Cursiter, *Peploe*, 1947, Plate 9; Billcliffe, *The
Scottish Colourists*, Plate 20
PRIVATE COLLECTION

29 **Still-life**, c.1905
Oil on panel
27 × 35 cm (10.5 × 13.8 in)
Prov. J.J. Cowan; Robert Wemyss Honeyman
Exhib. Kirkcaldy Museum & Art Gallery, 'Loan
Exhibition', 1928, No 36
PRIVATE COLLECTION

30 **Game of Tennis, Luxembourg Gardens**, c.1906
Oil on canvas
16.1 × 23.6 cm (6.5 × 9.25 in)
Prov. Dr R.A. Lillie
Exhib. Arts Council, Scottish Committee, Touring
Exhibition, 'Modern Scottish Painting from the
Collection of Dr R.A. Lillie', 1963, No 15; SAC,
Touring Exhibition, 'Three Scottish Colourists',
1970, No 59; SNGMA, 'S.J. Peploe', 1985, No 37;
SNGMA and tour to Barbican Art Gallery, 'Scottish
Art since 1900', 1989, No 284
SNGMA

31 **Still life with Bananas**, c.1906
Oil on panel
26.1 × 34.3 cm (10.5 × 13.5 in)
Prov. Purchased by the Scottish Modern Art
Association, 1907
Exhib. SNGMA, 'S.J. Peploe', 1985, No 31, ill.
Ill. Cursiter, *Peploe*, Plate 3
CITY OF EDINBURGH COLLECTION

32 **Pink Roses in Blue-and-White Vase, Black
 Background**, c.1906
Oil on canvas
40.6 × 45.7 cm (16 × 18 in)
Prov. Major Ion Harrison
Exhib. The Thistle Foundation, McLellan Galleries,
'Pictures from a Private Collection', 1951, No 29;
SNGMA, 'S.J. Peploe', 1985, No 32, ill.
Ill. Billcliffe, *The Scottish Colourists*, Plate 17
PRIVATE COLLECTION

33 **Girl in Pink**, c.1906
Oil on canvas, sbr
46 × 40.8 cm (18 × 16 in)
Exhib. McLellan Galleries, 'S.J. Peploe Memorial
Exhibition', 1937, No 118; NGS, 'S.J. Peploe', 1941,
No 20; Arts Council, Scottish Committee, Touring
Exhibition, 'S.J. Peploe', 1953, No 49; SAC, Touring
Exhibition, 'Three Scottish Colourists', 1970, No 57;
SNGMA, 'S.J. Peploe', 1985, No 39; TSG, 'S.J.
Peploe', 1990, No 7
PRIVATE COLLECTION

34 **Bathers, Etaples**, c.1906
Oil on panel
18.2 × 22.9 cm (7.25 × 9 in)
Prov. Prof. Macfie
UNIVERSITY OF GLASGOW, HUNTERIAN
ART GALLERY

35 **Paris-Plage**, c.1907
Oil on panel, sbr
26.7 x 21.6 cm (10.5 x 8.5 in)
Prov. The Scottish Gallery
PRIVATE COLLECTION

36 **Afternoon, Paris-Plage**, c.1907
Oil on panel, s verso
24.1 x 19.1 cm (9.5 x 7.5 in)
Prov. The Scottish Gallery
Exhib. TSG, 'S.J. Peploe and His Contemporaries',
1985, No 5
PRIVATE COLLECTION

37 **Plage Scene**, c.1907
Oil on canvas-board
22 x 27 cm (8.5 x 10.5 in)
Prov. J.W. Blyth
Exhib. Guildford House Gallery, 'The Scottish
Colourists', 1980, No 74; SNGMA, 'S.J. Peploe',
1985, No 40; Kirkcaldy Art Gallery, 'The Peploe
Show', 1998; City Art Centre, Edinburgh,
'Scotland's Paintings', 1999
FIFE COUNCIL MUSEUMS; KIRKCALDY
MUSEUM & ART GALLERY

38 **Portrait of Mrs Peploe**, c.1907
Oil on canvas, sbr
61 x 50.9 cm (24 x 20 in)
Prov. Dr A. Hyslop
Exhib. McLellan Galleries, 'S.J. Peploe Memorial
Exhibition', 1937, No 85; SNGMA, 'S.J. Peploe',
1985, No 36
Ill. Cursiter, *Peploe*, Plate 13
ABERDEEN ART GALLERY & MUSEUMS

39 **Lady in Black**, c.1907
Oil on canvas, sbr
61 x 40.7 cm (20 x 16 in)
Prov. Major Ion Harrison
Exhib. Thistle Foundation, McLellan Galleries,
'Pictures from a Private Collection', 1951, No 11;
SNGMA, S.J. Peploe, 1985, No 38, ill.
PRIVATE COLLECTION

40 **A Girl in White**, c.1908
Oil on canvas, s lower right
122 x 108.6 cm (48 x 42.75 in)
Prov. The Scottish Gallery; J. Middleton Esq; Fine
Art Society
Exhib. RSA, 'S.J. Peploe, Memorial Exhibition',
1936, No 60
Ill. Billcliffe, *The Scottish Colourists*, No 22
PRIVATE COLLECTION

41 **Elegance**, c.1908
Oil on canvas, sbl
33.5 x 30 cm (13.25 x 11.75 in)
Prov. J.W. Blyth
Exhib. Guildford House Gallery, 'The Scottish
Colourists', 1980, No 55; Kirkcaldy Museum & Art
Gallery, 'The Peploe Show', 1998

FIFE COUNCIL MUSEUMS; KIRKCALDY
MUSEUM & ART GALLERY

42 **Park Scene**, c.1909
Oil on panel,
19 x 24 cm (7.5 x 9.5 in)
Prov. J.W. Blyth
Exhib. SNGMA, 'S.J. Peploe', 1985, No 48
Ill. Cursiter, *Peploe*, Plate 5; Billcliffe, *The Scottish
Colourists*, Plate 33
FIFE COUNCIL MUSEUMS; KIRKCALDY
MUSEUM & ART GALLERY

43 **Sunlit Street, Royan**, 1910
Oil on board, sbl
26.7 x 35.5 cm (10.5 x 14 in)
Exhib. Duncan R. Miller Fine Art, 'S.J. Peploe',
1993, No 11
PRIVATE COLLECTION

44 **Royan**, 1910
Oil on board, s verso
26.7 x 35.5 cm (10.5 x 14 in)
Prov. Reid & Lefevre; Fine Art Society
PRIVATE COLLECTION

45 **Royan**, 1910
Oil on board, sbr
29 x 33 cm (10.5 x 14 in)
Prov. The Fine Art Society
Exhib. Musée de l'Art Moderne, Paris, 'Le Fauvisme;
ou l'épreuve du feu', 1999–2000, No 189
Ill. Billcliffe, *The Scottish Colourists*, Plate 35
LORD & LADY IRVINE OF LAIRG

46 **Boats at Royan**, 1910
Oil on board, sbl
26.7 x 35.5 cm (10.5 x 14 in)
Prov. Reid & Lefevre; Major Ion Harrison
Exhib. McLellan Galleries, 'S.J. Peploe Memorial
Exhibition', 1937, No 103; Reid & Lefevre, 'Three
Scottish Painters', 1939, No 28; Thistle Foundation,
McLellan Galleries, 'Pictures from a Private
Collection', 1951, No 3; Glasgow Museums,
'Scottish Painting', 1961, No 181; SAC, Touring
Exhibition, 'Three Scottish Colourists', 1970, No 61;
SNGMA, 'S.J. Peploe', 1985, No 50
Ill. Honeyman, *Three Scottish Colourists*, Plate 4
PRIVATE COLLECTION

47 **Luxembourg Gardens**, c.1910
Oil on panel, sbr
35.5 x 26.8 cm (14 x 10.5 in)
Prov. Inscribed: 'To Flora Galbraith, née McPhail on
her wedding day'; The Scottish Gallery; Fine Art
Society
Exhib. SNGMA, 'S.J. Peploe', 1985, No 45, ill.;
Duncan R. Miller Fine Art, 'S.J. Peploe', 1993, No
8, ill.; Kirkcaldy Museum & Art Gallery, 'The Peploe
Show', 1998
Ill. Billcliffe, *The Scottish Colourists*, Plate 37
THE FLEMING WYFORD ART FOUNDATION

48 **Sunlit Street, Royan**, 1910
Oil on board, sbr
26.7 × 35.5 cm (10.5 × 14 in)
Prov. James Bridie
Exhib. Duncan R. Miller Fine Art, 'S.J. Peploe',
1993, No 12
PRIVATE COLLECTION

49 **Jug and Yellow Fruit**, c.1910
Oil on panel, sbl
33.5 × 41 cm (13.25 × 16 in)
Prov. J.W. Blyth
Exhib. SNGMA, 'S.J. Peploe', 1985, No 52, ill.;
Kirkcaldy Museum & Art Gallery, 'The Peploe
Show', 1998
FIFE COUNCIL MUSEUMS; KIRKCALDY
MUSEUM & ART GALLERY

50 **Ile de Bréhat**, 1911
Oil on board, sbl
33 × 40.6 cm (13 × 16 in)
Prov. Inscribed: 'To Tommy and Cathy Honeyman
with love and affection, Margaret Peploe'
Exhib. SNGMA, S.J. Peploe, 1985, No 56; Duncan
R. Miller Fine Art, 'S.J. Peploe', 1993, No 17, ill.
Ill. Billcliffe, *The Scottish Colourists*, Plate 42
PRIVATE COLLECTION

51 **Street Scene, France**, c.1911
Oil on board
34.3 × 26.8 cm (13.5 × 10.5 in)
Prov. Major Ion Harrison
Exhib. The Thistle Foundation, McLellan Galleries,
'Pictures from a Private Collection', 1951, No 35;
SNGMA, 'S.J. Peploe', 1985, No 54
Ill. Honeyman, *Three Scottish Colourists*, Plate 8;
Billcliffe, *The Scottish Colourists*, Plate 36
PRIVATE COLLECTION

52 **The House in the Woods**, c.1911
Oil on board
26.8 × 34.3 cm (10.5 × 13.5 in)
Prov. Major Ion Harrison
Exhib. Thistle Foundation, McLellan Galleries,
'Pictures from Private Collection', 1951, No 36;
SNGMA, 'S.J. Peploe', 1985, No 57
PRIVATE COLLECTION

53 **Veules les Roses**, c.1911
Oil on board
35.6 × 26.7 cm (14 × 10.5 in)
Prov. J.W. Blyth
Exhib. SNGMA, 'S.J. Peploe', 1985, No 49, ill.;
SNGMA, and tour to Barbican Art Gallery, London,
'Scottish Art since 1900', 1989, No 286; Kirkcaldy
Art Gallery, 'The Peploe Show', 1998
SNGMA

54 **Luxembourg Gardens**, c.1911
Oil on board, sbl
33 × 26 cm (13 × 10.25 in)
Prov. The Scottish Gallery; presented by S.J. Peploe

to Scottish Artists' Benevolent Fund, 1915, (cert., No
175); James Wilson
Exhib. SAC, 'Three Scottish Colourists', 1970, No
60, ill.; Guildford House Gallery, 'The Scottish
Colourists', 1980, No 38; City Art Centre,
Edinburgh, 'Full of the Warm South', 1998
FIFE COUNCIL MUSEUMS; KIRKCALDY
MUSEUM & ART GALLERY

55 **Tulips**, c.1911
Oil on canvas, sbr
45.8 × 40.8 cm (18 × 16 in)
Exhib. Goupil Galleries, London Salon, 1911;
Duncan R. Miller Fine Art, 'The Scottish Colourists',
No 2, ill.
PRIVATE COLLECTION

56 **Tulips in Two Vases**, c.1912
Oil on canvas, sbr
47 × 56 cm (18.5 × 22 in)
Exhib. SNGMA, 'S.J. Peploe', 1985, No 58
Ill. Billcliffe, *The Scottish Colourists*, Plate 63
PRIVATE COLLECTION

57 **Tulips and Vases**, c.1911
Oil on canvas, sbr
45.6 × 40.6 cm (17.75 × 15.75 in)
Prov. Alexander Reid; his widow, Mrs Mary E.
Patrick; George Smith
UNIVERSITY OF GLASGOW, HUNTERIAN
ART GALLERY

58 **Portrait of a Girl, Red Bandeau**, c.1912
Oil on canvas, sb centre left
45.7 × 38.1 cm (18 × 15 in)
Exhib. SNGMA, 'S.J. Peploe', 1985, No 68
PRIVATE COLLECTION

59 **Still-life**, c.1912
Oil on canvas, sbr
55 × 46 cm (21.75 × 18.25 in)
Prov. A.J. McNeill Reid
Exhib. SSA, 1912; TSG, 'S.J. Peploe Memorial
Exhibition', 1936, No 78; Glasgow Art Gallery, 'A
Man of Influence: Reid 1854–1928', 1967, No 66;
SNGMA, 'S.J. Peploe', 1985, No 62, ill.; SNGMA,
and toured to Barbican Art Gallery, London,
'Scottish Art since 1900', 1989, No 288; Barbican
Art Gallery, London, 'Modern Art in Britain
1900–14', 1997, ill.; Kirkcaldy Art Gallery, 'The
Peploe Show', 1998
Ill. Cursiter, *Peploe*, Plate 18; Billcliffe, *The Scottish
Colourists*, Plate 61
SNGMA

60 **Arran**, 1913
Oil on board, sbl
30 × 39 cm (12.5 × 15.5 in)
Prov. Willy Peploe
PRIVATE COLLECTION

61 **Landscape, Cassis**, 1913
Oil on panel, sbr
31.8 × 45.7 cm (12.5 × 16 in)
Prov. John Guthrie; Fine Art Society
Ill. Billcliffe, *The Scottish Colourists*, Plate 43
PRIVATE COLLECTION

62 **Street in Cassis**, 1913
Oil on panel, sb centre left
32.8 × 45.8 cm (12.75 × 16 in)
Prov. Reid & Lefevre; Major Ion Harrison
Exhib. The Thistle Foundation, McLellan Galleries,
'Pictures from a Private Collection', 1951, No 34;
SAC, Touring Exhibition, 'Three Scottish Colour-
ists', 1970, No 75, ill.; Kirkcaldy Museum & Art
Gallery, 'The Peploe Show', 1998
Ill. Honeyman, *Three Scottish Colourists*, Plate 7
PRIVATE COLLECTION

63 **Square, Cassis**, 1913
Oil on panel, sbr
33 × 46 cm (12.5 × 16 in)
Prov. Willy Peploe
PRIVATE COLLECTION

64 **Schooner, Cassis Harbour**, 1913
Oil on panel, sbl
32.7 × 45.6 cm (12.5 × 16 in)
Prov. Duncan R. Miller Fine Art
PRIVATE COLLECTION

65 **Crawford**, 1914
Oil on panel, sbr
32.4 × 45.6 cm (12.75 × 16 in)
Exhib. SNGMA, 'S.J. Peploe', 1985, No 64
PRIVATE COLLECTION

66 **Anemones**, c.1914
Oil on canvas, sbr
45.8 × 40.6 cm (18 × 16 in)
Prov. Sir John Richmond; Dr Jim Ritchie
Exhib. Glasgow Museums, 'Scottish Painting', 1951,
No 220; SNGMA, 'S.J. Peploe', 1985, No 63
Ill. Cursiter, *Peploe*, Plate 19
PRIVATE COLLECTION

67 **A Corner of the Studio**, c.1915
Oil on canvas, sbl
61 × 50.8 cm (24 × 20 in)
Prov. Reid & Lefevre; Mr and Mrs Hunter
Exhib. TSG, 'S.J. Peploe', 1990, No 13, ill.
PRIVATE COLLECTION

68 **Interior with Japanese Fan**, c.1915
Oil on canvas, sbr
80 × 62.2 cm (31.5 × 24.2 in)
Prov. Reid & Lefevre; Anthony d'Offay; Fine Art
Society; George Black
Exhib. McLellan Galleries, 'S.J. Peploe Memorial
Exhibition', 1937, No 87 (as *The Bowler Hat*);
SNGMA, 'S.J. Peploe', 1985, No 69, ill.; Sotheby's,
'Monet to Freud, NACF Loan Exhibition', 1988–89,

No 111, ill.; RA, London, 'The Art Treasures of
England', 1998; Kirkcaldy Art Gallery, 'The Peploe
Show', 1998
UNIVERSITY OF HULL ART COLLECTION

69 **Flowers and Fruit (Japanese Background)**, c.1915
Oil on canvas, sbr
40.5 × 45.5 cm (16 × 18 in)
Prov. J.W. Blyth
Exhib. Guildford House Gallery, 'The Scottish
Colourists', 1980, No 56; SNGMA, 'S.J. Peploe',
1985, No 79; FAS, 'Masterpieces of the Scottish
Colourists', 1989; Kirkcaldy Art Gallery, 'The Peploe
Show', 1998; City Art Centre, Edinburgh,
'Scotland's Paintings', 1999
Ill. Billcliffe, The Scottish Colourists, Plate 62
FIFE COUNCIL MUSEUMS; KIRKCALDY
MUSEUM & ART GALLERY

70 **The Blue-and-White Teapot**, c.1916
Oil on canvas, sbl
48 × 57.5 cm (18.75 × 22.5 in)
Prov. J.W. Blyth
Exhib. McLellan Galleries, 'S.J. Peploe Memorial
Exhibition', 1937, No 17; Guildford House Gallery,
'The Scottish Colourists', 1980, No 57; SNGMA,
'S.J. Peploe', 1985, No 74; Kirkcaldy Art Gallery,
'The Peploe Show', 1998
Ill. Cursiter, *Peploe*, Plate 6
FIFE COUNCIL MUSEUMS; KIRKCALDY
MUSEUM & ART GALLERY

71 **Still-life, Black Bottle**, c.1916
Oil on canvas, sbl
45.8 × 55.9 cm (18 × 22 in)
Prov. Alex Reid & Lefevre; Major Ion Harrison
Exhib. The Thistle Foundation, Pictures from a
Private Collection, McLellan Galleries, 1951, No 2
PRIVATE COLLECTION

72 **Cornfield, Douglas Hall**, c.1917
Oil on panel, sbr
31.8 × 38.2 cm (12.5 × 15 in)
Prov. William McInnes
Exhib. McLellan Galleries, 'S.J. Peploe Memorial
Exhibition', 1937, No 22; Empire Exhibition,
Glasgow, 1938, No 471; Guildford House Gallery,
'The Scottish Colourists', 1980, No 60
Ill. Cursiter, *Peploe*, Plate 25
GLASGOW MUSEUMS

73 **Laggan Farm Buildings, near Dalbeattie**, c.1917
Oil on panel, sbl
31.8 × 38.1 cm (12.5 × 15 in)
Prov. William McInnes
Exhib. McLellan Galleries, 'S.J. Peploe Memorial
Exhibition', 1937, No 13; RSA, 'The Scottish
Colourists', 1949, No 49; Glasgow Art Gallery and
Hamburg Kunsthaus, 'Scottish Painting 1880–
1930', 1973–74, No 47, ill.; SNGMA, 'S.J. Peploe',
1985, No 70 ill.
GLASGOW MUSEUMS

74 **Dish with Apples** c.1918
Oil on canvas, sb centre left
63.5 × 76.2 cm (25 × 30 in)
Prov. William Burrell; Major Ion Harrison
Exhib. Thistle Foundation, McLellan Galleries,
'Pictures from a Private Collection', 1951, No 8
SNGMA, S.J. Peploe, 1985, No 75, ill.; Reid &
Lefevre, London, 'Two Scottish Colourists', 1988,
No 9, ill.
PRIVATE COLLECTION, WITH ABERDEEN
ART GALLERY

75 **Tulips and Fruit**, c.1919
Oil on canvas, sbr
58 × 50 cm (22.75 × 19.5 in)
Prov. Major Ion Harrison
Exhib. The Thistle Foundation, McLellan Galleries,
Pictures from a Private Collection, 1951, No 41
Ill. Honeyman, *Three Scottish Colourists*, Plate 6;
Billcliffe, *The Scottish Colourists*, Plate 71
PRIVATE COLLECTION

76 **Still-life with Tulips**, c.1919
Oil on canvas, sbl
56 × 51 cm (22 × 20 in)
Prov. William Bowie; Fine Art Society
Ill. Billcliffe, *The Scottish Colourists*, Plate 70
PRIVATE COLLECTION

77 **Girl in a White Dress**, c.1919
Oil on canvas, stl
61 × 40.6 cm (24 × 16 in)
Prov. Reid & Lefevre; William Burrell
Exhib. Arts Council, Scottish Committee, 'Paintings
from the Burrell Collection, Scottish Tour',
1947–48, No 63
GLASGOW MUSEUMS, BURRELL
COLLECTION

78 **Roses and Still-life**, c.1920
Oil on canvas, sbr
73.7 × 50.9 cm (24 × 20 in)
Prov. Professor Cargill; Major Ion Harrison
Exhib. RA, London, 'Scottish Painting', 1939; The
Thistle Foundation, McLellan Galleries, 'Pictures
from a Private Collection', 1951, No 26; SNGMA,
S.J. Peploe, 1985, No 82
Ill. Honeyman, *Three Scottish Colourists*, Plate 3;
Billcliffe, *The Scottish Colourists*, Plate 74
PRIVATE COLLECTION

79 **Pink Roses in a Japanese Vase**, c.1920
Oil on canvas, sbl
50.9 × 40.7 cm (20 × 16 in)
Prov. Sir John Richmond; Dr Jim Ritchie
Exhib. McLellan Galleries, 'S.J. Peploe Memorial
Exhibition', 1937, No 86; SNGMA, 'S.J. Peploe',
1985, No 88
Ill. Cursiter, *Peploe*, Plate 26
PRIVATE COLLECTION

80 **Peonie Roses**, c.1920
Oil on canvas, sbr
55.9 × 45.7 cm (22 × 18 in)
Prov. Duncan R. Miller Fine Art
PRIVATE COLLECTION

81 **Roses and Fruit**, c.1921
Oil on canvas, sbl
55.9 × 50.9 cm (22 × 20 in)
Prov. The Scottish Gallery; Major Ion Harrison
Exhib. The Thistle Foundation, McLellan Galleries,
'Pictures from a Private Collection', 1951, No 21;
SAC, Touring Exhibition, 'Three Scottish
Colourists', 1970, No 71, ill.
Alex Reid & Lefevre, London, 'Two Scottish
Colourists', 1988, No 6, ill.
Ill. Honeyman, *Three Scottish Colourists*, Plate 6
PRIVATE COLLECTION

82 **Iona, North End**, c.1920
Oil on panel, sbr
32.4 × 41.3 cm (12.75 × 16.25 in)
PRIVATE COLLECTION

83 **Boy Reading**, c.1921
Oil on canvas, sbl
76.2 × 63.5 cm (30 × 25 in)
Exhib. SNGMA, 'S.J. Peploe', 1985, No 85
Ill. Cursiter, *Peploe*, Plate 38
RSA, DIPLOMA COLLECTION

84 **Old Duff**, c.1922
Oil on canvas, sbr
101.6 × 76.2 cm (40 × 30 in)
Exhib. RSA, 1922; RGI, 1923; McLellan Galleries,
S.J. Peploe Memorial Exhibition, No 18; Reid &
Lefevre, 'Three Scottish Painters', 1939, No 49;
TSG, 'S.J. Peploe', 1947, No 52; SAC, Touring
Exhibition, 'Three Scottish Colourists', 1970, No 70,
ill.; Glasgow Museums and Hamburg Kunsthaus,
'Scottish Painting 1880–1930', 1973–74, No 44
Ill. Cursiter, *Peploe*, Plate 29
GLASGOW MUSEUMS

85 **Still-life with Mixed Roses**, c.1922
Oil on canvas, sbl
50.9 × 40.6 cm (20 × 16 in)
Prov. Hugh Stodart; Lord Stodart of Leaston; The
Scottish Gallery
Exhib. TSG, 'S.J. Peploe', 1923
PRIVATE COLLECTION

86 **Roses**, c.1922
Oil on canvas, sbr
61 × 50.8 cm (24 × 20 in)
Prov. Reid & Lefevre; Robert Wemyss Honeyman
Exhib. Kirkcaldy Museum & Art Gallery, 'Loan
Exhibition', 1928
PRIVATE COLLECTION

87 **Still-life with Roses**, c.1923
Oil on canvas, sbr
50.9 × 40.6 cm (20 × 16 in)
Prov. John Grant
Exhib. Guildford House Gallery, 'The Scottish
Colourists', 1980, No 61, ill.; SNGMA, 'S.J. Peploe',
1985, No 90, ill.; Aberdeen Art Gallery, 'The Colour
of Light', 1996; Kirkcaldy Art Gallery, 'The Peploe
Show', 1998
Ill. Billcliffe, *The Scottish Colourists*, Plate 131
ABERDEEN ART GALLERY & MUSEUMS

88 **Still-life**, c.1923
Oil on canvas, sbr
55.9 × 45.8 cm (22 × 18 in)
Prov. The Scottish Gallery; Robert Wemyss
Honeyman
PRIVATE COLLECTION

89 **Roses**, c.1924
Oil on canvas, sbr
61 × 50.8 cm (24 × 20 in)
Prov. Robert Wemyss Honeyman
Exhib. TSG, 'S.J. Peploe Memorial Exhibition',
1936, No 33
PRIVATE COLLECTION

90 **The Rainbow**, c.1924
Oil on canvas, sbr
50.8 × 71.1 cm (20 × 28 in)
Prov. The Scottish Gallery; Robert Wemyss
Honeyman
PRIVATE COLLECTION

91 **Iona, Mull and Ben More in the Distance**, c.1924
Oil on canvas, sbr
50.8 × 61 cm (20 × 24 in)
Prov. The Scottish Gallery; J. Geoghegan.
PRIVATE COLLECTION

92 **Landscape at Cassis**, c.1924
Oil on canvas, sbr
55.4 × 45.7 cm (21.75 × 18 in)
Prov. Reid & Lefevre; Gordon Binnie
Exhib. McLellan Galleries, 'S.J. Peploe Memorial
Exhibition', 1937, No 27; SNGMA, 'S.J. Peploe',
1985, No 92, ill.; SNGMA, and tour to Barbican Art
Gallery, London, 'Scottish Art since 1900', 1990, No
292; Isetan Museum of Art, Tokyo, and a tour in
Japan, 'Masterpieces from the National Galleries of
Scotland', 1993; Kirkcaldy Art Gallery, 'The Peploe
Show', 1998
SNGMA

93 **The Aloe Tree**, c.1924
Oil on canvas, sbl
61 × 50.8 cm (24 × 20 in)
Prov. Reid & Lefevre
Exhib. SNGMA, 'S.J. Peploe', 1985, No 107, ill.
MANCHESTER CITY ART GALLERIES

94 **Landscape, Cassis**, c.1924

Oil on canvas, sbr
63.5 × 53.5 cm (25 × 21 in)
Prov. Reid & Lefevre
Exhib. Aberdeen Art Gallery, 'Peploe Exhibition',
1971
ABERDEEN ART GALLERY & MUSEUMS

95 **Tulips**, c.1924
Oil on canvas, sbl
61 × 50.8 cm (24 × 20 in)
Prov. The Scottish Gallery; Robert Wemyss
Honeyman
Exhib. TSG, 'S.J. Peploe, Memorial Exhibition',
1936, No 13
Ill. Cursiter, *Peploe*, Plate 11
PRIVATE COLLECTION

96 **Michelmas Daisies and Oranges**, c.1925
Oil on canvas, sbl
61 × 50.8 cm (24 × 20 in)
Prov. Reid & Lefevre; Major Ion Harrison
Exhib. The Thistle Foundation, McLellan Galleries,
'Pictures from a Private Collection', 1951, No 17;
SAC, S.J. Peploe, 1953, No 27, ill; FAS, Three
Scottish Colourists, 1977; SNGMA, S.J. Peploe,
1985, No 100, ill.
Ill. Cursiter, *Peploe*, Plate 13; Billcliffe, *The Scottish
Colourists*, Plate 133
PRIVATE COLLECTION

97 **Lillies**, c.1925
Oil on canvas, sbr
51 × 41 cm (20 × 16 in)
Prov. J.W. Blyth
Exhib. Venice, 'Biennale Internazionale d'Arte de
Venezia', 1936; Guildford House Gallery, 'The
Scottish Colourists', 1980, No 54; Kirkcaldy Art
Gallery, 'The Peploe Show', 1998
FIFE COUNCIL MUSEUMS; KIRKCALDY
MUSEUM & ART GALLERY

98 **Morar**, c.1925
Oil on panel, sbr
38.1 × 45.6 cm (15 × 17.75 in)
Prov. Reid & Lefevre; J.W. Blyth; Dr Jim Richie
Exhib. TSG, 'S.J. Peploe Memorial Exhibition', No
36; SNGMA, 'S.J. Peploe', 1985, No 89
PRIVATE COLLECTION

99 **The Brown Crock**, c.1925
Oil on canvas, stl
61 × 50.8 cm (24 × 20 in)
Prov. William Burrell; William McInnes
Exhib. McLellan Galleries, 'S.J. Peploe Memorial
Exhibition', 1937, No 55; RA, London, 'Scottish
Art', No 589; RSA, 'S.J. Peploe', 1949, No 34; Glas-
gow Art Gallery and Hamburg Kunsthaus, 'Scottish
Painting 1880–1930', 1973–74, No 47, ill.; Guild-
ford House Gallery, 'The Scottish Colourists', 1980,
No 59, ill.; SNGMA, 'S.J. Peploe', 1985, No 94, ill.
Ill. Cursiter, *Peploe*, Plate 27
GLASGOW MUSEUMS

100 New Abbey, Dumfriesshire (Summer), c.1926
Oil on canvas, sbl
56.4 × 78.5 cm (22 × 30 in)
Prov. Reid & Lefevre; Robert French; Professor A.L. Macfie
Exhib. RSA, 'S.J. Peploe Memorial Exhibition', 1936; McLellan Galleries, 'S.J. Peploe Memorial Exhibition', 1937, No 63; SNGMA, 'S.J. Peploe', 1985, No 95, ill.
UNIVERSITY OF GLASGOW, HUNTERIAN ART GALLERY

101 Summer, New Abbey, c.1926
Oil on canvas, sbl
50.8 × 61 cm (20 × 24 in)
Prov. Robert Wemyss Honeyman
Exhib. TSG, 'S.J. Peploe Memorial Exhibition', 1936, No 12; Empire Exhibition, Glasgow, 1938, No 456; SAC, Touring Exhibition, 'Three Scottish Colourists', 1970, No 74
Ill. Cursiter, *Peploe*, Plate 12
PRIVATE COLLECTION

102 North Wind, Sound of Iona, c.1926
Oil on canvas, sbl
50.8 × 61 cm (20 × 24 in)
Prov. Major Ion Harrison
Exhib. The Thistle Foundation, McLellan Galleries, 'Pictures from a Private Collection', 1951, No 20
PRIVATE COLLECTION

103 The Ginger Jar, c.1926
Oil on canvas, sbl
45.8 × 55.9 cm (18 × 22 in)
Prov. The Scottish Gallery; J.W. Blyth
Exhib. Kirkcaldy Exhibtion, 1928; TSG, 'S.J. Peploe Memorial Exhibition', 1936, No 20; McLellan Galleries, 'S.J. Peploe Memorial Exhibition', 1937, No 23, ill.; RA, London, 'Scottish Art', 1939; NGS, 'S.J. Peploe', 1941, No 53; Ewan Mundy Fine Art, 'The Scottish Colourists', 1989, No 10, ill.; Duncan R. Miller Fine Art, 'S.J. Peploe', 1993, No 28, ill.
Ill. Cursiter, *Peploe*, Plate 34
PRIVATE COLLECTION

104 Aspidistra, c.1927
Oil on canvas
61 × 50.8 cm (24 × 20 in)
Prov. Dr A Hyslop
Exhib. SNGMA, 'S.J. Peploe', 1985, No 99
Ill. Cursiter, *Peploe*, Plate 31
ABERDEEN ART GALLERY & MUSEUM

105 The Abbey, Iona, c.1927
Oil on canvas, sbl
40.6 × 50.8 cm (16 × 20 in)
Prov. Willy Peploe
PRIVATE COLLECTION

106 Iona, Cloudy Sky, c.1927
Oil on canvas, sbl
45.8 × 56 cm (18 × 22 in)

Prov. J.W. Blyth
Exhib. National Gallery, London, 'Twentieth-century British Paintings', 1940; RSA, 'S.J. Peploe', 1949; Ewan Mundy Fine Art, 'The Scottish Colourists', 1989. No 9, ill.; Duncan R. Miller Fine Art, 'S.J. Peploe', 1993, No 26, ill.
PRIVATE COLLECTION

107 Trees, Antibes, 1928
Oil on canvas, sbr
63.5 × 76.2 cm (25 × 30 in)
Prov. James G. Spiers; Major Ion Harrison
Exhib. McLellan Galleries, 'S.J. Peploe Memorial Exhibition', 1937, No 45, ill.; Thistle Foundation, McLellan Galleries, 'Pictures from a Private Collection', 1951, No 40; Arts Council, Scottish Committee, 'S.J. Peploe Touring Exhibition', 1953, No 25; SNGMA, 'S.J. Peploe', 1985, No 106, ill.
Ill. Cursiter, *Peploe*, Plate 41; Honeyman, *Three Scottish Colourists*, Plate 5; Billcliffe, *The Scottish Colourists*, Plate 132
PRIVATE COLLECTION

108 Palm Trees, Antibes, 1928
Oil on canvas, sbr
61.5 × 51 cm (24 × 20 in)
Prov. J.W. Blyth
Exhib. RSA, 'Summer Show', 1930; TSG, 'S.J. Peploe Memorial Exhibition', 1936, No 62; McLellan Galleries, 'S.J. Peploe Memorial Exhibition', 1937, No 21; NGS, 'S.J. Peploe', 1941, No 39; Guildford House Gallery, 'The Scottish Colourists', 1980, No 73; SNGMA, 'S.J. Peploe', 1985, No 105, ill.; Kirkcaldy Art Gallery, 'The Peploe Show', 1998; City Art Centre, Edinburgh, 'Scotland's Paintings', 1999
Ill. Cursiter, *Peploe*, Plate 39
FIFE COUNCIL MUSEUMS; KIRKCALDY MUSEUM & ART GALLERY

109 The Pink House, Cassis, c.1928
Oil on canvas, sbl
61 × 50.8 cm (24 × 20 in)
Prov. The Scottish Gallery; John Geoghegan
Exhib. SNGMA, 'S.J. Peploe', 1985, No 109
PRIVATE COLLECTION

110 Blue Water, Antibes, 1928
Oil on canvas, sbr
63.5 × 63.5 cm (25 × 25 in)
Prov. The Scottish Gallery: J.W. Blyth
Exhib. TSG, 'S.J. Peploe Memorial Exhibition', 1936, No 14; RA, London, 'Scottish Art', 1939; Ewan Mundy Fine Art, 'The Scottish Colourists', 1989, No 11, ill.; Duncan R. Miller Fine Art, 'S.J. Peploe', 1993, No 29, ill.
Ill. Cursiter, *Peploe*, Plate 40
PRIVATE COLLECTION

111 Sweetheart Abbey, c.1928
Oil on canvas,
51 × 61 cm (20 × 24 in)

Prov. J.W. Blyth
Exhib. Kirkcaldy Art Gallery, 'Inaugural Loan
Exhibition', 1928; TSG, 'S.J. Peploe Memorial
Exhibition', 1936, No 17; NGS, 'S.J. Peploe', 1941,
No 46; RSA, 'Three Scottish Colourists', 1949, No
46; SAC, Touring Exhibition, 'Three Scottish
Colourists', 1970, No 80; SNGMA, 'S.J. Peploe',
1985, No 111, ill.; Kirkcaldy Art Gallery, 'The
Peploe Show', 1998
Ill. Cursiter, *Peploe*, Plate 15
FIFE COUNCIL MUSEUMS; KIRKCALDY
MUSEUM & ART GALLERY

112 **La Forêt**, c.1929
Oil on canvas, sbl
63.5 × 76 cm (25 × 29.75 in)
Prov. Reid & Lefevre
Exhib. Galerie Georges Petit, Paris, 'Les Peintres
écossais', 1931
FRENCH STATE COLLECTION

113 **Boat of Garten**, c.1929
Oil on canvas, sbr
58.4 × 76.3 cm (23 × 30 in)
Prov. The Scottish Gallery; Robert Wemyss
Honeyman
Exhib. TSG, 'S.J. Peploe Memorial Exhibition',
1936, No 70
Ill. Cursiter, *Peploe*, Plate 44
PRIVATE COLLECTION

114 **Still-life with Yellow Jug and Vegetables**, c.1929
Oil on canvas
50.8 × 53.4 cm (20 × 22 in)
Prov. The Scottish Gallery; Mr Pownall; Duncan R.
Miller Fine Art
PRIVATE COLLECTION

115 **Stormy Weather, Iona**, c.1929
Oil on canvas, sbl
50.8 × 61 cm (20 × 24 in)
Prov. The Scottish Gallery; Lord Aitchison
Exhib. TSG, 'S.J. Peploe Memorial Exhibition',
1936, No 34; NGS, 'S.J. Peploe', 1941, No 47; Arts
Council, Scottish Committee, 'S.J. Peploe Touring
Exhibition', 1953, No 1; The Saltire Society, Edin-
burgh, 'Four Scottish Colourists', 1952, No 37;
Aberdeen Art Gallery, 'Peploe Exhibition', 1977;
Guildford House Gallery, 'The Scottish Colourists',
1980, No 62; SNGMA, 'S.J. Peploe', 1985, No 116,
ill.; Kirkcaldy Art Gallery, 'The Peploe Show', 1998
ABERDEEN ART GALLERY & MUSEUMS

116 **Nude in Interior, with Guitar**, c.1929
Oil on canvas, sbr
101.6 × 76.2 cm (40 × 30 in)
Prov. Fine Art Society
Exhib. SNGMA, 'S.J. Peploe', 1985, No 120
PRIVATE COLLECTION

117 **Willy Peploe**, c.1930
Oil on canvas, sb centre
92 × 71.1 cm (36 × 28 in)
Prov. Willy Peploe; Reid & Lefevre
Exhib. Reid & Lefevre, 'Two Scottish Colourists',
1988, No 14, ill.
PRIVATE COLLECTION

118 **Cassis**, c.1930
Oil on canvas, sbl
61 × 50.8 cm (24 × 20 in)
Prov. The Scottish Gallery; George Proudfoot; The
Scottish Gallery
Exhib. RSA, 'Three Scottish Colourists', 1949, No
57; TSG, 'S.J. Peploe and his Contemporaries', 1985,
No 17, ill.
PRIVATE COLLECTION

119 **Birds-eye View, Cassis**, c.1930
Oil on canvas, sbr
50.8 × 61 cm (20 × 24 in)
Prov. John Geoghegan; Sir Alexander Gibson
Exhib. McLellan Galleries, 'S.J. Peploe Memorial
Exhibition', 1937, No 78; TSG, 'S.J. Peploe', 1947,
No 30; Arts Council, Scottish Committee, 'S.J.
Peploe Touring Exhibition', 1953, No 15; Duncan
R. Miller Fine Art, 'S.J. Peploe', 1993, No 35, ill.;
Duncan R. Miller Fine Art, 'The Scottish Colourists',
1996, No 5, ill.
PRIVATE COLLECTION

120 **Still-life with Chops**, c.1930
Oil on canvas, sbl
45.3 × 40.5 cm (18 × 16 in)
Prov. Dr A. Hyslop
Exhib. The Saltire Society, 'Four Scottish Colourists',
1952; SNGMA, 'S.J. Peploe', 1985, No 119, ill.;
Aberdeen Art Gallery, 'The Colour of Light', 1996
ABERDEEN ART GALLERY & MUSEUMS

121 **Still-life with Plaster Cast**, c.1931
Oil on canvas, sbl
58.4 × 54.6 cm (23 × 21.5 in)
Prov. K. Sanderson
Exhib. SNGMA, 'S.J. Peploe', 1985, No 125, ill.;
SNGMA, and tour to Barbican Art Gallery, London,
'Scottish Art since 1900', 1989, No 294; Kirkcaldy
Museum & Art Gallery, 'The Peploe Show', 1998
Ill. Cursiter, *Peploe*, Plate 16
SNGMA

122 **Iona**, c.1930
Oil on canvas, sbl
50 × 71 cm (20 × 28 in)
Prov. J.W. Blyth
Exhib. RSA, 'The Scottish Colourists', 1949;
Guildford House Gallery, 'The Scottish Colourists',
1980, No 64; SNGMA, 'S.J. Peploe', 1985, No 121,
ill.
FIFE COUNCIL MUSEUMS; KIRKCALDY
MUSEUM & ART GALLERY

123 **Still-life (Fruit)**, c.1930
Oil on canvas, sbr
51 x 62 cm (20 x 24 in)
Prov. Andrew Harley
Exhib. Guildford House Gallery, 'The Scottish
Colourists', 1980, No 43; SNGMA, 'S.J. Peploe',
1985, No 126, ill.; Kirkcaldy Art Gallery, 'The
Peploe Show', 1998
FIFE COUNCIL MUSEUMS; KIRKCALDY
MUSEUM & ART GALLERY

124 **Tulips in a Brown Jar**, c.1933
Oil on canvas, sbl
45.7 x 40.6 cm (18 x 16 in)
Prov. Dr A. Hyslop
Exhib. McLellan Gallery, 'S.J. Peploe Memorial
Exhibition', 1937, No 19; SNGMA, 'S.J. Peploe',
1985, No 133; Aberdeen Art Gallery, 'The Colour of
Light', 1996; Kirkcaldy Museum & Art Gallery, 'The
Peploe Show', 1998
Ill. Cursiter, *Peploe*, Plate 47
ABERDEEN ART GALLERY & MUSEUMS

125 **River**, c.1933
Oil on canvas
53 x 63.2 cm (20.75 x 34.75 in)
Prov. Reid & Lefevre; Dr A. Hyslop
Exhib. TSG, 'S.J. Peploe Memorial Exhibition',
1936, No 55; Aberdeen Art Gallery, The Colour of
Light, 1996
ABERDEEN ART GALLERY & MUSEUMS

126 **Rothiemurchus**, 1934
Oil on canvas, sbl
40.6 x 45.7 cm (16 x 18 in)
Exhib. SNGMA, 'S.J. Peploe', 1985, No 132
Ill. Cursiter, *Peploe*, Plate 48
PRIVATE COLLECTION